Black Film British
Cinema II

Black Film British Cinema II

Edited by
Clive Nwonka and Anamik Saha

Goldsmiths
Press

www.gold.ac.uk/goldsmiths-press

Goldsmiths
UNIVERSITY OF LONDON

Contents

Contents

Contributors

Bidisha is a broadcaster, writer, and filmmaker. She specialises in human rights, social justice, gender, and the arts and offers political analysis, arts critique, and cultural diplomacy, tying these interests together. She writes for *The Guardian* and *The Observer* (where she is currently an arts critic) and for BBC TV and radio, Channel 4 News, and Sky News. Her fifth book, *Asylum and Exile: Hidden Voices of London* (Seagull Books, 2015), is based on her outreach work in UK refugee charities and detention centres. Her first film, *An Impossible Poison (2017)*, has been highly critically acclaimed and selected for numerous international film festivals.

Erica Carter is Professor of German and Film at King's College London, and Chair of the UK German Screen Studies Network. She began her academic career at the University of Birmingham, working across German and Cultural Studies, the latter at the Centre for Contemporary Cultural Studies. She took time out of the academy in the mid-1980s to co-found, with Chris Turner, the translation cooperative Material Word. Following two subsequent years as Director of Talks at the Institute for Contemporary Arts, London, Erica returned to academic life in 1989, with posts at the University of Southampton (1989–95), the University of Warwick (1995–2011), and King's College London (2011–present).

Ashley Clark is Senior Repertory and Specialty Film Programmer at Brooklyn Academy of Music (BAM). He has curated series at MoMA, New York, BFI Southbank, London, and BAMcinématek. Ashley writes about film and culture for *The Guardian*, *VICE*, *Film Comment*, and *Sight & Sound*, among others, and he is a regular guest critic on BBC TV's Film show. His first book is *Facing Blackness: Media and Minstrelsy in Spike Lee's Bamboozled* (The Critical Press, 2015).

Shelley Cobb is Associate Professor of Film at the University of Southampton and was Principal Investigator of the research project, Calling the Shots: Women and Contemporary Film Culture in the UK. She is the author of *Adaptation, Authorship and Cotemporary Women Filmmakers* (Palgrave, 2015) and co-editor of *First Comes Love: Power Couples, Celebrity Kinship and Cultural Politics* (Bloomsbury, 2015). Her most recent publications are on gender, diversity, and data in the film industry and the use of oral histories for contemporary cinema studies. Currently she is writing about the role of celebrities in media discourses about equality and diversity.

James Harvey is Lecturer in Film Studies at the University of Sussex. His research focuses on the politics of contemporary art cinema, artists' film, and documentary. He is the author of *Jacques Ranciere and the Politics of Art Cinema* (Edinburgh University Press, 2018) and the editor of *Nationalism in Contemporary Western European Cinema* (Palgrave Macmillan, 2018). He is currently writing the first monograph devoted to the career of British-Ghanaian artist-filmmaker, John Akomfrah.

Melanie Hoyes is Industry Inclusion Executive at the British Film Institute, working on a project to acquire diversity data about gender and ethnicity for the BFI Filmography, telling stories about UK film history using data from the archive. She continues to use data and research in order to monitor and inform improved policy and practice at the BFI and the UK film industry. She completed a BA in Film and Literature at the University of Warwick and an MA in the History of Film and Visual Media at Birkbeck College, University of London. Before joining the BFI she taught undergraduates in Film, Media, and Cultural Studies at the University of Sussex, as well as working in Library Services at UCL.

Maryam Jameela researches film and trauma in relation to Islamophobia. Her work focuses on researching across disciplines in order to sharpen tools of anti-racist resistance. She completed her PhD at University of Sheffield.

Kara Keeling is Associate Professor of Cinema and Media Studies at The University of Chicago. Keeling is author of *Queer Times, Black Futures* (New York University Press, 2019) and *The Witch's Flight: The Cinematic, the Black Femme, and the Image of Common Sense* (Duke University Press, 2007) and co-editor (with Josh Kun) of *Sound*

Clash: Listening to American Studies (Johns Hopkins University Press, 2012), and (with Colin MacCabe and Cornel West) a selection of writings by the late James A. Snead entitled *European Pedigrees/ African Contagions: Racist Traces and Other Writing* (Palgrave Macmillan, 2003).

Ozlem Koksal is Senior lecturer at the University of Westminster School of Media Arts and Design. Her research focuses on representations of the past, as well as the notions of memory, loss, and displacement in visual culture. She is the author of *Aesthetics of Displacement: Turkey and its Minorities on Screen* (Bloomsbury, 2016). Her other publications include 'Past Not-So-Perfect: Ararat and its Reception in Turkey' in *Cinema Journal* (54.1, 2014) and 'From Wim Wender's Lisbon to Fatih Akin's Istanbul' in *Cool Istanbul: Urban Enclosures and Resistances* (Transcript Verlag, 2015).

Rabz Lansiquot is a filmmaker, writer, curator, and DJ. She was a leading member of sorryyoufeeluncomfortable (SYFU) from 2014–18, and currently works with Imani Robinson as the curatorial and artistic collective Languid Hands, who are the Cubitt Curatorial Fellows for 2020–21. Rabz was Curator In Residence at LUX Moving Image in 2019, developing a programme around Black liberatory cinema. She was a programme adviser for LFF's Experimenta strand in 2019, and is on the selection committee for Sheffield Doc/Fest 2020. She is also training to deliver Super 8 workshops at not. nowhere and is a board member at City Projects.

Sarita Malik is Professor of Media, Culture, and Communications at Brunel University London. Her research explores issues of social change, inequality, communities, and cultural representation. Sarita is currently leading 'Creative Interruptions', a large international research project funded by the UK Arts and Humanities Research Council. The project examines how the arts, media, and creativity are used to challenge marginalisation. Her books include: *Representing Black Britain* (Sage, 2002), *Adjusting the Contrast: British Television and Constructs of Race* (Manchester University Press, 2017) and *Community Filmmaking: Diversity, Practices and Places* (Routledge, 2017).

Richard Martin is Curator of Public Programmes at Tate, Tutor at the Bartlett School of Architecture, UCL, and writes on contemporary art and film for a range of publications. He previously taught literature, film, visual culture, and critical theory at King's College London,

Middlesex University and Birkbeck, University of London. He is the author of *The Architecture of David Lynch* (Bloomsbury, 2014). He holds a BA in English and American Studies from the University of Manchester, an MA in English from University College London, and completed his PhD in Cultural Studies at the London Consortium, a multi-disciplinary programme partnering Birkbeck with the Architectural Association, the Institute of Contemporary Arts, the Science Museum, and Tate.

So Mayer is a writer, programmer and activist whose recent books include *Political Animals: The New Feminist Cinema* (I.B. Tauris, 2015) and *From Rape to Resistance: Taking Back the Screen* (Verso Books, 2017); recent scholarship includes essays on Julie Dash's 'Four Women' in *Women Artists, Feminism and the Moving Image* (Bloomsbury, 2019), and on Tracey Moffatt's 'Moodeijt Yorgas' in *Female Authorship and the Documentary Image* (Edinburgh University Press, 2018). A BFI Film Classics on ORLANDO is forthcoming. They are a regular contributor to *Sight & Sound, Literal and Film Quarterly*; programme with queer feminist film curation collective Club des Femmes, and with Queer Lisboa/Porto; and co-founded Raising Films, a campaign and community for parents and carers in the screen sector.

Clive James Nwonka is a Fellow in Film Studies in the Department of Sociology at the London School of Economics and Political Science. His work explores issues of realism, race, class, and representation in British and American cinema, and the institutional frameworks of the British film and TV industries. His published research includes writings on contemporary social realism, Black British cinema, film and architecture, and diversity policy. He is the author of the forthcoming book, *Black Boys: The Aesthetics of British Urban Cinema* (Bloomsbury Academic, 2021).

Alessandra Raengo is Associate Professor of Moving Image Studies at Georgia State University, founder and coordinator of *liquid blackness*, a research project on blackness and aesthetics, and Founding Editor of its journal, now with Duke University Press. She is the author of *On the Sleeve of the Visual: Race as Face Value* (Dartmouth College Press, 2013) and of *Critical Race Theory and* Bamboozled (Bloomsbury Press, 2016). Her work has appeared in *Camera Obscura, Discourse, Adaptation, The World Picture Journal, Black Camera, The Black*

Scholar, and several anthologies. She is working on a book tentatively titled, *Liquid Blackness: Gathering the Aesthetic*.

Richard T. Rodríguez is Associate Professor of Media & Cultural Studies at the University of California, Riverside. The author of *Next of Kin: The Family in Chicano/a Cultural Politics* (Duke University Press, 2009), he is at work on two book projects: *Undocumented Desires: Fantasies of Latino Male Sexuality* and *Latino/UK: Transatlantic Intimacies in Post-Punk Cultures*.

Anamik Saha is Senior Lecturer in the Department of Media, Communications and Cultural Studies, Goldsmiths, University of London. His research interests are in race and the media, with a particular focus on cultural production and the cultural industries, including issues of 'diversity'. He is the author of *Race and the Cultural Industries* (Polity, 2018). In 2019 he received an Arts and Humanities Research Council Leadership Fellow grant for a project entitled 'Rethinking Diversity in Publishing'. Anamik is an editor of the *European Journal of Cultural Studies*. He is currently working on a new book entitled *Race, Culture, Media* (Sage, 2021).

Tess Sophie Skadegård Thorsen is a doctoral candidate of media, race, and representation at the Department of Politics and Society, at Aalborg University, Denmark. Her work explores practices of representation of various minoritised groups in the production of Danish film and in Danish film policy, minority taxation in the Danish academy and racialisation.

Natalie Wreyford is currently Research Fellow on A Vision for Women in VR (VWVR.org) in partnership with the University of Nottingham and King's College London. The project is funded by Refiguring Innovation in Games (ReFiG), itself a five-year project supported by the Social Sciences and Humanities Research Council of Canada. Natalie writes about gender and creative labour and is author of *Gender Inequality in Screenwriting Work* (Palgrave Macmillan, 2018).

Preface

Erica Carter

On 2 February 2019, the Stuart Hall Foundation, launched at the British Film Institute in September 2015 to carry forward the critical and creative work of Britain's foremost post-war black intellectual, ran its second Annual Public Conversation in Conway Hall, London. Taking as its theme 'Stuart Hall and the Future of Public Space', the event included presentations by Farzana Khan, curator of the Foundation's Black Cultural Activism Map; *Novara Media* editor Ash Sarkar and *The Guardian* journalist John Harris, speaking on media interventions in times of crisis; the Foundation's then Executive Director Hammad Nasar; and Stuart Hall Scholar Ruth Ramsden-Karelse, speaking on her PhD research on South African queer feminine gender performance, funded during a first programme of support for new research 'resonant with' the Foundation's aims (Stuart Hall Foundation, 2020).

Like the Conway Hall speakers, this present volume seeks to prompt a public conversation that engages, historicises, and remediates black cultural production – in this volume's case, black British cinema. One panel at the February 2019 event stands out for its especially pertinent address to *Black Film British Cinema II*. An absorbing conversation on the Conway Hall platform between photographer and video artist Willie Doherty and curator Elvira Dyangani Ose revealed a mutual commitment to art that imagines shared senses of postcolonial place and mutual belonging. Doherty's landscape photographs return repeatedly to his home territory of Derry in Northern Ireland, tracing borders marked by histories of sectarian, colonial, and British state violence – as in his *Border Road* (1991), a bleak image of a road to nowhere, with the viewer's visual access to a green horizon barred by concrete road blocks in the image's foreground.

This and other photographs by Doherty from the 1980s and early 1990s capture in poignant visual metaphors the capacity of geopolitical and physical borders to foster violence and rupture communal lives.

But in a later work by Doherty, *The Road Ahead* (1997), the motif of the road signals a different possibility. Shot during the negotiations over what would become the 1998 Good Friday Agreement – the cross-border accord under whose terms military checkpoints were dismantled, paramilitary arms decommissioned, and North-South connectivities slowly re-formed – the road now opens to a new horizon, pointing to a distant city (Derry) whose flushed skies and glittering lights occupy an ambivalent temporality: this could conceivably be a twilight, but the sky's blush pink points also, and contradictorily, to an approaching dawn.

The road in Doherty's landscape photographs might be read as a metaphor for the cultural labour performed both by the Stuart Hall Foundation, and by this volume. The Foundation's website uses a spatial term – the national cultural 'landscape' – to signal both the organisation's alertness to the racialised borders whose analysis was central to Hall's work, and its commitment to dismantling nationalist, nativist, and racist frontiers by forging 'global connections', in particular amongst 'black and brown students, activists and artists' (ibid.). Doherty's Derry 'road ahead' finds its operative equivalent here in lines of connection that break through cultural and institutional blockades, generating a partnership network that spans arts organisations, trusts and foundations, universities and research institutes, as well as private donors who work to develop with the Foundation its expanding programme of fellowships, scholarships, residencies, and public events.

But Doherty's road images also provide a visual frame for this present volume. Like the Foundation, *Black Film British Cinema II* uses the work of the late Stuart Hall as one key nodal point within a larger map of interconnected conversations across cultural, socio-economic, political, and institutional divides. The multilogue began in 1988, when Hall gave what was to become a foundational talk, 'New Ethnicities', at the first ICA (Institute of Contemporary Arts) conference on Black Film and British Cinema. New Ethnicities' offered an influential reformulation of the 1980s politics of race. Hall used here a discussion of the photography of Robert Mapplethorpe to show how black bodies are traversed not only by divisions and hierarchies of racial difference, but also by sexual, class, and gender difference – so a critical understanding of straight masculinity, for instance, is as crucial to unlocking Mapplethorpe's images as is an awareness of their address to questions to blackness and the racialised body.

Despite the persistence in Thatcher's Britain of a dualistic race politics organised around violently policed black-white boundaries,

Hall perceives, then, in a black artist's exploration of sexual and gender differentiations within racialised discourses of difference the need for a new theorisation (what he terms a 'non-coercive and more diverse conception of ethnicity'), but also a new 'politics of ethnicity predicated on difference and diversity' (Hall, 1988: 29). Thirty years on, Hall's observations appear characteristically prescient. The multiplication of categories of difference has emerged in the intervening three decades as a characteristic of neoliberal cultural economies in which Hall's 'diversity' is commodified and recast conceptually and economically as market segmentation. Yet what Hall terms a politics of representation organised around multiple differences has also been an energising force fuelling twenty-first-century intersectional politics. In her foundational article on intersectionality, Kimberlé Crenshaw, writing one year after 'New Ethnicities', echoes Hall in her critique of a 'single-axis' politics of race, as well as her call to 're-center' the 'politics of discrimination' at the border on which multiple differences meet (Crenshaw, 1989: 167). In a tantalising conclusion, Crenshaw makes observations that further illuminate the connections between this present volume, and the work of cognate black, brown, and intersectional cultural projects, including the Stuart Hall Foundation.

Crenshaw's call is for a 'language' that 'provides some basis for unifying activity' (ibid.). That call was already answered from within black British Cinema when the ICA published a 1988 Document featuring Hall's speech, with a contextualising introduction on 'reframing narratives of race and nation' by Kobena Mercer, and further contributions from cultural theorists and critics Paul Gilroy and James Snead, curators Coco Fusco and June Givanni, journalist and academic Judith Williamson, British Film Institute Head of Production Colin McCabe, and Channel 4 commissioning editor Alan Fountain. The Document's multi-disciplinarity, its transnationalism (Snead worked in the US, Fusco in Cuba), and its inclusion of a dossier of reviews and interviews, created a forum in which multiple voices contributed to crafting a discursive framework (Crenshaw's 'unifying … language') for the critical, theoretical, and historical appraisal of black British film.

Black Film British Cinema II is similarly capacious, creating space for activists, academics, writers, curators, and industry researchers to address together what Sarita Malik terms below the 'impasse' of diversity discourse in a still perniciously racialised 'creative economy'. The collection builds on work begun three decades ago to construct for black British cinema what the theorist Christian Metz once termed 'cinema's third machine' (Metz, 1982). Here, the apparatus

of cinematic writing that is film's conduit into public discourse as well as the source of its embedding in social networks (see Casetti, 2015). In 1988, I was privileged to witness that project of discursive production at work when, during a two-year stint as ICA Director of Talks, I worked alongside Kobena Mercer to organise the first *Black Film British Cinema* conference and publish the proceedings as ICA Documents 7. The 1988 Document was an important milestone in attempts made within and beyond the ICA to find a language (visual, audiovisual, conceptual) that might envision, in the manner both of Crenshaw's unifying discourse, and of Doherty's photographs, open roads to possible futures. But the Document was also a precarious marker of that late 1980s moment, published in an *ad hoc* series and with a limited print run, distributed through fragile artist and filmmaker networks, and largely unavailable since the 1980s until its rescue by Clive James Nwonka and Anamik Saha, who have worked with the ICA to digitise the 1988 document and make it available for readers now (Institute of Contemporary Arts, 2017).

With *Black Film British Cinema II*, editors Nwonka and Saha have also produced what promises to be a fulcrum for a forging of new connections across blockaded roads. Those connections will depend, as the chapters in this volume show, on activities beyond the critical and theoretical writing that is the mainstay of film journalism and scholarship. Metz's machine metaphor for film writing breaks down at the point where criticism and theory meet the activist or counter-cinematic practice encountered in this book. Traced in this volume are the outlines of a contemporary black British film culture that finds (often precarious) shelter in fluid local, regional, national, and transnational networks of knowledge production, political activism, and creative labour. Taking a final cue from Willie Doherty, as well as from Sarita Malik and others on situated writing and the 'locations of film culture', we might in this context usefully spatialise and historicise Metz's discursive account, tracing the emergence of this present volume's cinematic 'third machine' across key interconnected sites of institutional and activist intellectual and creative production (Gudrun, Oliver, and Vinzenz, 2011). These would certainly include – alongside the ICA – Goldsmiths, University of London, the location of day one of the Nwonka and Saha's 2018 conference, the publishing house for *Black Film British Cinema II*, and a key site for further black cultural initiatives including (to select just a handful of numerous possible examples) a partnership with the Stuart Hall Foundation; a women of colour artists' reading group, the Women of Colour Index; and a recently launched MA

in Black British History. Contributors below pinpoint further nodal points in this transnational network: galleries, bookshops, archives (foremost among them June Givanni's Pan African Cinema Archive), research networks, screen studies departments, digital platforms, and networks, as well as activist initiatives that channel 'transnational circuits of influence … from Harlem to Mazatlán' (see Chapter 4 by Rodríguez). Those circuits may be persistently blocked and black cultural mobilisation hindered within media economies marked, as contributions below by Malik, Cobb, and Wreyford, Bidisha, Hoyes, and others show, by structural inequalities as well as (see Chapter 7 by Mayer, Chapter 8 by Harvey, Chapter 9 by Raengo and Chapter 11 by Thorsen) archival absences and historical amnesia. But *Black Film British Cinema II* enters these circuits as an important resource, and an entirely energising journey across a black British cultural landscape. As in 1988, I thank the editors for inviting me to join the ride.

Bibliography

Casetti, F. (2015) *The Lumière Galaxy. Seven Key Words for the Cinema to Come.* New York: Columbia University Press, 109.

Crenshaw, K. (1989) 'Demarginalizing the Intersection of Race and Sex: A Black Feminist Critique of Antidiscrimination Doctrine, Feminist Theory and Antiracist Politics'. *University of Chicago Legal Forum* 1.

Hall, S. (1988) 'New Ethnicities' in *Black Film, British Cinema*. Edited by Kobena Mercer. ICA Documents 7. London: ICA.

Institute of Contemporary Arts (2017) 'Black Film British Cinema'. ICA Documents 7. Available at: https://issuu.com/icalondon/docs/blackfilmbritishcinema/28 (accessed 6 February 2020).

Metz, C. (1982) *The Imaginary Signifier: Psychoanalysis and Cinema.* Bloomington: Indiana University Press.

Sommer, G., Fahle, O., and Hediger, V. (2011) *Orte filmischen Wissens: Filmkultur und Filmvermittlung im Zeitalter digitaler Netzwerke.* Marburg: Schüren.

Stuart Hall Foundation (2020) 'Fellowship and Scholarships'. Available at: http://stuarthallfoundation.org/what-we-do/fellowships-and-scholarships/ (accessed 3 February 2020).

Film, Culture, and the Politics of Race: An Introduction to Black Film British Cinema II

Clive James Nwonka and Anamik Saha

Blackness and the Politics of Diversity

In January 2020, the British Academy of Film and Television Arts (BAFTA) announced their nominations for their annual awards. The sense of familiarity and the subsequent (and very public) debate over the racial profile of the nominations is a result of the UK film industry's rhetoric on diversity over the last 20 years. That latest moment of furore over what was described as a 'whitewashing' of the BAFTA nominations for 2020 related specifically to the lack of non-white recognition in any of the four acting categories. In addition, the presence of British ethnic minorities was virtually non-existent beyond its traditional feature in the Rising Star Award, with no nominations in any of the key categories including Best Film, Outstanding British Film, British Debut, Director, Screenplay, or Cinematography. While the public, industrial, and critical response could be described as widespread outrage, if not surprise, at the nominations, one must understand the whitewashing of the BAFTA awards as symptomatic of the value system placed on non-white talent and a conceptual crisis over the management of racial difference within the film industry. The official response from BAFTA (somewhat strangely) criticised the

absence of racial diversity in its own showcase award categories, while simultaneously celebrating the presence of Black and Minority Ethnic (BAME) talent within its Rising Star Award nomination. Indeed, the fact that between 2006 and 2020 six BAME actors have won the award, and a BAME actor has featured in the nominations every year bar 2011 in this period, the declaration that this category represented a triumph of diverse acting talent spoke to the continuing contestation over not just the presence of black film, but the presence and significance of blackness *within* non-black film.

The public backlash over the BAFTA nominations is not to imply that films are automatically worthy of value and consecration simply because they are, by some definition, black – the precise argument made by the late cultural theorist Stuart Hall in his influential article 'New Ethnicities', 32 years previously. Nor is it the insistence that the film industry simply awards non-white films and talent in a symbolic liberal gesture in the face of the national populism that continues to dictate the politics of racial identity and Britishness. Undoubtedly, film culture, alongside various other modes of cultural production has and continues to offer a crucial contribution to how black Britain is recognised and celebrated, and how the nation is visualised and narrated; in other words, the intervention that blackness makes in the homogeneity of *Britishness*. However, the hyper celebration and inclusion of ethnic difference in the film industry, as was witnessed in the New Labour agenda for the cultural industries as repository for the seductive visage of post-multiculturalism, can also fall into the trap-door of the *politics of diversity* in the cultural industries that simply instrumentalise non-white cultural products and icons as a temporary demonstration of its inclusivity. In the same moment, it can also conveniently ignore its own role in the continued excluding of racial difference. One may question the validity of such debates: why should the decisions of an award ceremony be understood as a matter of racial inequality? After all, the BAFTA nominations simply represent a collection of industry stakeholders making subjective value judgements on the worthiness of films. However, this ventures beyond a concern with cultural representation, but of how consecration through awards speaks to how blackness, both culturally and socially, is valued and recognised.

The BAFTA nominations issue took place just several weeks after another noteworthy moment of public debate over the presence and content of black British film: the decision by the cinema chains Vue and Showcase to withdraw *Blue Story* (2019), the film by British rapper Rapman (Andrew Onwubolu). This was following an incident

where up to 100 young people were involved in a mass brawl at a Vue Cinema in Birmingham during a screening of the film, where a number of arrests were made. *Blue Story*, produced by BBC Films and Paramount, operates within what has been described as the British urban film genre (Nwonka, 2017) in which a social life (not exclusively, but predominantly) germane to London's black youths is narratavised through the recognisable themes of violent conflict and accompanying this, an educative sermon to both its target demographic and liberal whiteness on the causes and effects of gang culture. The graphic violence in the film, interspersed with a subplot of friendship and romance challenged by gang rivalry and malevolence, recalls the fragile 'positive/negative strategy' of representation, in which Hall suggests the potency of 'negative' representation and its fixity in hegemonic imaginations render it both unable to be dislodged by the 'positive', but equally becomes the primary optic through which 'meaning continues to be framed' (Hall, 2001: 274). Indeed, it appeared that the negative aspects of *Blue Story*'s representational repertoire became the justifiable rationale for institutional censorship. While West Midlands police had stated that the decision to bar the film was not based on official advice from them, the cinema chain later revealed that there had been 25 'significant incidents' in 24 hours involving screenings of the film at its cinemas across the UK. Further, the rationale was based not solely on its content necessarily inciting violence, but rather, the response implied that the *kind* of audience the film was attracting to its cinemas were of a social group predisposed to expressions of violence. Such a position of course speaks to the classic moral panic Hall and his colleagues had identified with media discourses around street mugging in the 1970s (Hall 1987), a moral panic that is the mediated preserve of young black people, one that eventually provokes public hysteria of the kind witnessed in the aftermath of the *Blue Story* debate.

Black Film British Cinema 1988

We use these examples to demonstrate the 'triangulation of ownership' that underpins black British film. This means thinking of black British film as something that produces a shared custodianship, but not necessarily in the traditional relationship between the practitioners who create it and the institutions who fund, distribute, and exhibit it. Rather, there is a triangle of ownership that takes place in the *circulation* of the black British film as it enters into an ecology of value and meaning, which are inscribed onto the black British film through its production context, its audience, and its critical reception, and

3

bound by the prefix of 'black'. These are precisely the issues that were first tackled by the original publication of *Black Film British Cinema*. Originating from the 1988 conference of the same title, held at the ICA, for Kobena Mercer, the conference organiser, *Black Film British Cinema* attempted to create new insights into contemporary black film practices, while contributing to the wider black film scholarship. Through a diverse range of perspectives, themes, and approaches, a new framework was presented that considered the political, cultural, and creative dimensions that shape the making of race. Specifically, these contributions converged on the central issue of how, rather than simply what, is 'black' in British cinema? The subsequent ICA Documents 7 that collected papers from the conference sought to respond to this question through a range of interrelated themes: Alan Fountain and Colin MacCabe, reflecting on their positions at Channel 4 and the BFI respectively, assessed how institutional approaches would reflect, promote, or potentially inhibit the pursuit of black filmic representation and production. Each of the chapters by Kobena Mercer, Paul Gilroy, and June Givanni converged on the question of the ways in which black film culture was reflecting, representing, and re-shaping black Britain. In particular, in attempting to understand the tenets of black cultural politics, Gilroy advances the idea of a 'populist modernism' to pose the question 'can black consciousness and artistic freedom be complementary rather than mutually exclusive?' (1988: 46). A transatlantic investment is found in both James Snead's comparative analysis of the various modalities of US and British independent film and Coco Fusco's writing on the existence of black British film in US contexts, the later finding a relationship in Judith Williamson's contribution that is interest in, amongst other things, the racial and gendered 'othering' within the critical context of black Avant Garde film. How have historical understandings of 'black film' been affected by that late-1980s moment of social, political, and cultural change, the relevance of 'black' as an ethnic category in film and its use in working through the 'relations of representation', which was of course a central occupation of Stuart Hall's 'New Ethnicities'?

This was accompanied by the range of practitioner-led perspectives in 'Film Maker's Dossier', where Horace Ové, Martine Attille, John Akomfrah, Reece Auguiste, Lina Gopaul, Avril Johnson, Maureen Blackwood, Isaac Julien, and Nadine Marsh-Edwards provided a window into the aesthetic, institutional, cultural and political contexts in which their films exist, an understanding of the potential of black film practice to be informed by critical debates and academic positions on black*ness*, and respond to 'the ways in which

particular cultural artefacts do indeed shift and transform perceptions of ethnic and national identities' (Carter, 1988: 2). In addition, the inclusion of contributions by Hanif Kureshi, Julian Henriques, Norman Stone, Mahmood Jamal, and Salman Rushdie in 'Critical Voices' sought to recognise what Carter described as 'the wider debates which set the parameters for the ICA conference' (ibid.). Such debates, the 'volatility' of Britishness as it continued to be challenged by the category 'black' (Gilroy, 1987), and the very public debates that the use of film imbued (see Rushdie, 1987; Hall, 1987) pointed to both the centrality of race and ethnicity in the construction of British national identity and equally the primacy of the ICA as a locus for the aesthetic Avant Garde and the race cultural politics, upon which academics, practitioners and public intellectuals were coalescing. This was the context that the 1988 conference and publication came out of, and in many ways, the ambition for *Black Film British Cinema II*, while recognising that new social, textual, political, and institutional situations create and necessitate the space for new analytical positions, retains a fidelity to the heterogeneity of voices in *Black Film British Cinema*, that any contemporary reading of black film requires.

Black Film British Cinema 2020

These considerations have a particular salience in the attempts to both bridge and recognise the departure from *Black Film British Cinema II* and its first iteration. This collection equally recognises black film in its historical understanding, while permitting the expansion and fissuring of ethnic difference within it, but still bound by the politics of racial representation that the umbrella term of 'black' that, as the chapters will demonstrate, permits black film to exist as a unifying cinema of *resistance*. If, previously, the paucity of blackness in film was determined by what James Snead described as wilful 'omission' (1994), the historic (but often revived) argument by the industry that such omission is based on an inability to locate the black actors, directors, and screenwriters has been undermined by the sheer thrust of the diversity agenda over the last 20 years, combined with the emergence of a critical mass of black talent in screen representation and authorship. This has inevitably shifted attention, in both scholarship and popular debate, from *if* to *how*, and to what degree the film industry includes, appreciates, and values both black film and blackness *within* film. Such an investigation requires looking at the locus of how and what black film is perceived and imagines itself to be. This in turn necessitates a consideration of the concept of cinema (in all its

5

totality) with the reality of black circumstances; in terms of race and ethnicity, aesthetics, politics, culture, technology, and following the connections between these contexts. As such, an investigation of this kind is going to coincide with not simply a rethinking of racism, nor even rethinking identity, but exploration of the organic relationships *between* black people in the context of film culture.

It is interesting to think of this triangulation of ownership of black film as one framed by a number of gates of entry. This alludes to the whole textual, political, and psychological positioning of black film and whether there is a compromise in how it must be received. If black film operates as assimilation and subsuming into the idea of British cinema, akin to what Mercer described as the colonial surrender of the monological film (Mercer, 1994), then the issue of the gate as a form of compromise is no longer substantial. However, if it operates as the counter-narrative, representation, authentic narration, and self-realisation, considerations of which black people are faced with in the context of living in the UK, these gates reappear as problems because the choice, if you will, becomes a requirement: getting through the gates of compromise, and accepting the *forms* of representation available to you. The long-protracted history of racism that the first iteration of *Black Film British Cinema* built its sophisticated critique on what was very much invested in the idea of compromise, an undertaking made all the more significant given the small number of available textual references in the 1980s. In the intervening decades, black film *culture* has innately grown its own deep reservoir of what identity is, by its volume, the force of its industrial economy and its expanding meanings which are, as we have seen, both internally and externally constructed. We are beginning to see that it is not erroneous at all to suggest that in the very idea of black film, there still remains certain familiar forms of discussion that emerge from it. There is a classic exploration that, by its nature, is both political and textual, as it must dabble at the very marrow of its subject matter and racial prefix. Indeed, the legacy that has been inherited from the analyses found in the original *Black Film British Cinema* publication is, especially after key moments in the recent history of the politics of race in the UK (such as Macpherson), evident in the forms of cultural governance that inform the treatment of black texts and practitioners. This is because black film remains caught in a context that is a point of contestation over the visible, sometimes invisible, but present and impactful ways that the self continues to imagine, and therefore frame the other. In both its conscious and subconscious forms, conceptualising black

British film as a triangulation of ownership allows one to consider the tensions around black cinematic traditions and how institutions attempt to inorganically construct black images and stories, forgetting that they originate from an extremely rich and powerful visual and narrational tradition that constantly strives to alter the public orthodoxy.

The forensic trace of the *Black Film British Cinema* critique is also located in the desire amongst both scholars and practitioners to decouple black film from its proximity to exclusively socio-political analyses, one, which for many (particularly in a British context), can often neglect a textual analysis foregrounding the aesthetic and narrational heterogeneity of black authored film. In this sense, there is a need to deracialise and depoliticise the context of analysis of black film. Of course, such analysis is identified in the creative autonomy located in moving image and art cinema, and its existence within a gallery/exhibition context can often insulate it from the frequent instrumentalisation as an emblem of the kind of cultural diversity politics that continuously frames more mainstream black British texts. One can understand such a desire. Indeed, the establishing of diversity as a policy discourse during the 2000s, its application to within the cultural and creative industries, and its manifestations in the institutional motivation, justification and appreciation of black film products have produced continued debate and contestation beyond the kind of academic research found in the work of Malik (2013b), Nwonka (2020), Saha (2018), and others. As we identify in the examples of the BAFTA nominations issue and the inclusion agendas that have preceded it, what has been debated is the nature of the governance of racial and cultural difference, the authoritative command determining its presence, the entrenched racial hierarchies existing within that authority, and its subsequent tensions, power relations, and outcomes. Thus, diversity, now synonymous with the presence, framing, and value applied to black film, renders it as an inherently political question, existing as part of a broader technology of agendas determined by 'creative diversity' and the economic dividends of difference (Malik, 2013b; Nwonka, 2020). If we are to examine such language, one can identify a central contradiction; it relies on concepts such as inclusion, cultural representation and the business case for diversity which are all important within the political *discourse*, but are not necessarily embedded in a larger political project of racial equality; it does not have any specific political context and is applied as an abstract notion, often reflecting the wishful thinking of a particular industrial culture that attempts to reshape equality with an engagement

7

with a particular set of established ideas. In this way, diversity is the mode of orchestrating the relationship between black film and the management of racial difference.

During the same period, themes of racial inequality, policing and sexuality have figured prominently in US films that attempt to portray the varied, intersectional social experiences of black America, particularly within a cinematic 'Black Lives' awareness. However, as black America continues to be beset by social and political challenges throughout both the Obama and Trump administrations, the complicated relationship between the politics of race, identity, and 'black film' in the contemporary American context allows for a consideration of how changing perceptions of black*ness* and cinema's role in its framing have contributed to a host of broad, intersectional representations of racial inequality informing the nature of recent films intending to address them. The didactic, aesthetic and narrational quality of films such as *Moonlight* (2016), *Blackkklansman* (2018), *Sorry to Bother You* (2018), *Monsters and Men* (2019), *Last Black Man in San Francisco* (2019), and *Queen and Slim* (2020) display black film operating as a cinema of possibility, while existing within a similar politics of race where, as we see in the almost bi-annual #OscarsSoWhite debates, the idea of black film remains embedded in a contestation over how blackness is valorised socially.

Higher Education and the Study of Black Film

An additional tenet of the visibility of the idea of black film's continuing challenge to the fixity of British *cinema* is its affecting of the academic discourse around film studies. It is very tempting to discuss the study of black film, or black representation *within* film, as an inherently automated and universal process. It does not occur that way, especially for black and ethnic minority people. It requires a different concept of film and cinema precisely because it is a different cultural identity and relationship with society. Indeed, that the development of black film production, spectatorship, circulation and textuality has not been matched in institutional pedagogy or scholarship directly centring itself to within the study of film. Specifically, the emergence of the dedicated study of race and ethnicity via the now familiar (but equally marginalised) pathways of black studies over the last 30 years, where the critical study of black film has generally found its place, suggests that the study of black film within the British academy remains restricted, and subsequently speaks to the continuing Eurocentricity

of British film studies, where the analysis of blackness, race, and black film remains a novel feature in the otherwise stable film studies canon.

Further, the idea that black British film studies, as it continues to penetrate the arcane spaces of traditional film analysis, has moved further away from that organic relationship with black Britishness at a community level, neglects a recognition of black students, who also represent black film spectatorship beyond university lecture rooms and screening spaces. What role does Higher Education, which in this context must be decoupled from the idea of *academia*, have and continue to perform alongside cultural institutions such as the ICA, the BFI, and the many community-based venues around the UK from Brixton's Black Cultural Archives to Nottingham's Broadway Cinema in further developing that relationship? What Black Film British Cinema did in 1988 was create a resource to defile the whiteness of both the academic and non-academic study of film. The emergence of Cultural Studies as an academic discipline and its investment in black film culture in particular offered a theoretical framework that defined understandings of race and representation in film and TV throughout this period. It was the interwovenness of black film production and the academic analysis of black film, notably in films such as *Territories* (Isaac Julien, 1984), that led Gayatri Spivak to identify a 'literary quality' in the ability for film theory to be translated into film text (Mercer et al., 1988: 24). A cognate version of this defiling would be agendas to decolonise the curriculum, and the impact of that on those residing outside of the academy in the creation of non-Eurocentric cultural knowledge. In many ways, this book is a similar attempt to bridge those fields.

Structure of the Book

This book emerges from the 2017 Black Film British Cinema II conference, held at the Institute of Contemporary Arts and at Goldsmiths, University of London (in the *Professor Stuart Hall Building* no less) on 17 May. That first publication, *Black Film British Cinema*, was made historic not solely by its range of contributions, nor by the intervention it continues to make in the study of film, race and identity, but by its relative obscurity. Despite this, that 64-page ICA Documents 7 became the foundational text for the study of black British film prior to Sarita Malik's landmark *Representing Black Britain* (2002). And it was in recognition of the significance of the publication alongside a desire for the coming together of the existing and emerging intellectual and popular perspectives that this second iteration emerges.

The contributions that constitute *Black Film British Cinema II* take a number of forms and thematic concerns. With this collection, as with the conference, we produce a *contextual* account of the making and circulation of black cinema. This entails a consideration of the political-economic, the socio-cultural, and the creative and aesthetic dimensions that shape the making of race in film and cinema. As the title of the collection suggests, the primary focus is the UK, but we recognise as well that it is impossible to talk about black in the context of British film without a consideration of global blackness, especially as digital distribution has turned national borders porous (at least when media content is concerned). Moreover, in searching for the 'black' in British cinema, rather than provide a fixed, closed definition of what 'black' is, we deliberately leave the term *up for grabs*. The term 'black film' remains a significant, potent but contested concept with a range of interpretations and expressions within it. And as Stuart Hall reminds us as well, the meaning of 'black' is always contingent and contested, and comes *without guarantees*. Thus, the aim of the book is to explore these varying definitions through past, emerging, and future forms of black film creativity, considering how they have and continue to both penetrate and subvert normative definitions. Indeed, the authors in this collection consider 'black' in a number of ways, from thinking through the value of political black, to exploring blackness in relation to a diversity of racial and ethnic identifications, whether 'Asian', 'Muslim', or 'brown'. But we fundamentally underscore the heterogeneity of black cultural production, with a specific focus on the role played by blackness, its practice, values and networks of collaboration in the broader development of global black film culture. Emulating the original *Black Film British Cinema* publication, authors within this collection come from a range of fields including the arts, policy, academic scholarship, and journalism. As such, through a combination of long-form academic essays and shorter think pieces, the collection presents a range of cross-generational, inter-disciplinary and international approaches to the issue of 'black British' film.

The book is organised into four parts. In *Part I, The New Politics of Representation in Black Film*, contributions draw upon a range of case studies that reveal change and continuity in contemporary representations of race and blackness and identity, and also the political and institutional agendas that inform them. These chapters seek to explore and understand the various dimensions of representations of black Britishness and their interconnections with broader political discourses. Moreover, they consider how black filmmakers are themselves embedded in a cinematic landscape shaped by technology

and how these inform and influence their creative and representational choices.

The two opening chapters build on the themes presented from the keynote talks from the *Black Film British Cinema II* conference. Sarita Malik's chapter delineates the political and cultural routes that black British film in its various forms has taken since the 1980s. While she acknowledges that organising history in this way is never neat, she nonetheless identifies three moments or *Acts* that characterise the development of black film, the first of which is captured by the original *Black Film British Cinema* conference and publication. Malik adopts a historical approach to race and cultural production that examines how at specific points in time the politics of 'multiculturalism' and Brit-nationalism, technological change, and wider political-economic shifts, including the ascendancy of *creative diversity* policy, come together to shape black filmic practices in particular ways. In doing so Malik highlights the ongoing contestations and challenges that black filmmakers encounter, as well as points to the radical potential such films still retain.

Kara Keeling's chapter brings a black transatlantic perspective to the study of black filmic practices. The chapter considers the technological as well as political dimensions of the context in which black film and media are produced and exhibited today, and in turn what this means for the methods and assumptions that inform studies of contemporary black film and media. Keeling does this by bringing into conversation influential British artist and filmmaker John Akomfrah, who features several times throughout this collection, and black American filmmaker Arthur Jafa and, specifically, his short film *Love is the Message, the Message is Death* (2016). In doing so Keeling explores, like Malik, the potential of film and media culture in black politics, specifically in articulating a counter-culture to neoliberal multiculturalism as well as ongoing anti-black racism.

Maryam Jameela uses the case study of representation of Muslims in mainstream film to explore the (im)possibility of the category 'black'. Connecting her study for the critical discussions of 'black' that featured in the original publication of *Black Film British Cinema*, Jameela demonstrates the limitations of *Political Black* for film analysis for the way that leads to the flattening of experience in the attempt to build solidarities. Jameela's primary concern is how the conflation of Islam with brownness excludes the experience of Black Muslims in particular. She argues that racial categories such as 'black', 'BAME' and 'people of colour' as well centering whiteness invariably erase difference.

In *Part II, Black Film Aesthetics*, we shift from the debate on representation and into the field of aesthetics, specifically thinking through the tremendous diversity in black British film's formal approaches and the meaning encoded within them. The contributions here consider the formal heterogeneity of black British film, moving beyond simple questions of realism and exploring how filmmakers have and continue to use a range of visual art devices to provide new articulations of black identity in their work. The focus on these aesthetic approaches also allows for the kind of close textual reading and formal analysis that has too often been neglected when discussing black British cinema. The theme of Rabz Lansiquot's chapter is the footage of police and white supremacist brutality on black people, shot by onlookers, often by black folk themselves. The purpose of these films that circulate on social media is to expose these injustices and bring the perpetrators to justice but Lansiquot wants to consider what these images are doing and what affects they are enacting upon black psyches and bodies. Reflecting on their own visual art practice and a journey through the *Restraint Restrained* solo show by artist Kat Anderson, Lansiquot explores black aesthetic responses to the exposure of anti-black violence in this new digital form, and in turn, the liberatory potential of black filmic practices.

Richard T. Rodríguez's discussion of the aesthetics of black film delineates the relationship between black British and black American filmmaking – though the study of Isaac Julien's work, specifically his 1989 film *Looking for Langston*. Rodríguez draws attention to the transatlantic cinematic and cultural exchange that undergird's Julien's film practice, that makes an indelible impact on both the history of queer black British filmmaking and the history of queer people of colour and cultural politics. In doing so Rodríguez demonstrates the 'mutual influences of Black, Brown (here meaning US Latinos as well as Asians in the UK), and queer cultural workers whose work generates a more capacious understanding of distinctly articulated and grounded cinemas'. In following the routes of Julien's practice, Rodríguez delineates the *Queer Black Atlantic* and so highlights the contingent nature of black and brown queer identities.

Chapter 5 is an edited transcription from a roundtable discussion from the *Black Film British Cinema II* conference, featuring Richard Martin, Clive James Nwonka, Ozlem Koskal, and Ashley Clark that considers the work of Steve McQueen, arguably the most acclaimed black British filmmaker in history. The first black director to win the Best Picture award at the Oscars, McQueen is also the only person to win both the Turner Prize and an Academy Award. The wide-ranging

Film, Culture, and the Politics of Race **Clive James Nwonka and Anamik Saha**

discussion by the four film scholars in this chapter focuses on McQueen's three feature films to date: *Hunger* (2008), *Shame* (2011), and *12 Years a Slave* (2013). The conversation explores both the formal attributes of McQueen's films – a mode of analysis too often neglected in black cinema scholarship – and the wider political and cultural contexts in which they might be assessed. The participants pay particular attention to questions of duration, the representation of male bodies, and the notion that McQueen occupies an exceptional position in black British cinema.

In *Part III, Curatorship, Exhibition, and Arts Practice* we focus on the forms of black film existing in non-mainstream spaces and the collection, preservation and exhibition of film that respond to and reflect expanded definitions of racial and ethnic identity. These contributions offer new perspectives on the cultural significance of these forms of black film curatorialship, creative expressions and the challenges they offer to traditional modes of audience engagement, filmic interpretation and cultural meaning. Two of the chapters in this section look at the work of John Akomfrah, who has been a key and consistent figure in black film over a number of decades, in Britain and beyond. James Harvey focuses on the use of artifice and montage in Akomfrah's work, that he, following Hall's own critical defence of the Black Audio Film Collective film, *Handsworth Songs*, argues constructs a new language of representation that rejected both dominant white and black hegemonies. Harvey's intervention is in situating Akomfrah's experimentation with archival images in the context of the gallery space. Harvey argues that such a setting opens up Akomfrah's montage practice, not least for the way that it provides the opportunity to break away from the traditional audience-single-screen arrangement and produce a different type of immersion. Harvey also explores briefly the theme of migration in Akomfrah's work, which is the topic of Alessandra Raengo's chapter. More precisely, Raengo considers notions of movement, motion, and migration in Akomfrah's gallery practice. This is not just in terms of the themes of his films, but their very form.

So Mayer also tackles the exhibition of black film and the role of gallery space for black filmmaking, but with a particular and unique focus on the question of cultural distribution. Mayer considers how the relative autonomy of gallery spaces allow for an opening of black aesthetic practice. In addition, Mayer argues that there has been a history of alternative distribution that shows how black cinema has reached audiences but because this history is invisible, it produces the 'industry lore' (Havens, 2013) that black cinema is unmarketable.

In response, Mayer calls for the creation of an archival history of the distribution and circulation of black film, echoing the important project of recovering lost histories, as outlined in Stuart Hall's 'New Ethnicities' essay from the original collection.

Finally, *in Part IV, The politics of diversity,* authors take a critical, cross-generational lens to the issue of racial diversity within film culture and consider the role of cultural policy in supporting (and inhibiting) black cinema. By examining how and why film organisations and policymakers produce, measure and narrate blackness and race in film, and with international perspectives offering a crucial comparative analysis to explore the influence of UK diversity discourses in other territories, the political dimensions of diversity and how the role of race is addressed in this context are given a new and urgent analysis. Diversity and the inclusion of black and ethnic minorities with film culture has been a perpetual and contested theme within debates on representation and equality within the UK film sector and beyond. These chapters aim to interrogate diversity policy in the film industry, and seek to explore the under-representation of ethnic groups and the shifting political and cultural discourses that have informed them.

Based upon a large-scale longitudinal study involving quantitative and qualitative methods, Shelly Cobb and Natalie Wreyford provide the hard data that demonstrates the stark absence of BAME women in the UK film industry – specifically in the key roles of director, screenwriter, editor, cinematographer, and executive and non-executive producer. While the stats for women as a whole were stark, for BAME women it was even more so, accounting for less than 2 per cent of the entire workforce (with not one BAME woman cinematographer). Drawing from the data, Cobb and Wreyford go further and identify three employment patterns – 'tokenism', 'segregation', and 'homophily' – that restrict the mobility of BAME women, who suffer the twin oppression of racism and sexism. Taking the discussion of diversity into a different location, as well as locale, Tess S. Skadegård Thorsen's chapter adds to the growing literature on production studies of race and media. Thorsen provides a critical examination of the diversity initiatives set up by the Danish Film Institute, including a mentorship program, the creation of a casting database, and a charter for ethnic representation in film. But while these appear progressive aims, Thorsen argues that they are essentially based on a *deficit model*, that is, based upon minorities bettering themselves so they can fit in the industry, rather than focus on how the industry itself is structurally biased against said minorities. In this way, diversity initiatives fulfil a neoliberal logic where social problems are to be fixed by the individual themselves

rather than the state taking responsibility for their marginalisation/ exclusion. Thorsen goes further to argue that such initiatives have racialising dynamics, reproducing the idea that ethnic minorities are not really Danes, even when paradoxically trying to be inclusive.

In a BFI survey of black participation in UK film industry, Mel Hoyes considers the huge challenges in collecting and monitoring data on the racial and ethnic composition in the cultural industries. Focusing on onscreen representation and black roles, Hoyes demonstrates the marginal status of black actors in British film. But, as stated, her main point is to underline the difficulty conducting research on diversity in film, and capturing data on race and ethnicity in a field that is unregulated and largely freelance. Despite these obstacles, Hoyes is clear that the industry can do more in terms of self-monitoring, and in doing so, would show that it takes seriously the structural and systemic discrimination that black actors encounter in the British film industry. Finally, writer, critic, photographer and filmmaker Bidisha provides a personal account of her experience watching the images of 'black, brown, red and yellow' bodies that unfold on screens before her. In her survey of the state of race across the terrain of contemporary British and North American film and cinema, Bidisha shows, starkly, the whiteness of filmic worlds (both on and off-camera), and reflects upon the treatment of black filmmakers, including herself. She finds that such figures, even when celebrated, struggle for recognition, let alone actual cultural legitimation, and, when it comes down to it, to make money to make their art in the first place. Even in recognising her relative privilege, Bidisha finds working in the creative industries a bruising affair that constrains artists of colour, rather than allowing them to fully flourish.

Combined, *Black Film British Cinema II* offers a comprehensive, sustained, wide-ranging collection that offers new frameworks for understanding black British film, a strand of British cinema that still remains underexplored, underappreciated and in need of a much overdue re-exposure to new audiences and continued discussion on their relevance in the current political and cinematic landscape. The term 'black film' continues to be a significant, potent but equally contested concept, possessing a range of interpretations, meanings, and expressions within it. *Black Film British Cinema II* aims to explore these varying definitions through past, emerging, and future forms of black film creativity and to show how these forms continue to both support and subvert mainstream definitions. But what is black British cinema? This was the central question Mercer, Hall, Fusco, Gilroy, Snead, Fountain, Givanni, MacCabe, Williamson, and others

15

posed at the conference in 1988 and its subsequent book publication. In considering the complex relationship between race, nationhood, institutional governance, and film representations of black Britishness in the 1970s and 1980s, those thinkers emerged as responsive to the emergence of black British filmmakers exploring issues of race and racism within the British political sphere and the social and political tensions such structures produced. For some, as we see in Hall's 'New Ethnicities', an ambition for theoretical positions on black film to inform black film practice was equally an attempt to reconcile issues of national identity and race in their filmic representations with the lived reality of ethnic difference.

How do contemporary black films and blackness within film produce meaning and what are the political, social and aesthetic motivations and effects? How are the new forms of black British film facilitating new modes of representation, authorship and exhibition, modes that are equally alive to the gender and ethnic identities that both unify and fissure racial difference? *Black Film British Cinema II* provides the platform for the emergence of new scholars, thinkers and practitioners to coalesce on these central questions.

Bibliography

Carter, E. (1988) 'Editorial Note' in *Black Film British Cinema*. Edited by K. Mercer, 2. London: ICA Documents.

Gilroy, P. (1987) *Ain't No Black in the Union Jack*. London: Unwin Hyman.

Gilroy, P. (1988) 'Nothing But Sweat Inside My Hand: Diaspora Aesthetics and Black Arts in Britain' in *Black Film British Cinema*. Edited by K. Mercer, 44–46. London: ICA Documents.

Hall, S. (1987) 'Song of Handsworth Praise' (Letter to the Editor). *The Guardian*, 15 January 1987. Available at: http://new.diaspora-artists.net/display_item. php?id=428&table=artefacts (last accessed 6 February 2000).

Hall, S. (1988) 'New Ethnicities' in *Black Film British Cinema*. Edited by K. Mercer, 27–31. London: ICA Documents.

Hall, S. (2001) 'The Spectacle of the "Other"' in *Representation: Cultural Representations and Signifying Practices*. Edited by S. Hall, 223–279. Milton Keynes: Open University Press.

Havens, T. (2013) *Black Television Travels: African American Media Around the Globe*. New York: New York University Press.

Malik, S. (2002) *Representing Black Britain: Black and Asian Images on Television*. London: Sage.

Malik, S. (2013b) 'Creative Diversity: UK Public Service Broadcasting After Multiculturalism'. *Popular Communication: The International Journal of Media and Culture 11*: 227–241.

Malik, S. and Nwonka, C.J. (2017) 'Top Boy: Cultural Verisimilitude and the Allure of Black Criminality for UK Public Service Broadcasting Drama'. *Journal of British Cinema and Television 14*: 423–444.

Mercer, K. (1988) *Black Film British Cinema*. London: ICA Documents.

Mercer, K., McRobbie, A., Rose, J.A., and Spivak, G. (1988) 'Sexual Identities: Questions of Difference'. Undercut: Cultural Identities No.17. Available at:

Mercer, K. (1994) *Welcome to the Jungle: New Positions in Black Cultural Studies*. London: Routledge.

Nwonka, C.J. (2017) 'Estate of the Nation: Social Housing as Cultural Verisimilitude in British Social Realism' in *Filmurbia: Screening the Suburbs*. Edited by D. Forrest, G. Harper, and J. Rayner. London: Palgrave Macmillan.

Nwonka, C.J. and Malik, S. (2018) 'Cultural Discourses and Practices of Institutionalised Diversity in the UK Film Sector: "Just Get Something Black Made"'. *The Sociological Review* 66(6): 111–1127.

Nwonka, C.J. (2020) 'The New Babel: The Language and Practice of Institutionalised Diversity in the UK Film Industry'. *Journal of British Cinema and Television 17*(1): 24–46.

Rushdie, S. (1987) 'Songs Doesn't Know the Score: Review of Handsworth Songs'. *The Guardian*, 12 January 1987. Available at: www.diagonalthoughts.com/?p=1343 (last accessed 6 February 2020).

Saha, A. (2018) *Race and the Cultural Industries*. Cambridge: Polity.

Snead, J. (1994) *White Screens, Black Images*. New York: Routledge.

Part I
The New Politics
of Representation
in Black Film

1 Black Film British Cinema: In Three Acts

Sarita Malik

Thirty years ago, pioneers in making and thinking about black cultural production were holding the first *Black Film British Cinema* conference (1988) at the Institute of Contemporary Arts (ICA). That conference, and the subsequent publication of ICA Documents 7 of the same title, were to become critical interventions for a generation of emerging scholars, students, and practitioners interested in the place of film culture in the formation of national identities. As transformative as that moment was, I would like to revisit why those interventions mattered, and take up one of the key questions that a retrospective of that period poses for the current moment; what has, and what has not, become of black British film?

Black British film (film that has involved a significant black presence in the means of production) has, in varying degrees, been racially governed through discursive, institutionalised frames such as 'multicultural arts' and 'diversity' (both 'cultural' and 'creative') (Malik, 2013). Outside of these contexts, it has demonstrated its radical potential as a form of culture that can provoke, disrupt, and recode normative understanding of the British experience. The question of black British *cinema* (as distinct from film) pertains to other dimensions such as the curatorship, programming, distribution, and exhibition required for theatrical release. In what is now being described as a post-cinema landscape, how might we, in current contexts, strategise around the spaces of representation from which black British film might be able to resist prevailing forms of racialised governance both within the screen sector and in wider society? What kind of creative interruptive practices and possibilities emerge in the seemingly less

hierarchical post-cinema age, but when one is still disenfranchised by industrial processes such as commissioning, funding, distribution, and policy and by the wider hostile environment that has ensued? How sustainable is a model of film production that is, to use a phrase by bell hooks when speaking about the site of marginality, 'part of the whole, but outside of the main body' (hooks, 1984, xvi)?

My use of the term 'black' is informed by how it was referenced in this earlier, formative moment which was, in Stuart Hall's words, used with 'deliberate imprecision', not as a 'sign of a genetic imprint but as a signifier of difference' (Hall, 2006: 2). This is an idea of 'black' as a political umbrella term that historically forged progressive alliances, including amongst filmmakers themselves, between those of African, Asian, and Caribbean heritage in the UK. It is also an idea that recognises the instability of the term 'black' and its over-determination by a complex set of social relations and questions of identity that have seen these alliances fracture since the mid-late 1980s (Alexander, 2018). The chapter combines personal reflection with cultural historical review in order to discuss the *relations between* shifting structures of governance and power that have helped shape an aspect of British culture that has sought to reshape our national story, even as its formations have mutated. My interest is in the shifting role and value of what has variously been understood as a politically oppositional film culture or cinema of resistance.

Revisiting some of these early debates, black film was recognised as a site of struggle emerging within vexed forms of racial politics under Thatcherism in the UK. It provided an alternative lens to the ways in which mainstream narratives (in press, television and cinema for example) constructed 'the black experience'. The chapter is structured around three interrelated phases that reference the artistic and social contexts of black-British film and, in keeping with a relationship to film narration, is organised in a classic three-act structure representing each of the three decades that have passed since that determining moment. I recognise that these phases have as much in common as what makes them distinct, hence the emphasis on the *relations* and intensified continuities between them. The three-act structure also alludes to Hall's 'Black diaspora artists in Britain: three "moments" in post-war history', in how it attempts to 'make connections between works of art and wider social histories without collapsing the former or displacing the latter' (Hall, 2006: 23).

In May 2017, people assembled at Goldsmiths and the ICA to remember the first iteration of *Black Film British Cinema*. In the same month, a symposium took place marking the Birmingham Centre for

Contemporary Cultural Studies' publication, *The Empire Strikes Back* (1982), a major piece of scholarship that linked the construction of an authoritarian state in Britain with the growth of popular racism in the 1970s. Although 'race', culture, and identity are always being constituted by geo-political transformations, ideas of 'blackness' are today deeply situated within a new cultural politics of difference. This is being manufactured as crises and articulated as a rising xenophobia forming the basis of renewed populist movements that are partly being fuelled by mainstream media discourses, the latest stage in a post-war British social and cultural history of racism and anti-racism. A new exclusionary idea of national belonging recognisable in the former Conservative Prime Minister Theresa May's assertion at the 2016 Conservative Party Conference that 'if you believe you're a citizen of the world, you're a citizen of nowhere' has converged with the anti-immigrant rhetoric that framed both the 2016 EU Referendum campaign and the 2019 General Election. This is a politics that repudiates globalisation, hybridity, and 'unassimilable' forms of cultural difference and seeks to ridicule and protect itself against what is now commonly termed 'woke' culture (to be 'woke' essentially means being alert to social justice). These new agendas, in producing what was declared by the UK government in 2012 as a deliberately 'hostile environment', act as a direct negation of the idea of diasporic belonging that early black film was so invested in. If the earlier forms of hostility, rising populisms and racialised regimes of representation at the crossroads of the 1980s coincided with interruptive film practice seeking to challenge those forces, the current conjuncture is overlaid with new institutional demands and discourses of conservative nationalism that appear to limit such possibilities. Black British film exemplifies the indeterminacy around the kind of cultural work that specific economic, social, and political processes help produce; that is, modes of cultural production cannot be determined, always in the same way, based on the conditions of their existence.

The politics of representation that Stuart Hall first introduced us to in his seminal 'New Ethnicities', delivered at the 1988 ICA conference, has accumulated new meanings. It is a cultural continuum that has coincided with ongoing claims for fairer representation and challenges to sector inequalities against the backdrop of a new 'clamour of nationalism' that has become 'the politics of everything' in governing nation-state politics (Valluvan, 2019). Hall told us then about black culture not, by chance, 'occurring at the margins, but placed, positioned at the margins, as the consequence of a set of quite specific political and cultural practices which regulated, governed and "normalized"

the representational and discursive spaces of English society' (Hall, 1988: 27). If those conditions of existence set in motion black cultural forms which sought to interrupt the 'relations of representation' through struggles for access, in our current condition black British film has hit an *impasse* as exclusionary tactics have renewed themselves to sustain a creative sector that is imbued with racially marked as well as intersectional inequalities (Malik and Shankley, 2020). The everyday encounters, modes of practice, and creative tussles that so-called 'minority producers' have increasingly had to collide with – or indeed collude with – since the early 2000s is a requirement from the paradigmatic 'creative economy' that has forcefully come to characterise culture itself (Schlesinger, 2017), shaping the possibilities of black British film in new ways. But so too has the digital space, altering reception practices as well as the way films can be produced, circulated, marketed and remembered.

Act One: Black Film, Openness and Critical Interventions – 1987–97

Thinking back to the 1980s, the idea of 'openness' (critical, intellectual, radical) was a key feature of this moment of complexity and theoretical intervention in understandings of culture, identity, and representation. This offered an exciting intellectual period that was to be fragmented by a rapid contrast. On the one hand, this was a moment of hopefulness for the future of black cultural production. On the other, it rather depressingly prophesied some of the complexities that black film was to go on to be bound by. The title *Black Film British Cinema* was pertinent – black film *as* British cinema was not just the underlying provocation, but an assertion; locating black cultural production within (not outside) constructions of national identity and opening up the space of the national at a time when the very idea of 'Britishness' was being contested. So too could 'black film' be 'British cinema'. It voiced and juxtaposed the presence of black film with its relative absence in British cinema (with regards to the industrial complex that selects which films come to screen). The implication in the title that 'film' (black and otherwise) can occupy the space of the more highbrow sounding, spectator-oriented industrial dimension of film, also invited a direct probing of both the distinction between high and low culture and between different kinds of visual orders or 'scopic regimes' (Metz, 1977). Even in these apparently simple ways, it triggered critical (and still radical) debates at the intersection of screen and cultural theory based around an enthusiastic interdisciplinarity,

converging in a unique and more open form of *critical race studies film criticism.* Such an advanced theoretical proposition approached screen theory in its broadest sense, suggesting an intermediality that connected film with other spaces such as television, literature, and visual arts. Practically, this made perfect sense given film's strong links to other media forms and notably to television through shared personnel, funding, distribution, exhibition, and increasingly economic and cultural objectives. Channel 4, for example, supported many of the early films through funding and screenings in cinemas before transmission. Participants at the 1988 ICA conference were academics, critics, curators, programmers, building an inclusive, and collaborative way of thinking about the field. Cultural theorists such as Stuart Hall, Paul Gilroy and Kobena Mercer helped produce this space of critical openness, pointing to the interdependence of theory and practice.

The 'cultural turn' described in 'New Ethnicities' represented what Hall called the 'end of the innocent notion of the essential black subject' (Hall, 1988: 28); a new liberatory position from which the black artist or filmmaker could speak and a more diverse expectation of black representation to articulate difference not just across communities and individuals, but within them as well. Hall pinpointed this transformational politics as 'a change from a struggle over the relations of representation to a politics of representation itself' (28) so it became less about access and more about decoding what such representation means. This influential conceptualisation of Britain's new multiculturalism was articulated in feature films such as *My Beautiful Laundrette* (Dir: Stephen Frears 1985), *Looking for Langston* (Dir: Isaac Julien 1989), and *Young Soul Rebels* (Dir: Isaac Julien 1991), as well as in shorter form films such as those that emerged from the independent sector. The retrospectively, globally acclaimed workshop movement, notably the work of Black Audio Film Collective, Ceddo and Sankofa sought to make audiences more self-reflexive precisely through the recoding of dominant racialised discourses such as those that had been screened on British television for decades, particularly in realist formats. This was work that was preceded by the critical, albeit limited, presence of black artists in Britain such as those involved in Festac 77, the Organisation for Black Arts Advancement and Leisure Activities, Creation for Liberation, and the Black Art Gallery (Chambers, 2012).

The revelatory potential of black British film of the 1980s emerged against a socio-political backdrop of racial violence and social exclusion, signalling the paradoxes of black cultural production and

perhaps the necessary conditions for this kind of radical grassroots cultural intervention to thrive. Black film production was a range of collective, creative interventions where the interrogative, interruptive, and aesthetic were converging to assert a critical, visual presence. In brings to mind bell hooks' idea of 'radical openness' (hooks, 1989), a disruptive practice emanating from spaces that have actually been marginalised through structural inequalities, enacted through spaces that have been chosen as a central location for the production of social action that can 'conceptualise alternatives, often improvised' (hooks, 1989: 19). Here, the lived experience of marginality becomes not just about deprivation, but also a site of resistance and radical possibility; chosen as a critical response to domination, reformulated here as a progressive coalition of race, gender, sexuality, and class solidarity, now articulated through film as a form of radical cultural practice.

These self-representational practices were contingent on a certain level of institutional support. The governing contexts of 1980s multiculturalism, a liberal principle predicated on the idea of mutual co-existence, was deliberately agitated by the more radical expressions of municipal, anti-racist politics inscribed in the Labour local authorities as a response to the 1981 UK riots and the subsequent Scarman Report (1981), as well as exploiting opportunities provided by existing race relations legislation and central government funding (Kushner and Lunn, 1990: 184). While many films were made in an environment of self-organisation and relative independence, what this contextualisation draws attention to is that local and national public policy was also one of the conditions through which black cultural production arose. Thus, the state occupied a contradictory space. While the law, police, education, and, indeed, the media were implicated in structures of racism (intersecting with a deep class bias) as forms of 'institutional racism' (Carmichael and Hamilton, 1967) that were later to be recognised in the Lawrence/Macpherson moment of the mid to late 1990s, the state also had its own approaches to the management of culture. Publicly funded avenues such as the Greater London Council (GLC) local authority helped boost local democracy through the support of discriminated against local citizen groups, including disadvantaged students and minority artists primarily under the banner of 'multicultural arts'. In the same year that it set up its Black Arts Centre, 1985, the GLC held the 'Third Eye Film Festival' to be followed by the Anti-Racist Film Programme, through which black filmmakers were able to promote and exhibit their work. The 1982 Workshop Declaration had provided financial security and new audiences for the independent sector, evolving from discussions

between the Independent Filmmakers Association, the British Film Institute (BFI), Channel 4 and ACTT. Promoting an 'integrative practice' model, the Declaration led to the aforementioned franchised workshops coming from outside of mainstream film and television culture, with a particular focus on ethnic diversity and a commitment to local issues.

In 'De Margin and De Centre' (1988), Julien and Mercer identified these developments in the institutional framework of UK public funding as arising from a wider social and political struggle to secure black rights to representation. Creatively, there was an emphasis in the emergent films, on syncretism not integration, on fluidity not fixity, on the processes of differentiation as much as the differences themselves. There was a discernible aesthetic shift, with films such as Sankofa's *Territories* (1984) moving away from the social realist tradition of the 1970s and early 1980s towards the more experimental turn of the late 1980s and 1990s. As a deconstructive documentary, assembling intermittent imagery with repetitive voice-over and eclectic source music; the first part of *Territories* assembled 'official' documentary footage of the Notting Hill Carnival with the second part presenting two filmmakers deconstructing that footage in order to implicitly mobilise a critique of the established documentary realist mode and of media stereotyping of the Carnival.

Sites of exclusion depend on borders, including those established in the prevailing forms and tones of cultural criticism. Julien and Mercer noted how film theory (exemplified by the *Screen* journal from whose pages they were now mobilising this critique) 'participated in a phase of British left culture that inadvertently marginalized race and ethnicity as a consequence of the centrifugal tendency of its "high theory"' (Julien and Mercer, 1988: 7). As an important alternative, the BFI's African-Caribbean Unit's publication of the *Black Film Bulletin* magazine, edited by June Givanni and Gaylene Gould, was by the mid-1990s, to become a significant platform that facilitated a 'depth of cross-collaborative ideas and intersectional dialogues' that acted 'symbolically as a trans-generational, critical intervention on Black creative tradition' (Asante, 2014). The films themselves, in addition to related cultural theory and wider forms of engagement such as the *Black Film Bulletin*, became modes of representation that radically opened up and directly subverted from *within* the mainstream cultural sector, be it Channel Four or the BFI.

Of course, not all work was political in the same way, and some more nuanced in its anti-racist sensibilities such as Retake Film Collective's *Majhdar* (1984). Other film practices were arguably

marginalised within what was now regarded as black British cinema (the work of the Bangladesh-born filmmaker, Ruhul Amin, stands out as an example). Curator and scholar Eddie Chambers has critiqued the historisation of black British arts of the 1980s, arguing that there is a 'a profound *not knowing*' about the range of black British artists' participation more widely (Chambers, 2012: 3). Further, Carol Dixon points to the problems of the prioritisation of selected archival repositories and research collections which have led to the dominance of certain kinds of narrative repositories around black British art history (Dixon, 2017). A glaring omission from prevailing historical accounts is the role of black women including in the film workshop movement, for example, Martina Attille (*Dreaming Rivers*, 1989), Maureen Blackwood (*The Passion of Remembrance*, 1986, with Isaac Julien), and Elmina Davis (director of *Omega Rising*, 1988) who were the precursors of today's artist filmmakers such as Rehana Zaman, Onyeka Igwe, and Ayo Akingbade. The story of curation, archiving, and exhibition of black British film also remains hidden within these histories. Another critical question that arises is whether the anti-racist, highly politicised film culture that this decade is now best known for might have produced its own iterative and essentialised typologies of black cultural production that may have even limited the boundaries of others' experimentalism at the time. For all this, a final observation of Act One is that it generated a perhaps impossible burden of expectation about the kinds of cultural possibilities to follow, especially against the powerful effects of the creeping neoliberalism that was to impact on the cultural terrain in the subsequent decade.

Act Two: The Fragmentation of the 'Black' in Black British Cinema – 1997–2007

If the 1980s were shaped by these kinds of openings and forms of connectivity, the mid- to late 1990s was marked by closure and fragmentation. The few spaces and funding streams which had explicitly supported black film in the 1980s no longer existed or were, by this point, revising their policies in line with the latest cultural imperatives; by the end of the decade their practical legacy seemed quite ephemeral. In 1993, the Black Art Gallery was shut down. A thriving African-Caribbean Unit at the BFI, one of the few institutional spaces specifically geared towards supporting the exhibition and critical momentum around black British and diaspora cinemas, was in the process of being closed (late 1996). These were

losses that intersected with a broader politics of cultural assimilation and a turn from anti-racist to post-multiculturalist sensibilities. Post-multiculturalism was underpinned by an assumption of cultural meritocracy and assimilation. At the same time, there was continued institutional support with partial funding from the BFI, BBC Films, Film4 and the Arts Council Lottery Fund. This led to films such as *Welcome II the Terrordome* (Dir: Ngozi Onwurah, 1994), *My Son, The Fanatic* (Dir: Udayan Prasad, 1997), and *Speak Like A Child* (Dir: John Akomfrah, 1998). Concurrently, national television broadcast was becoming a primary vehicle for black film rather than the theatrical distribution to qualify as British cinema.

Sociological scholarship (Les Back, Stuart Hall) has drawn attention to the weakening in commitment to social democratic reforms and its determination to modernise through expanding neoliberal policies that, in turn, impacted on the cultural terrain. When the New Labour regime came to office in 1997 it inaugurated a process of disavowal of, and a disavowal of the history of, left, feminist, and anti-racist work. McRobbie has analysed this in relation to feminism as a 'complexification of backlash' – in which the gains of the 1970s and 1980s came to subsequently be undermined (McRobbie, 2004). Both multiculturalism and anti-racism were now derided in wider public discourse, and resources were reallocated, assuming that the 'ethnic minority' groups of the 1970s and 1980s had now been, to quote Channel 4's then CEO, speaking in 2001, 'assimilated into the mainstream of society' (Jackson, 2001). The broader effect on black arts through the curtailment of the power of local government by the incoming commercial regime evidenced the increasing requirement to programme more populist, commercially driven work in order to 'break even'. Some have argued about the inevitability of public monies being retracted with Chambers pessimistically suggesting that the process of state funding, by its very nature, 'often consigns what it touches, to failure, disappointment, or a disempowering and moribund existence' (Chambers, 2012: 257).

Film policy was to become one of the areas in which New Labour immediately intervened upon entering government and the arts and culture more widely became a subject of political interest, influencing cultural policy directions, including how the 'creative economy' was to become a central policy object (Schlesinger, 2017). One of New Labour's legacies was the UK Film Council (UKFC) set up in 2000 to bring sustainability to the UK film industry. As Nwonka and Malik (2018) argue in their analysis of the production context for the 2005 film *Bullet Boy* (Dir: Saul Dibb), co-funded by the UKFC, it was

championed as their example of diversity commitment, but which can now be conceived within an overtly commercial imperative for British cinema. *Bullet Boy* typified the instrumentalist template for much of what would later purport to be British 'urban film': a prevailing and reductive narrative trope of black criminality through which the black British experience has been narrated in contemporary culture (Malik and Nwonka, 2018). New Labour's first Culture Secretary, Chris Smith, announced the 're-branding UK' cultural project, designed to transform its cultural image from a national heritage culture to what was now famously termed 'Cool Britannia'. This marked the monetisation of the UK's creative sector and an increasingly economic dimension in how culture was perceived (Hesmondhalgh et al., 2015). For Smith, such a hard wiring of the cultural sector for neoliberal reformation was most evident in his claim that 'as a new Government, we have recognised the importance of this whole industrial sector that no one hitherto conceived of as "industry"' (Smith, 1998: 26). This does not alone account for the dramatic shift that black British film was to face, because the wider political climate had also changed in other ways by the late 1990s. The choice for publics, as Jeremy Gilbert (2017) has observed, was now between a cosmopolitan version of neoliberalism represented by New Labour, or a new Right authoritarianism that had turned openly towards nationalistic populism, as a strategic response to the consequences of globalisation. This paved the way for our contemporary moment, symbolised two decades on by the UK's retraction from the European Union and a narrower conceptualisation of Britishness as part of a broadening and strengthened conservative nationalist agenda.

The rejection of the publicly funded provisions of multiculturalism was one of the signs of what has been termed the 'end of multiculturalism' (Adusei-Poku, 2016). A shift was now taking place towards the more innocuous idea of 'cultural diversity' and a reconstruction of assimilationist policies based around the notion of 'social cohesion'. A process of managerialism through depoliticisation, *infused from above*, involved separating the idea of the state from the idea of structure, now sitting in sharp contrast to that 1999 Macpherson report (Kapoor, 2013) which had put institutional racism on the public agenda. Furthermore, the accompanying fragmentation of the notion 'black', the foundation of which was laid in the previous decade, also led to a demise of critical voices of solidarity, including through film. The fragmentation of a strong black British political movement based on flexible solidarities was therefore abetted by the neoliberal institutionalisation of anti-racist activities but also by the

rise in black British social conservatism characterised, according to Warmington, by 'deliberate breaks with the social analyses developed by the black and anti-racist left' (2015: 1159). In any case, the limits of the notion 'black' as Hall acknowledged in the mid-2000s, also needed to be addressed because 'in the age of refugees, asylum seekers and global dispersal – [black] will no longer do' (Hall, 2006: 22). The presence of increasingly multiple, albeit overlapping 'outsiders', as well as a more networked and global media ecology was inevitably starting to shake up the idea of who and what is situated as marginal, including in terms of national film cultures.

Within what was now commonly termed as the 'creative industries', a premium was placed on freelance, contract-culture entertainment. This was mirrored within the television sector with a focus on films, programmes, and genres increasingly tied to notions of industry and economy. Within these working contexts (because in the new creative economy, cultural production was inextricably tied to the idea of 'cultural work'), there was now even less room for 'failure'. The short film format, which could be produced on smaller budgets, continued as a valuable space for film experimentation, including for black women. Amongst these were Ngozi Onwurah's *The Body Beautiful* (1991), Maureen Blackwood's *Perfect Image?* (1989), and Avril E. Russell's *Distinction and Revolver* (1996). Partially as a consequence of the fragmentation of 'black', and a certain process of self-scrutiny about the politics of mainstreaming during the 1990s, it was rendered possible to now speak of a distinctive form of British Asian cinema that had momentarily secured its place in the economy of what Hartman termed 'hypervisibility' (Hartman, 1997). Leading the way was British Asian female filmmaker Gurinder Chadha whose first feature, *Bhaji on the Beach* (1992), was part soap opera, part romantic comedy, part Bollywood melodrama, establishing the hybrid model for this tranche of crossover film. Asian Britons were now becoming the incumbents of a globalised, modern kind of creative culture, with the 'Bollywoodisation' of British culture becoming especially rife, compatible with the new internationalism represented by the aspirations and mechanisms put in place for 'going global'. By reaching an audience way beyond the art house and festival circuit, films such as *East is East* (Dir: Damien O'Donnell, 1999) and *Bend it Like Beckham* (Dir: Gurinder Chadha, 2002) facilitated a commercially successful celebration of New Labour's multicultural pluralism. *East is East*, a semi-autobiographical melodrama with broad-based appeal, would win a BAFTA and was a major UK box office success. The film touched on universal themes of love, alienation and generational

conflict through the spectacle of 1970s popular paraphernalia; spacehoppers, parka coats and bellbottoms. For its screenwriter, Ayub Khan Din, hiring a White Irish director, Damien O' Donnell, was a calculated decision in order to get the film commissioned. The parallel lived reality was the more modest film careers of important figures who had helped lay the foundations of black British cinema, including Yugesh Walia, Ruhul Amin, and Ahmed A. Jamal.

A focus on the divergent trajectories of black and Asian British cinema reveals the fascinating racial economies of contemporary British cinema. Where the culture clash/comedy-drama became a template for a now desirable incarnation of British Asian cinema, the urban/crime/youth drama became the trope of 'black' film (which as the 2019 film *Blue Story* (Dir. Andrew Onwubolu (Rapman)) was later to demonstrate is often taken up as a sign of 'real' potential disorder). But institutionally, black and British Asian cinema was coded more systematically – 'specialised', 'cultural', 'minority', 'ethnic', 'culturally diverse', or 'urban' – differentiated and marked out from the centre of British cinema culture. This recalls Gilroy's apparently prophetic claim about racially marked representations that, 'where West Indian Culture is weak, Asian communities suffer from a surfeit of culture that is too strong' (Gilroy, 1983: 131). Thus, the lens through which these films of variable 'box office success' (if we are to use that as a measure of value) came into being was acutely racialised and highly managed within a now much more commercially oriented, and indeed multinational culture industry, serving as cloned and 'low-risk' formulas precisely because they oriented around the pathologisation of (different kinds of) cultural difference. Intensifying forms of capital overlapped with how black screen representation and production were being formed and these dynamics were to institute much of what was to happen in the next decade.

Act Three: Current Frames: Black British film in the Creative Economy

As in any act of historicisation, the present is always the most difficult period to grasp. And just as post-multiculturalism and now post-racial become part of the post-signalling tendency, there is a burgeoning scholarship on how film has now well and truly left the cinema, departed from the cinematic regimes of the twentieth century and resulted in a 'post-cinema' age (Hagener, Hediger, and Strohmaier 2016) which has seen the end of medium specificity Significant developments in technological environment have indeed

involved the displacement of 35 mm and analogue film in favour of digital formats. *YouTube* emerged at the end of Act 2 (2005) marking the beginning of a golden age of independent filmmaking, and Act 3 ends with the arrival of Netflix's production hub at Shepperton Studios in the UK (2019). Some black filmmakers work with Netflix and other streaming services, while supporting their 'passion projects' on the side (sometimes more experimental or tackling social issues they are interested in). Meanwhile, film has been rendered free of the constraints of cinema; it exists in a gallery context, in the street, on planes and cars and on digital communication platforms, enabling what Hagener, Hediger, and Strohmaier (2016) call a 'low-end' of the circulation of filmic images, and informal networks of exchange and transaction.

Social media, online crowdfunding and video-sharing websites such as Vimeo all provide further opportunity to build solidarities, networks, and direct engagement with audiences. As Francesca Sobande observes in her work on black women filmmakers and spectatorship, video-sharing spaces such as YouTube can provide 'young Black women viewers with a stronger sense of ownership over their media spectator experiences' (Sobande, 2017: 665).

Digital potential is therefore equated with the promise of an updated modality of relative independence, equality, and connectivity that can take place outside institutional spaces, and where political and social transformations seem more possible precisely through these new forms of circulation, presentation, and marketing in which black filmmakers can make the most of alternative forms of visibility. Such 'bottom-up' possibilities help us to better understand the politics of marginalised producers and forms of production, in that they potentially weaken hierarchical structures of power and representation and therefore enables us to think about the optimum *spaces of representation* through which black film might (re)mobilise itself.

This latest period has brought us important examples of diverse film practices within black British cinema, some with institutional support. The year 2013 was notable for the films of John Akomfrah, Steve McQueen, and Amma Asante, a period which has seen these three filmmakers become rare permanent markers of a black presence in British cultural life. Akomfrah's BFI-supported, Sundance award-winning film, *The Stuart Hall Project* (2013), was distributed just a few months before Hall's death in 2014. It led to a renewed interest in Akomfrah's work and, more broadly, in black British visual culture. Steve McQueen evolved within a 20-year journey from making

the ten-minute film *Bear* (1993) while at Goldsmiths to being the first black filmmaker to win an Academy Award for Best Picture with *12 Years a Slave* in 2013. McQueen's unique trajectory, a rare story of commercial and international acclaim, is part of a new internationalism into the filmic mainstream, and from an ostensibly non-mainstream set of stylistic approaches. Amma Asante's romantic period drama, *Belle* (2013), taken up for UK distribution by Fox Searchlight Pictures, marks a particular success with regards to the vexed issue of distribution.

The relations between the different periods of black British film run deep. George Amponsah's 2015 observational documentary feature, BFI-supported, and BAFTA nominated *The Hard Stop*, named after the police procedure, told the story of Mark Duggan's death in 2011 that was to be followed by riots in London that summer. The film shares some of the traits of the earlier deconstructive documentaries, notably Black Audio Film Collective's *Handsworth Songs* made 30 years earlier. It assembles mainstream media representations of the Duggan killing alongside personal testimonies, retelling the story from an alternative perspective and tracing the linkages between Duggan and the death of Cynthia Jarrett in 1985 that sparked the Broadwater Farm riots (similar to Duggan, Jarrett's death was marred by controversy). *The Hard Stop* can be considered as part of a broader tradition led by black visual artists of referencing the conditions, nature, and occurrence of riots in the making of black British history and serves as a fine recent example of black film's continuing radical potential.

While such films stand out, the forces of capital have accelerated cultural commodification within the mainstream, while local and regional capabilities have been squeezed since 2008 by a financial austerity agenda that has restricted support for public spaces (local film clubs and community cinemas, community centres, youth services, and societies) for creative exchange, production, and exhibition. There has been a fresh impetus to tackle these restrictions head-on and recent years have seen a range of independent initiatives to counter the obstacles of distribution and exhibition. There are several current examples, many female-led, of programmes, seasons and initiatives to boost the visibility of black film and bring it to a range of audiences (outlined in detail in So Mayer's contribution in this collection). June Givanni's Pan African Cinema Archive demonstrates the care with which this film history is being preserved and circulated, even in fragile circumstances. In 2020, the Independent Cinema Office toured 'Second Sight', to foreground the work of black women in the workshop movement, and commissioned new work by black

women filmmakers, some of it inspired by the work of those who set the foundation of black British film such as Claudette Johnson. For filmmaker Ayo Akingbade,

> I knew from day one that I would feature artist Claudette Johnson's artwork *Trilogy (Parts One, Two and Three) 1982– 6* … the film is partly an ode to her and countless women who were involved in the movement, but who are now either forgotten or simply not spoken about to the same degree as their male counterparts.
>
> (Akingbade, 2020)

Of note with respect to the question of distribution is Priscilla Igwe's The New Black Film Collective (TNBFC), a nationwide network of film exhibitors, educators, and programmers of black representation on screen. In 2015, Igwe and TNBFC pushed for the UK distribution of the low-budget, partly crowd-funded US comedy-drama, *Dear White People* (Dir: Justin Simien), on learning that the DVD and Video on Demand timeframe could be altered to allow for a full theatrical release. TNBFC made public appeals for the BFI to reverse its decision and provide lottery funding, which it eventually did by shifting its distribution strategy. In its appeal, Black Activists Rising Against Cuts and TNBFC called out what they identified as the industry's racist practices that directly inhibited black film *as* British cinema:

> We believe that the response to 'Dear White People' by the UK film industry is part of a wider problem of institutional racism in the industry, whereby films featuring black characters, exploring race and identity and / or made by black producers/directors are repeatedly rejected for theatrical release, meaning that they go straight to DVD/ Blue Ray release.
>
> (www.change.org/p/uk-cinemas-bfi-screen-dear-white-people-in-cinemas-across-the-uk)

If the 1980s represented a value of black film that was strongly related to ideas of social democracy, what remains today, vis-à-vis a period of mounting marketisation of culture through the 1990s and early 2000s, is an idea of value that views culture through the prism of unescapable market forces. This has eroded spaces of municipal support for black British film and imposed other agendas that it now

has to grapple with, in what has been a dual story of resistance and governance. The question of resistance co-exists with some hard realities in the screen sector. Black Britons are less likely to work in the creative industries than their white counterparts and more likely to experience unemployment from precarious labour in the sector (Malik and Shankley, 2020). In spite of the post-racial signalling and a thriving cultural policy diversity agenda, industry data continues to report the real systemic inequalities in the sector, particularly behind-the-scenes. *Creative Skillset's* 2012 *Employment Census* found that BAME (by now the preferred term in public policy) representation in the industry declined across production, distribution and exhibition between 2009 and 2012. BAME employment in the film production sector fell from around 10 per cent to 3 per cent. There has been a growth in recent literature that evidences a deep connection between social and cultural inequality in the creative sector, though there remains considerable scope for the specific issues around race and the UK film sector to be examined. The implications of this long-standing under-representation suggests that the UK's BAME communities experience multi-dimensional inequalities and forms of discrimination, an example of which can be found in the film sector. That the exclusion of BAME groups in the sector has continued unabated over the last decade where the non-white workforce remains below 5 per cent (CAMEo, 2018) speaks to the failures of decades of diversity policy (Nwonka, 2020).

Limited opportunity in the UK has led to what has been termed 'Black flight' – where black directorial and acting talent has progressively moved to the US for recognition. This in turn has caused a rather perverse set of recent discussions about black British actors taking opportunities of work away from black US actors. The specific UK environment is brought into even sharper focus when discussed in comparison to the recent body of black-directed films in the US. While there are obvious differences between the UK and US production contexts in terms of budgets and a critical mass of black spectatorship, Barry Jenkins' *Moonlight* (2016) and *If Beale Street Could Talk* (2018), Jordan Peele's *Get Out* (2017) and *Us* (2019), and Trey Edward Shult's *Waves* (2029) all demonstrate how commercial and critical success can be achieved while also recoding dominant racialised representations; all of these examples capturing primarily the multiple facets of black masculinity.

Institutionally within the UK screen sector, inequalities are restated again and again, while diversity initiatives gain traction. In late 2016, the British Academy of the Film and Television Arts

(BAFTA) announced new initiatives to boost the numbers of ethnic minority and socially disadvantaged filmmakers, including plans for more diverse membership and reworked eligibility criteria for some of its award categories. In 2020, BAFTA failed to nominate any non-white people in acting categories, signalling a spate of public criticisms of the industry's deep whiteness. The new diversity model is a form of depoliticisation, signalling a gradual institutional repositioning of anti-racism to 'multiculturalism' to cultural diversity and a new emphasis on the now well-established (and essentially de-raced industry discourse) 'creative diversity' (Malik, 2013). A new focus on 'talent', 'training', and extreme competition is part of the overarching 'creative economy' enterprise that in any case never had as its central priority the tackling of systemic, structural inequalities within the creative sector.

Cultural 'workers', including black filmmakers, are themselves implicated in an industry that has shifted towards these neoliberal market models. It is not simply the case that these diversity models, themselves forms of governance, are resisted. Rather, the 'art of acquiescence' is required – if one is to work within or be supported by such institutional spaces (Nwonka, 2020). If the 1970s to 1980s represented the moment when 'race' had been 'fully indigenized' (Hall, 2006: 17) then this is the decade that institutionalised diversity subsumed it, as race and racism are rarely identified or referenced in these new governing contexts of 'social mobility' and 'creative diversity'. One can assess such a process of defining racism out of its existence as an ideological and discursive mechanism and a form of 'racial neoliberalism' in which, as David Goldberg puts it, 'The postracial buries, alive, those very conditions that are the grounds of its own making' (Goldberg, 2015). In this regard, institutionalised diversity functions as what Herman Gray describes as a 'technology of power, a means of managing the very difference it expresses' (Gray, 2016: 242).

Conclusion

Our current moment can be characterised as one involving both restraint and yet transformative possibility. Digital capabilities are a space of representation that might be the cause for some optimism in how they are making accessible so much of this marginalised critical canon, otherwise silenced or forgotten, asserting through their circulation on YouTube, Vimeo or the BFI player a critical 'audiovisual memory of our culture' (Ruschmeyer, 2012: 36). Nana Adusei-Poku (2016), in her work on 'post black art', proposes that any transformation

is likely to be a performative approach that takes place outside of institutions. This conjuncture comes into being precisely because of the technological and related economic evolution through which it is being claimed visual culture, digitality, and politics can converge. But its backdrop is what needs to be understood as one permeated by ongoing institutional failures, or perhaps manoeuvres. The film sector today, as it did in the 1980s, continues to marginalise black filmmakers and black films.

Moten's work that links aesthetics of the black radical tradition with radical ideas of freedom (Moten, 2008) and hooks' arguments about the 'radical openness' that becomes possible from being in that space of the margins foregrounds the ongoing predicament of margins and centre. From where can anti-racist strategies within black cultural production be built? As I close, I return to Hall's comment in 'New Ethnicities' about the conjuncture of the *relations of representation* (which today pertains to issues of access, labour, precarity) and the conjuncture of the *politics of representation* (based on the contested meanings that representation always opens itself up to). Since these are still in the frame, as it were, then it seems that we can speak of a new stage and struggle which is centred on the *spaces of representation*. How do we start to address the problem of *from which spaces* black cultural production can be most effectively presented, positioned in a way that moves beyond its classic and present-day restrictions? To this end, an ontology of black British film in its three interrelated acts becomes a framework in which we can address, and eventually challenge, the past, present, and sometimes overbearing forms of social and cultural governance. These are forms that have simultaneously helped to de-marginalise but also re-marginalise and have therefore shaped the possibilities of the very 'black film as British cinema' that we are even able to assemble ourselves around, over 30 years on.

Bibliography

Adusei-Poku, N. (2016) 'Post-post Black'. *NKA, The Journal of Contemporary African Art 38–39*, November, 80–89.

Akingbade, A. (2020) 'Is Claudette's Star a New Thing?' Available at www.independentcinemaoffice.org.uk/blog-on-claudettes-star-is-claudettes-star-a-new-thing/ (accessed 13 January 2020).

Alexander, C. (2018) 'Breaking Black: The Death of Ethnic and Racial Studies in Britain'. *Ethnic and Racial Studies 41*(6): 1034–1054.

Asante, J. (2014) 'Black Film Bulletin Revisited'. Available at: www.junegivannifilmarchive.com/wp-content/uploads/2014/09/BLack-Film-Bulletin.pdf (accessed 21 November 2019).

CAMEo (2018) *Workforce Diversity in the UK Screen Sector: Evidence Review*. Leicester: CAMEo Research Institute.

Carmichael, S. and Hamilton, V. (1967), *Black Power: Politics of Liberation* (November 1992 ed.) New York: Vintage.

Chambers, E. (2012) *Things Change Done: The Cultural Politics of Recent Black Artists in Britain*. Amsterdam and New York: Rodopi.

Creative Skillset (2012) 'Creative Skillset Employment Census of the Creative Media Industries'. Available at: www.screenskills.com/media/1552/2012_employment_census_ of_the_creative_media_industries.pdf (accessed 21 November 2016).

Dixon, C. (2017) 'British Black Art in the 1980s: Visualising the Political Aesthetics of Sufferation, Resistance and Liberation'. Available at: https://museumgeographies. wordpress.com/2017/05/01/british-black-art-in-the-1980s-visualising-the-political-aesthetics-of-sufferation-resistance-and-liberation/ (accessed 20 December 2019).

Gilbert, J. (2017) 'The Crisis of Cosmopolitanism'. Available at: http://stuarthallfoundation.org/library/the-crisis-of-cosmopolitanism/ (accessed 3 November 2019).

Gilroy. P. (1983) 'Channel 4 – Bridgehead or Bantustan?' Screen *24*(4–5): 130–136.

Goldberg, D.T. (2015) *Are We All Post-Racial Yet?* Cambridge: Polity Press.

Gray, H. (2016) 'Precarious Diversity: Representation and Demography' in *Precarious Creativity*. Edited by M. Curtin and K. Sanson. Berkeley, CA: University of California Press.

Hagener, M., Hediger, V., and Strohmaier, A. (2016) *The State of Post-Cinema: Tracing the Moving Image in the Age of Digital Dissemination*. London: Palgrave Macmillan.

Hall, S. (2006) 'Black Diaspora Artists in Britain: Three "Moments" in Post-War History.' *History Workshop Journal 61*, Spring: 1–24.

Hall, S. (1988) 'New Ethnicities' in *Black Film/British Cinema*. Edited by K. Mercer, 27–31. London: Institute of Contemporary Arts.

Hartman, S. (1997) *Scenes of Subjection: Terror, Slavery, and Self-Making in Nineteenth-century America*. New York: Oxford University Press.

hooks, b. (1984) *Feminist Theory: From Margin to Center*. Boston: South End Press.

hooks, b. (1989) 'Choosing the Margin as a Space of Radical Openness'. *Framework: The Journal of Cinema and Media 36*: 15–23.

Hesmondhalgh, D., Oakley, K., Lee, D., and Nisbett, M. (2015) *Culture, Economy and Politics: The Case of New Labour*. Basingstoke: Palgrave Macmillan.

40 Jackson, M. (2001) 'The Fourth Way'. *The Observer*, 29 July 2001.

Julien, I. and Mercer, K. (1988) '*De Margin and De Centre*'. *Screen 29*(4): 2–11.

Kapoor, N. (2013) 'The Advancement of Racial Neoliberalism in Britain'. *Ethnic and Racial Studies 36*(6): 1028–1046.

Kushner, Tony and Lunn, Kenneth (eds) (1990) *The Politics of Marginality: Racism and the Radical Right in Twentieth Century Britain*. London: Frank Cass.

Malik, S. (2013) '"Creative Diversity": UK Public Service Broadcasting After Multiculturalism'. *Popular Communication 11*(3): 227–241.

Malik, S. and Shankley, W. (2020) 'Arts, Media and Ethnic Inequalities' in *Ethnicity, Race and Inequality in the UK*. Edited by B. Byrne, C. Alexander, O. Khan, J. Nazroo, and W. Shankley, 167–202. Bristol: Policy Press.

McRobbie, A. (2004) 'Post-Feminism and Popular Culture'. *Feminist Media Studies 4*(3): 255–264.

Mercer, K. (1988). *Black Film, British Cinema*. London: ICA Documents.

Metz, C. (1977) *The Imaginary Signifier: Psychoanalysis and the Cinema*. Bloomington: Indiana University Press.

Nwonka, C.J. and Malik, S. (2018). 'Cultural Discourses and Practices of Institutionalised Diversity in the UK Film Sector: "Just Get Something Black Made"'. *The Sociological Review 66*(6): 1111–1127.

Nwonka, C. J. (2020) 'The New Babel: The Language and Practice of Institutionalised Diversity in the UK Film Industry'. *Journal of British Cinema and Television 17*(1): 24–46.

Ruschmeyer, Simon (2012) 'Shifting Paradigms in Web Video: From Access to Curation' in *Film in the Post-Media Age*. Edited by Agnes Petho, 35–56. Newcastle Upon Tyne: Cambridge Scholars Publishing.

Schlesinger, P. (2017) 'The Creative Economy: Invention of a Global Orthodoxy'. *Innovation: The European Journal of Social Science Research 30*(1): 73–90.

Smith, C. (1998) *Creative Britain*. London: Faber & Faber.

Sobande, F. (2017) 'Watching Me Watching You: Black Women in Britain on YouTube'. *European Journal of Cultural Studies 20*(6): 655–671.

Valluvan, S. (2019) *The Clamour of Nationalism*. Manchester: Manchester University Press.

Warmington, P. (2015) 'The Emergence of Black British Social Conservatism'. *Ethnic and Racial Studies 38*(7): 1152–1168.

2 On Digitopia and Neoliberal Multiculturalism: Black Cinema and the Image's Digital Regime

Kara Keeling

This is an exciting time to raise questions and offer insights into Black cinema and British cinema because it is a moment in which people in a variety of geographic locations have unprecedented access to the technology of film and video production and, therefore, to the means through which to produce and distribute audiovisual images. The industrial arrangements of film production, exhibition, and distribution that have been in place for decades have been disrupted and, though new configurations are beginning to become clear, we do not yet know for certain how these industries will re-organise themselves.

Black British filmmakers and actors are accessing Hollywood's resources in ways that blur the lines between Black British and Black American cinema. These transformations in media industries, technologies, and access call for studies of Black film and media attentive to the local, the regional, and the national specificity of particular cultural productions. At the same time, the transformations we are witnessing open ways to re-conceptualise the sensibilities and

cultural politics that animate transnational configurations of Black image-making. With this in mind, it is salutary to pay attention to the context in which these transformations in the industry, technologies, and practices of Black filmmaking are occurring.

In this chapter, I consider what the political and technological aspects of the context in which Black film and media are produced and exhibited today mean for the methods and assumptions that inform studies of contemporary Black film and media. I focus on what I call the digital regime of the image, putting John Akomfrah's thoughts about 'digitopia' and the film *The Last Angel of History* (released in 1996), a 45-minute documentary that Akomfrah directed as part of Black Audio Film Collective, into conversation with the insights that can be gleaned from an analysis of Arthur Jafa's short film released in 2016 entitled *Love is the Message, the Message is Death*. In 2010, John Akomfrah wrote:

> There is a sense in which my generation, those not born that far from 1968 – but not far enough for it to have a past in which we had any meaningful political agency – received most of our understandings of the politics of identity and race as a digital signal, as an upload, if you like, of an always-already marked set of structured absences: Fanon, The Panthers, Black Power and so on. So there is a sense in which the founding regime, the narrative regime that overdetermined everything we did, came to us as a set of digital simulacra; as traces of moments forever fixed as virtual references, but always deferred and always already there as a signal, a noise, a kind of utopian possibility. And if you look at most of the films we did, either Black Audio or Smoking Dogs, you get the sense that they are marked by this sense of the utopian as a digital referent.
>
> (Akomfrah, 2010: 27)

Though the short essay by John Akomfrah from which this quotation has been excerpted should not be taken as an authoritative statement about the relationship of Black filmmakers to digital technologies in general, it does articulate some of the most salient issues and questions raised from within the history of Black film and media about the transitions to digital media. It is important to recall that the 1980s and 1990s were an exceptionally rich and vibrant time for innovative Black filmmaking and scholarship. For example, the filmmakers of the Black Audio Film Collective (of which Akomfrah

was a part) responded to the material conditions of their time by innovating within the existing conventions of the media with which they were working. Now, their films, videos, and statements arrive for us today as what Akomfrah would call 'digital signals' that underscore the role and potential of film and media culture in Black politics since the 1960s, and the dynamic possibilities of innovation with form.

I approach the body of work produced during the 1980s and 1990s as cultural products of a phase of racial capitalism described by Jodi Melamed as 'liberal multiculturalism'. Melamed's book, *Represent and Destroy: Rationalizing Violence in the New Racial Capitalism*, describes three phases of racial capitalism since the global dynamics of the Second World War and the advent of the Cold War put pressure on the United States to re-calibrate its overtly white supremacist modes of governance and officially adopt an anti-racist stance while 'making the inequalities that global capitalism generated appear necessary, natural, or fair' (Melamed, 2011: xvi).

The three successively prominent versions of 'official anti-racism' Melamed offers are: racial liberalism (mid-1940s to 1960s), liberal multiculturalism (1980s to 1990s), and neoliberal multi-culturalism (2000s) (Melamed, 2011). Melamed explains that 'liberal multiculturalism' (the phase of interest for thinking about the films of the 1980s and 1990s) is a 'means of counting and managing' the deployment of culture by the 'robustly materialist antiracisms of the 1960s' and 1970s' new social movements, including revolutionary nationalisms (Black Power, the American Indian Movement, Chicano nationalism), the third-world Left, the Asian American civil rights movement, Black lesbian feminism, and women-of-color feminism' by 'turning it into aesthetics, identity, recognition, and representation' (xx). In the context of the United States, liberal multiculturalist discourse and practice sought to defuse those movements' materialist praxes by adopting a textual, aesthetic engagement with the stories about and cultures of the groups most adversely affected by existing social and economic relations as part of the official narrative of the US State.

Struggles around filmic, literary, sonic, and other cultural representations were politicised long before the time period Melamed identifies as 'liberal multiculturalism', however, Melamed's analysis identifies how the logics of liberal multiculturalism defanged the materialist dimensions of the cultural practices animating those struggles and incorporated them into the workings of racial capitalism itself. During the liberal multiculturalist period, many

debates about cinematic cultural practices operated within binary terms such as whether cultural productions were commodified or not and whether they were positive or negative representations of a recognisable group.

Akomfrah's 'digitopia' offers a way of working within but against liberal multiculturalist cultural politics. In that essay, the history of debate, analysis, experimentation, and failure within analogue media forms, such as film and analogue video, that raise the possibility that those forms might support anti-racist and/or Black media practices point towards what Akomfrah calls a 'digitopic desire' or a 'digitopic yearning' which haunts the history of analogue media praxis.[1] Akomfrah argues that such a 'digitopia', perceptible throughout film history, anticipates today's digital media technologies, without being fully fulfilled by them.

If we can agree that the history of scholarship about and artistic production of Black cinema has been informed by the three paradigms identified by Akomfrah in that essay (he calls them 'tyrannies') – an investment in representational politics and their adjudication, an investment in authenticity, and an assessment of the politics of aesthetics – then we can see how the advent of digital film technologies offers a response to problems that have arisen out of these paradigms for scholars and producers of Black cinema over the years. Regarding the first 'tyranny' – that of representation: Because making a digital film is much less capital intensive than making a film on celluloid, and less cumbersome than videotape, the accessibility of the mode of production of digital film makes it possible for there to be a wider range of representations. In regards to the second – the investment in making Black film more like Black music, the ability to take more footage because there is less of a concern about cost, and the editing and postproduction possibilities that digital film makes possible has meant that filmmakers can experiment more with making Black art closer to Black music; and finally, regarding what Akomfrah calls 'the postcolonial screen debate', it could be argued that digital cinema fulfills a dream of Third Cinema by truly revolutionising the mode of production of images by making it possible for anyone with an iPhone and editing software to make a film.

Because I understand 'the cinematic' to involve not only the audiovisual technologies through which it continues to be produced and maintained as our commonly perceived reality, but also the socio-political and cultural processes through which we perceive what appears in any present thing, I am less invested in 'the digital' as it marks a change from one type of recording technology to another

and more interested in what thinking with and against 'the digital' opens up and/or forecloses vis-à-vis the cinematic. Debates about the disappearance of those indexical qualities of cinema that seemingly were secured through the logics of analogue media technologies are of interest here because they point to the emergent logics of the digital regime of the image as those might be perceived through a consideration of the technologies of media production.

These recent film theories miss or do not engage with the extent to which, throughout the history of cinema, as Alice Maurice has explained, film technologies have been imbricated with racial epistemologies and, as I have argued elsewhere, the history of the debates about Black images attest to the fact that the production of those images refute the logics of the profilmic reality on which predominant theories of the indexical nature of film technology relied (Maurice, 2013; Keeling, 2005). Following this, it could be said in regards to Black film production that elements of the cinematic are intensified in the digital regime of the image. Attending to what the digital makes more widely perceptible within the cinematic might simultaneously allow for re-assessments of the analogue along different historical, theoretical, and analytical lines than those we have pursued to date, such as those characteristic of the transformation from Foucauldian disciplinary societies to what Gilles Deleuze described as societies of control. At the same time, it emphasises the extent to which predilections of the analogue regime of the image continue in the digital.

Akomfrah's 1995 documentary film *The Last Angel of History* illustrates many of the points he makes in his 2007 keynote about 'digitopia'. Produced with Black Audio Film Collective, *The Last Angel of History* was one of many films that Akomfrah shot on Digibeta tape in the 1990s, and I engage it here not only in order to flesh out Akomfrah's concept of 'digitopia', but also to highlight how the film itself might be situated at a crossroads from liberal multiculturalist logics of governance within control societies to neoliberal multicultural ones.

The Last Angel of History provides a glimpse into the cultural formation known as Afrofuturism as it was being articulated in the late 1980s and early 1990s. In addition to giving a filmic expression to a dynamic cultural formation that today is experiencing revitalisation and transformations, *The Last Angel of History* itself is a creative enactment of Afrofuturism insofar as it opens a relationship between Black existence and technology through cinema. Coming to us today as a digital signal, *The Last Angel of History* exists as, among other things, an audiovisual index of the power relations in its time and an

aesthetic artefact (displayed, for example, in galleries and projected on computer screens via the recently released DVD distributed by Icarus Films).

The film focuses on the sonic aspects of Afrofuturism, especially music, and the geographical, industrial, political, and philosophical logics that have informed their production. It also frames a discussion of literary production, in particular the queer work of Octavia Butler and Samuel Delany (though it does not engage with their queerness per se), as well as issues having to do with space exploration, including the significance of the first Black astronaut in outer space, and the fictional character from *Star Trek*, Lt Uhura, and the actress, Nichelle Nichols, who portrayed her in the original *Star Trek* episodes. While the film centres issues of Black existence and science and technology, the way that the film itself works as a film – its formal characteristics as well as the specific contexts of its production and circulation – taps into the aesthetics and logics of computational, database-driven media.

For example, the beginning sequence of the film is an experiment in what might be called 'algorithmic' editing styles through which any image can be inserted into or combined with another. The figure of the 'data thief' in the film animates the processes through which images from the database of what we might call 'human history' can be cut, selected, and framed according to an algorithm calibrated to generate a combination of shared images and expressions that celebrate the intersection of Black existence and technē. The computation and database logics are apparent in the access that the 'data thief' has to the range of images, histories, and narratives about the past. In this regard, the 'data thief' is a character through which *The Last Angel of History* works to layer associations between audiovisual images from disparate times and geographical locations, an operation that reveals some of what filmmaking has in common with computation. If, as D. Fox Harrell points out, 'computers can improvisationally and dynamically combine media elements in new ways, at the same time as responding to user interaction' (2013: 45), then within the world of *The Last Angel of History*, the data thief might be understood as an expression of a human/computer interface from the film's future who responds to the film's present by offering novel combinations of digital archival images. In a quick succession of images, including sounds, the data thief invokes a present which, to reference the text from which Akomfrah takes the title of the film, Walter Benjamin's *The Last Angel of History* 'comprises the entire history of mankind in an enormous abridgment'.

Referring specifically to the computer's ability to combine elements in new ways, Harrell explains: 'This process always involves both human interpretation of meaning and the limited types of formal symbol manipulation possible on a computer … Such meaning construction processes also underlie many uses of the computer for expressive purposes' (2013: 45). With this in mind, it might be said that *The Last Angel of History* offers a cinematic meditation on the extent to which what Wendy Hui Kyong Chun refers to as 'programmed visions' (2011) shape in advance the futures imagined through the Afrofuturism of the documentary's day. While the range of possibilities for formal symbolic manipulation as well as the extent of the digital archive of 'human history' are limited to what has been programmed into them, the combinations cut, selected, and framed by the data thief in response to present concerns still might involve elements of surprise insofar as it could be argued that there is more in any present image than we commonly perceive and there is a creative element involved in any act of perception. The past appears with every present and harbours dimensions of itself that might challenge what already has been perceived about it.

Referencing Benjamin's influential essay 'Theses on the Philosophy of History' in its title, *The Last Angel of History*, presents the data thief as a figure from the future who haunts the documentary's present. An angel of history, he (in Benjamin's words) 'would like to stay, awaken the dead and make whole what has been smashed'. The *last* angel of history, he animates a temporality in which the past in general exists as a reservoir of potential presents, futures lying in wait, now. The film's present is his distant past, and he arrives to redeem it. In 'Theses on the Philosophy of History', Benjamin states:

> The past carries with it a temporal index by which it is referred to redemption. There is a secret agreement between past generations and the present one. Our coming was expected on earth. Like every generation that preceded us, we have been endowed with a weak messianic power, a power to which the past has a claim. That claim cannot be settled cheaply.
>
> (Benjamin, 2019: 197)

The data thief haunts the present from the future. He is a figure whose coming is expected in that present, a messianic figure who is, in Benjamin's words, 'man enough to blast open the continuum of history' (2019: 197). Indeed, *The Last Angel of History* is celebratory of and optimistic about the possibilities that reside at the intersections

of techno-culture and Black masculinity. The *last* angel of history's ability to stay and awaken the dead relies upon an understanding of the techno-culture of the film's day, and the cultural commodities put into circulation within that culture, as evidence of a type of progress through which the angel of history is propelled back in time. Eschewing the dynamic, progressive gender politics articulated elsewhere in the Afrofuturist cultural productions and scholarship of the 1990s, this last angel of history weathers the storm of progress, redeeming the techno-culture of the 1980s and 1990s as indeed progressive. In this regard, it operates according to a set of temporal logics that, while perhaps subterranean in the 1990s, are dominant in the era of neoliberal multiculturalism.

Neoliberal multiculturalism is a mode of governance that works in part by severing the material conditions organised by race from the power of modes of official racial representation and recognition to effectively redress them. The confluence of neoliberal multiculturalism as a mode of governance with a virulent anti-Black racism that maintains the socio-economic relations based in white supremacy indicates that analytics that rely upon 'race', 'representation', 'difference', 'recognition', and 'power' must be re-calibrated. Herman Gray diagnoses the situation when he writes:

> Today 'the recognition of social difference' allies with a conception of the modernist subject and practices of government where the free market reigns and self-governance provides for collective and individual needs of the population. The object of recognition is the self-crafting entrepreneurial subject whose racial difference is the source of brand value celebrated and marketed as diversity; a subject whose very visibility and recognition at the level of representation affirms a freedom realized by applying a market calculus to social relations. This alliance of social, technological, and cultural fields constitutes a new racial regime – the shift from race to difference – and the recognition and visibility on which it depends is a form of power ... This newly realized social visibility and cultural recognition is a form of power that regulates and manages through appeals to identifications with styles of life tied to identities based on difference.
>
> (Gray, 2013: 771)

The transformations Gray identifies here narrate a shift from what Stuart Hall characterised as 'a cultural politics of difference'

(1993: 104). Gray's assertion that an 'alliance of social, technological, and cultural fields constitutes a new racial regime' today also might be understood as a shift not only from 'race to difference', as Gray describes it, but also within the valuation and deployment of racial differences themselves. If, for example, 'Black', 'white', and other racial designations have indexed biological difference in ways that historically anchored power hierarchies (keeping in mind that there always were exceptions that themselves authorised the rule), today their correlation to socio-economic power hierarchies is underwritten by the renewed significance of those differences as themselves generative of capital and the modes of governance through which capital accumulates. This is one of the contexts in which we can assess the increasing visibility and access of Black people in Hollywood.

In a related context, Lawrence Grossberg argues: 'what is frequently dismissed as branding and niche-marketing signals a radical restructuring of value beyond our capacity to measure it. The result is, apparently, a situation of the increasing sense of the unpredictability of value itself' (2010: 35). Taken together, Melamed's exegesis of 'neoliberal multiculturalism', Gray's diagnosis of a 'new racial regime', and Grossberg's assertion that the very things constitutive of this new regime signal 'a radical restructuring of value beyond our capacity to measure it' indicate that transformations in the realm of representation are affecting our ability to narrate, assess, and intervene in how certain matter comes to matter more than other matter.

If *The Last Angel of History* predicts the temporal logics of the neoliberal multiculturalism of the 2000s by aesthetically and narratively seeking to redeem the Euro-American techno-culture of the 1980s and 1990s as marking a valuable difference vis-à-vis the cultural politics of race and technology, the film to which I now turn offers a more recent example of what I am calling a database film characterised by an algorithmic editing style. Produced in 2016, during the phase of racial capitalism that Jodi Melamed characterises as 'neoliberal multiculturalism', the algorithm in this film is not driven by redemption, but by what can be understood, following Édouard Glissant, as a *Poetics of Relation* (1997).

Arthur Jafa's seven minute and 33 second film, *Love is the Message, the Message is Death* was released in 2016. While Jafa's cinematography is well known for bringing out and revealing the beauty of the rich textures and skin tones of Black actors in *Daughters of the Dust* and Spike Lee's film *Crooklyn* (1994), he has been experimenting in his more recent work with ways to counter, or at least complicate, the politics of respectability – or 'uplift', as Allyson Nadia Field has characterised

it (2015) – by allowing his spectators to sit with the strangeness or alienness of Black people and Black culture alongside those aspects that could more easily be conscripted into respectability or uplift. Jafa's recent work is preoccupied with what in Black American existence (and American existence in general) has not been made to work in the interest of narratives of national or racial progress. In *Love is the Message*, Jafa's editing choices suggest that it is precisely these aspects of Black American vernacular culture that point to the existence of other modes of valuation; they harbour a type of wealth that might be felt, if not yet understood, within and through the technologically mediated culture of the late 2010s.

In *Love is the Message*, Jafa, like the data thief in *The Last Angel of History*, establishes a set of relations between various images and sequences found in the digital archives of human history. Yet, unlike the data thief's, whose editing logic achieves a rapid-fire assault on the senses, Jafa's editing algorithm is an audiovisual improvisation within the rhythms, yearnings, tempos, and lyrics of a hip-hop song. Set to Kanye West's song 'Ultralight Beam' from the 2016 album *Life of Pablo*, Jafa's *Love is the Message, the Message is Death* is a masterful montage of moving images and sonic expression. Jafa's editing can be described as 'algorithmic'. It creates sets of affinities between kinds of movement, particularly those innovated and/or expressed through bodies of Black folk, and it establishes visual and sonic matches between images in ways that create associations and disjunctions between them. I call Jafa's editing – that is, the film's style or logic of connection that motivates a cut from one shot to another – algorithmic to underscore that the aesthetic logic in *Love is the Message* is enabled by and comments on the digital image's relationship to computation, databases, and commensuration.

One of the tasks of *Love is the Message* involves working out a cinematic poetics of relation through which one might grasp what Édouard Glissant refers to as 'he threatened beauty of the world'. Jafa's montage embraces the opacity of images of Black bodies in motion in a variety of settings, activities, time periods, and geographic locations, while establishing sets of relations that connect and associate them, but do not reconcile them. Many of the images Jafa uses are likely familiar to viewers. They comprise historical footage of famous people or events, sequences from films that have been significant to the history of African American cinema, such as D.W. Griffith's *Birth of a Nation* and Charles Burnett's *Killer of Sheep*, or digital videos that have gone viral in recent years. There are images of explosions on a planet and other footage of outer space. Some of them may not be widely

familiar, but carry brands or other identifying markers. Some are high-definition footage of sporting events carrying NBC or another network's logo. Others are prominently marked 'Getty Images'. Some seem to be selfie videos.

Sometimes, the soundtrack works associatively – for example, when Minister Louis Farrakhan mentions Mr Wallace, the film cuts to Christopher George Latore Wallace, aka The Notorious BIG. We get to hear him rap once again. At times, the film coalesces around certain themes to create cinematic ideas, like a visual exploration of Greg Tate's likening of Black existence in the US to an alien abduction story in the early days of Afrofuturism, and its more recent refutation in Martine Syms' 'Mundane Afrofuturist Manifesto'. Throughout, the film interrogates the continuing resonance of early cinema, particularly *The Birth of a Nation*, and the efforts by filmmakers and others to redress those early images and representations. The mix of images of such wildly different resolution and provenance, such as Getty archival footage, cell phone video, C-Span footage, and clips from high-definition professional sports broadcasts, and so on, calls attention to the status of the digital image and the problems and possibilities of the archive of Black culture.

The temporality that emerges in *Love is the Message* is not that of redemption, but of radical contingency. The film's temporal mode draws on elements of improvisation (and therefore fulfills a long-standing desire stated by Jafa, Akomfrah, and other Black filmmakers to make Black film more like Black music), but also features sequences characterised by repetition and stasis. By calling attention to scale by, for example, presenting a high-resolution shot of the sun after a footage of Martin Luther King, Jr, *Love is the Message* returns at various times to an image, an affect, or an idea of what could have not been, but was, or what could have been, but was not.[2]

There is no commentary in *Love is the Message* besides the interplay between the sounds and the images that comprise the short film. There are many ways one can read or interpret this short film and various anchors through which one may give the film this or that meaning and assign significance to the images it assembles from the digital archives of Black history and culture. Yet, as a cinematic experience, *Love is the Message* does not invite meaning so much as it makes Black existence resonate within a media ecology in which the accumulated meanings ascribed to and on Black flesh continue to render Black bodies fungible, hypervisible, and legible in ways that reproduce existing power relations. The film is one response to the modes of governance characteristic of neoliberal multiculturalism: it

mines the digital archives to assemble what Herman Gray has called a 'feel of life', and relies heavily on intertextual references that are likely available to some viewers and not others (Gray, 2015). It pokes holes in clichéd images, including historical events and people, as it traffics in those clichés. It frustrates attempts to offer an authoritative 'reading'. By radically decontextualising certain familiar images of Black people and arranging them in a different affective constellation, *Love is the Message* interrupts its spectators' habitual reception of these images.

At one point early in the film, the editing algorithm hinges on Obama's performance of 'Amazing Grace' at the Black church to raise questions about how race can function in societies of control as a tool for severing the material conditions organised by race from the capacity of modes of official representation and recognition to effectively redress them. In the footage Jafa selects, we see the men behind Obama on the stage begin laughing, clapping, and/or standing from their seats as they recognise that the President of the United States of America is standing before them singing 'Amazing Grace' with what might be heard as Black vocal inflections. Their enthusiastic, joyful, surprised, response underscores the element of surprise and (im)possibility that attended Barack Obama's two terms in office and complicates an easy 'reading' of Jafa's subsequent association of this event through editing with Griffith's *The Birth of a Nation*.

In the face of neoliberal multiculturalism's severing of material relations from the representational logics previously devised to address racial and other inequalities, *Love is the Message* re-attaches racial difference to a historical accretion of sensible matters, allowing its spectators to remember the material relations that undergird Black existence and sense the possibilities it harbours. As technē, *Love is the Message, the Message is Death* presences a feel of life, making a poetics of relation resonate within and through technologies of control, especially audiovisual technologies. It brings forth a conceptualisation of Black American existence over time that includes those who continue to be excluded from the promises and protections of full citizenship in the United States of America.

The dialogue staged in this chapter highlights the ongoing cinematic conversation between the work of two Black male filmmakers, one British and one American, who have been in direct communication with each other over time. Indeed, Black American and Black British cultural scholars and producers continue to influence one another through provocation, dialogue, and collaboration. This chapter is my modest offering to that ongoing exchange.

Bibliography

Akomfrah, J. (2010) 'Digitopia and the Spectres of Diaspora'. *Journal of Media Practice 11*(1): 21–30.

Benjamin, W. (2019) *Illuminations: Essays and Reflections*. Edited by Hannah Arendt. New York: Mariner Books.

Field, A.N. (2015). *Uplift Cinema: The Emergence of African American Film and the Possibility of Black Modernity*. Durham: Duke University Press.

Fox Harrell, D. (2013) *Phantasmal Media: An Approach to Imagination, Computation, and Expression*. Cambridge: MIT Press.

Glissant, E. (1997) *Poetics of Relation*. Translated by Betsy Wing. Michigan: University of Michigan Press.

Gray, H. (2013) 'Subject(ed) to Recognition'. *American Quarterly 65*(4): 771–798.

Gray, H. (2015) 'The Feel of Life: Resonance, Race, and Representation'. *International Journal of Communication 9*: 1108–1119.

Grossberg, L. (2010) *Cultural Studies in the Future Tense*. Durham: Duke University Press.

Hall, S. (1993) 'What Is This "Black" in Black Popular Culture?' *Social Justice 20*(1/2) (51–52): 104–114.

Hui Kyong Chun, W. (2011) *Programmed Visions: Software and Memory*. Cambridge: MIT Press.

Keeling, K. (2005) 'Passing for Human: Bamboozled and Digital Humanism'. *Women & Performance: A Journal of Feminist Theory 15*(1): 237–250.

Maurice, A. (2013) *The Cinema and Its Shadow: Race and Technology in Early Cinema*. Minneapolis: University of Minnesota Press.

Melamed, J. (2011) *Represent and Destroy: Rationalizing Violence in the New Racial Capitalism*. Minneapolis: University of Minnesota Press.

Notes

1. As Philip Rosen points out, this is a common formulation of the digital regime of the image that Rosen addresses in ways that are relevant to my discussion here in the final chapter of his 2001 book *Change Mummified: Cinema, Historicity, Theory* (University of Minnesota Press). Rosen's formulations reverberate throughout my discussion of Akomfrah's *The Last Angel of History*.
2. This is an adaptation of language from Giorgio Agamben, 'Bartleby, or on Contingency' in *Potentialities: Collected Essays in Philosophy*, trans. Daniel Heller-Roazin (Stanford: Stanford University Press, 1999), 253–256.

3 Violence, Above All, Is What Maintains the Breach: Racial Categorisation and the Flattening of Difference

Maryam Jameela

The publication of *Black Film British Cinema* 30 years ago constituted a collection of boundary-pushing concepts on anti-racism, Cultural Studies, cinema critique, and, centrally, conversations on what can be defined as 'film', 'British', 'cinema', and, importantly for this chapter, 'Black'. As many anti-racist scholars, activists, and thinkers will attest, as much as the landscape of racial injustice changes, it stays the same. Indeed, in 1988 Hanif Kureishi wrote that:

> For some reason I am starting to feel that [England] is an intolerant, racist, homophobic, narrow-minded authoritarian rathole run by vicious, suburban-minded, materialistic philistines who think democracy is constituted by the selling of a few council houses and shares.
>
> (1988: 25)

To date, the past three years or so of British politics have been consumed with debate on Brexit, all while Grenfell Tower was allowed to burn down with poor Black and brown people inside it, while

the Windrush scandal saw immigrants die waiting for citizenship, while Universal Credit and policies of austerity enacted structural violence to already marginalised communities, while xenophobic racism that has come to be regarded as the hallmark of mendacious British politics has left us in rather the same situation as described by Kureishi some 30 years earlier. As much as the political landscape cannot be said to have changed for the better, so too are the discussions of the original collection relevant to activists and intellectuals concerned with anti-racism, anti-Blackness, and representation politics. The questions of who can be considered 'Black' and 'British' are still central to apprehending the radically different landscape of visual media in modern times.

The use of 'Black' in the original publication was debated by a number of authors, with discussion ranging from calls for community and unity, to moves towards recognising the specificity of racial backgrounds in Britain. Racial recognition is a generative process in that there can be no definitive or conclusive answer that signifies, in this instance, what 'Black' means in a satisfactory and all-encompassing manner. As with definitions of 'culture' or 'race' as entities subject to the changes and developments in understanding of a social world, so too do racial recognition definitions rely upon continued conversation. David Tyrer's work on mis/recognition is pertinent here, through its discussion of the coding process of racial categorisation:

> The thing about colour coding the world is that it grossly simplifies things to such an extent one can easily forget that each time we racially recognise other subjects, we are not simply reading racial meanings off their skin, but we are inscribing them onto their very bodies. This is quite a violent way of describing a violent practice that doesn't always seem so because after a couple of hundred years of practice, it has become routinised, normalised, and even commoditised.
>
> (2013: 16)

Racial coding or categorisation are far too euphemistic terms for the process of, as Tyrer argues, inscribing and writing on to bodies how they fit into society. It is not only a process of reading but a history-laden inscription with inevitable corresponding entanglements in the racial and economic logics of the day. Examining available media allows us access to visual discourse that also plays out in real-world experiences: in other words, media analysis is an avenue into

Violence, Above All, Is What Maintains the Breach Maryam Jameela

demonstrations of hegemonic categorisation of who belongs to which group.

The discussion on Blackness in Britain has evolved, as argued in the original publication, from a black-white dichotomy, to the use of political Blackness, to Blackness as a more discrete entity. These terms cannot usefully or accurately be tracked as historically linear with distinct periods of use, but broadly speaking, these terms characterise trends of personal racial identification. The terms themselves have coalesced around trends for Black and Minority Ethnic (BME), Black, Asian and Minority Ethnic (BAME), and person of colour (POC) as in vogue, with the former two arguably stemming top-down from institutional use, and the latter more from individual use. Tyrer's articulation of the process of recognition as inherently violent is one which speaks to both the intellectual, emotional, and bodily impact of having oneself identified, and often misidentified. The thread of minoritisation that runs through each of these terms has at its centre, whiteness. In being organised around whiteness, these terms are limited in their efficacy for communities of colour. While such terms have historically been used as points of organisation for these communities, I am interested in examining the impact that broad and generalising terms have on community cohesion and effective activism. Debates around solidarity and unity characterise the fluctuations of what we call ourselves, and how we recognise one another. Yet, organising against white supremacy requires naming of some manner, and the central question of this chapter is the role of solidarity and unity in reckoning with how we see individuals belonging to certain groups.

This chapter will, first, chart the developments in thinking around the use of political Blackness in relation to core concepts which have been deployed as central to understanding why others have identified, and still identify with, political Blackness. This will involve a look back at the original debates and contributions synthesised with more contemporary understandings in order to grapple with the role of racial identification in analysis of social and cultural machinations. Political Blackness has been chosen as an example of the consequences of flattening differences on solidarity, and the section of the chapter focused on examples of film will further discuss these ideas in relation to how anti-Blackness plays out in the context of Muslim solidarity and unity. Given my background in Muslim scholarship, I will enact this research by paying attention to the impacts of Blackness within Muslim circles, namely the anti-Blackness perpetrated by non-Black Muslims. I will argue that the use of political Blackness (itself an example of the politics of solidarity that seek

to blanket difference) is an impediment to incisive and inclusive film analysis, and that the example of the erasure of Black Muslims speaks to wider anti-Blackness in social, cultural, and political spheres. Further, acknowledgements of both historical and contemporary differences from within communities are no barrier to solidarity, and instead deepen activist work that looks to dismantle white supremacy.

Formation Processes of Racial Categorisation

As with many of the collections in which their work appears, Stuart Hall and Paul Gilroy's contributions are most memorable. I will now turn towards their articles in the original publication, before looking to their other work on political Blackness and racial identification in Britain. Stuart Hall in particular is central to understanding racial and cultural politics in Britain, and his work throughout his career was notably accessible and possessed a clarity that spoke to the evolutions of understanding in identity. Here, Hall outlines the importance of categorising the emergence of new terms for identity categories not as reversals or replacements of previous terms in a linear fashion, but rather a transformative process that constitutes a shift, a movement cognisant of what Hall calls the 'slipperiness' (1988: 28) of representational politics. Hall's argument centres on moving away from a politics of authenticity or essentialisation which positions identity as fixed and immovable. Instead, Hall argues that contextualised understandings alive to identity as unfixable and complex serve us better in understanding ethnicity (1988: 29). In other words, identity is no one single and immutable thing.

This notion is commented on by several of the other authors in the collection, and a theme emerges of pieces which express concern at stereotypical representations in film, and agree with Hall's central argument in relation to identity as altogether more fluid and permeable than the racial politics of the time allowed for. Kobena Mercer, for example, outlines the use of Black as a political rather than racial category predicated upon a shared struggle of racism for Asian, African, and Caribbean people which in turn rests on overturning assumptions about Blackness as a fixed or essential identity (1988). Similarly, Paul Gilroy also argues for particularism in relation to identity (1988: 45), but Gilroy categorises the alliance between Africans and Asians as 'fragile' (1988: 45) and cautions against ethnic particularism if used to sow, in Gilroy's view, disunity amongst people of colour. Gilroy argues that orthodoxy and authenticity are corrosive for Black film, and while it is difficult to

anticipate where cultural specificity in film production will lead, there is much to say about what is 'Black' and much that has been said, but 'none of us has a monopoly on black authenticity' (1988: 46). Similarly, James Snead argues that 'a narrow usage of the term "black" is divisive where what is now needed is the forging of new alliances and audiences' (1988: 48). Broadly speaking, the concerns of the authors in the collection in relation to Blackness as an identity category cautioned against shutting people out, against spreading disunity, and wished to ensure moves away from essentialism and constructed authenticity. While there was certainly dissension within this, in general terms, many of the arguments took influence from Hall's and, through varying methodologies, looked to Blackness as an identity category which needed to be in flux in order to encompass the concerns of representation and authenticity. This openness to fluidity has remained central to the emergence of new terms that seek to communicate and reflect the changes in inter-community conversations and alliances amongst people of colour.

Difference in Unity

It is telling for those still identifying with political Blackness as a tool for activist organising that Gilroy was expressing his discontent with the term in both *There Ain't No Black in the Union Jack* (1987) and *Small Acts* (1993). Throughout the former text, Gilroy provides an exploration of Blackness in Britain, as well as the symbols, race riots, and genealogies that have become commonplace in discussions of Britain and formations of race. Gilroy reflects that 'the delicate and special dynamics of what used to be called "AfroAsian unity" no longer colour either strategic alliances or analyses in the same manner … the racial idea "Asian" has, for example, been broken down and enumerated into a multiplicity of regional, religious and other cultural fractions' (2007: xiv). Cultural and racial specificity has been integral in moving away from catchall terms like 'politically Black', and this is a central question for understanding both the history and future of race in Britain. As a range of antiracist social justice movements interact with modern forms of oppression, it is becoming altogether more apparent that Gilroy's understanding of difference in unity speaks to a contemporary engagement with the position of race in Britain.

While there is not necessarily a sizeable number of individuals that call themselves 'politically Black', if there ever were, it is the case that debates around the position of Black communities

amongst non-Black communities is hotly debated. Examples are – #OscarsSoWhite being complained about from Asians, people saying people of colour when they mean Black, #MuslimLivesMatter as a co-option of #BlackLivesMatter, #BlackoutEid, the "Muslim Ban". These examples traverse social media, global policy, and representational debates stemming from content, but their range demonstrates the ubiquity of the use of Blackness as a catch-all term that often relies upon erasing difference amongst communities of colour.

Movements in the 1980s and 1990s may well have been able to practice Gilroy's description of AfroAsian unity, but even the latter half of the 1990s saw, along with the advent of online social organising, a kind of democratic platform availability which allowed individuals to intervene directly into the process of identity and race subject formation. The most pertinent strategies for organisation, then, have been the inclusion of platforms which allow for greater interaction with the social world on every level which have also allowed for individuals to inscribe their own bodies with their own racial subjectivities; this inscription no longer relies upon unity or solidarity built upon homogenous unity. In other words, a specificity which seeks to articulate differences amongst a range of racial identifiers.

Decentring Whiteness

The room for difference in social justice movements across communities of colour speaks to an evolving version of identity and race formation and central to this is activism that occurs without being beholden to or enamoured with whiteness. Political Blackness is a term which categorises all people of colour as 'Black' and is often used as a catchall for anyone that isn't white. The centring of whiteness at the heart of the term, while a draw among communities looking to understand and process race formation, is a centring which is, at best, a shaky foundation for antiracist work, and particularly so in terms of community alliances, solidarity, or unity.

Deliovsky and Kitossa push against the Black/white paradigm, and critique the epistemologically faulty praxis which seeks to locate Black people as 'impediments to multiracial coalition building' (2013: 158) and instead argue that 'the difference is that whiteness is a positive, chameleonlike, marked and unmarked racialization and a privileged location that eludes the markings of a racial position and, as such, is constructed as a "natural" rather than a raced category' (2013: 164). They call for closer attention to be paid to anti-Blackness as giving shape to analysis of other marginalised groups, particularly as Blackness is

so often called upon to stand against whiteness, with the latter as an ostensibly neutral starting point. This is not intended to place anti-Black racism as a 'superior form of oppression' (Deliovsky and Kitossa, 2013: 173) but rather to demonstrate the political structure of racism at large. The presumed neutrality of whiteness dominates, in one way or another, both the start and end points for critical considerations of race; to do so is to place whiteness as central to determining and apprehending, in this example, Blackness. In turn, this positions Blackness as the natural and only unified opposition to whiteness. As Deliovsky and Kitossa outline, this is not only epistemologically faulty, but ethically unsound.

While the development of terms for categorising race have fluctuated along with changing identities, it is a central element of organising to be able to focus on who is included in the conversation and who is not. For example, while there have been ongoing discussions around descriptors for race (BME, BAME, POC), Kehinde Andrews points out that 'there is no evidence that political blackness has ever been adopted by the range of people it is meant to represent' (2016: 2067). While these terms are also certainly subject to 'diversity' initiatives and the commodification and tokenisation of people of colour, it is 'politically Black' which purports to a particular sameness which overrides Blackness as a discrete identity ostensibly in favour of social justice. Indeed, Andrews continues and argues that 'it is even more problematic on the global level to expect that the interests of the majority of the world will be aligned simply on the basis of people not being white' (2016: 2072). This is the crux of arguments against the continued use of political Blackness and arguments which contend that solidarity and community are undermined by recognition of difference: whiteness can be no bedrock of antiracist praxis which seeks to effect change, justice, and liberation.

Gilroy's concerns about AfroAsian unity speak to concerns about racial solidarity – if we are focused on difference, how can we be united in solidarity? When considering the functions of solidarity, unity or cohesion are often couched in static terms focused more on whiteness as a qualifier, rather than the cultural and social traditions that form the identities of any one group or subgroups (see Andrews, 2016: 2067). To presume solidarity amongst groups, while having been politically expedient particularly with an influx of immigration into Britain after the end of the Second World War, has clearly come to demonstrate the conclusions of a thought process that has not taken in developments in cultural and social shifts, in addition to changing categorisations in understanding race.

Further, Moon-Kie Jung argues that when discussing the problems amongst communities of colour in relation to racial cohesion, that 'violence, above all, is what maintains the breach. Anti-Black racism does not exhaust but, without equivalent or analog, is singularly fundamental to white supremacy' (2015: 195). Such an argument brings forward the truly global impact of white supremacy as propagated by European colonialism, as Jung further argues, considering what we know about global colourism (particularly, the lighter the better), that anti-Blackness is practiced regardless of 'qualitatively different logics' (2015: 195) irrespective of culture or community (see also Hussein, 2010: 405). This is precisely the argument that Hall and Gilroy lay the foundation for, especially in terms of how we understand the process of racial categorisation. To continue to refuse to see differences within and across communities (as with the logic of political Blackness), and to call for unity and sameness in solidarity, is to continue to violently inscribe subjects with racial categorisation that flattens cultural and historical specificities. Ruíz and Dotson, in their work on the politics of coalition, while discussing the failures of white feminism, point out that 'What is key is an awareness that coalition … is not a homogenous hermeneutic space that provides an equal sense of home for all involved' (2017: 12). This remains central to understanding the urgency of the limits of unity or solidarity in antiracist praxis, as well as providing the emotional impetus for comprehending that any discussion of racial categorisation processes is a discussion of the rights of people to exist and be valued in communities that could be called home.

Solidarity in Intersections of Race and Religion

Presumed neutrality in racial categorisation also rears its head when we consider race and religion together. Claire Alexander concludes a brief history of the definition of Black in Britain by arguing that while political Blackness was already on its way out as a viable descriptor, largely through the rise of diaspora studies, 'the rise of Islamophobia and the manifold global and domestic targets of the War on Terror' (Alexander, 2018: 1042) caused a split between academic work in critical race studies not only through using diaspora as a tool to focus on specific cultural heritages and thus identities, but through intersectionality as a tool to map difference which became instrumental in categorising Muslims along with racial identity. This in turn led to a renewed focus on immigration and refugees, but with Islamophobia as the driving force, rather than the Black/white binary seen with the

rush for independence after the end of the Second World War. Of course, 9/11 has become a significant cultural marker for irrevocably altering understandings of race in general, but its impact on terms used to describe race in Britain, who 'looks' Black and who 'looks' Muslim cannot be overstated. Immediately after, and until the present day, the racial makeup of someone who can be considered Muslim, and by white supremacist standards, a terrorist Muslim, has been equated with brownness. To be brown, then, is to be Muslim – but such an association places Islam only across the Middle East and in South Asia, a specific subversion and manipulation of the development of racial politics in the West (see Chande, 2008; Jackson, 2005). This is of particular concern when it comes to discussion about solidarity amongst people of colour, as when race and religion are considered together to the point where they coalesce and brownness is associated with Islam, and Islam only with brownness, this constitutes an erasure and flattening of brown people, of Muslims more broadly, but particularly of Black Muslims whose Blackness and status as Muslims erases cultural heritages, diasporic movements, to say nothing of the removal of colonial and decolonial history that precipitated diasporic movements around the globe. Such an erasure calls to mind the earlier discussion of identity as an ever-changing process and the importance of recognising difference when considering the difference possible in communities that share some commonalities.

Identity Formation in British Film

The erasure of difference or, in other words, the flattening of the landscape of communities, does much of the work of anti-Blackness in presenting reductive representations of *who can be seen* to belong. A prescient example here is Mahmood Jamal's review of *My Beautiful Laundrette* in the original publication. The film features a South Asian character who falls in love with a skinhead in 1980s Britain, and is often hailed by some as a diverse and progressive film for its depiction of an interracial and queer relationship. Jamal, however, argues that the film is a neo-Orientalist production which deploys assimilationist narratives for the consumption of white liberals (1988: 21). Given that the narrative focuses on a brown boy falling in love with a Nazi skinhead, Jamal's critique is convincing and provides a useful backdrop for understanding that mere inclusion is not enough for films to be progressive or useful for anti-racist politics.

While film and visual media broadly provides an accessible platform for wide consumption of, it is also a platform that tells us

something about who is seen, both literally and societally, to belong to racial categories. Film critique predicated upon representational politics cannot be the end point of analysis, but can function as a useful marker for broad analysis on belonging, both narratively and culturally. In this vein of thinking, films that purport to depict Muslims in Britain tell us something about the hegemonic and mainstream understandings of *who can be seen to be* Muslim in Britain.

Claire Alexander's contention that 9/11 constituted a milestone for understanding race in the West lays the groundwork for the claim that 9/11 also brought about a shift of racial markers in film. There are certain Hollywood and UK productions which deal directly with 9/11, ranging from missions to take down Osama bin Laden, and stories of army operatives fighting the 'war on terror', such as *American Sniper* (2014), *Zero Dark Thirty* (2012), and (2015). The former film, *American Sniper*, is based on the memoir of US Navy SEAL Chris Kyle, 'American Sniper: The Autobiography of the Most Lethal Sniper in US Military History' (2012), and focuses on how Kyle's kills abroad affected his mental health. Predictably, the film serves as US war propaganda which focuses not on the civilians murdered by Western regimes, but rather on the feelings of the operatives tasked with their killings. *Zero Dark Thirty* and *Eye in the Sky* both function with a same narrative trajectory as they follow operatives on their missions to combat Islamic fundamentalism. Each of these films feature Black and brown Muslims, but more often than not, we are cast as bodies waiting to die in the background, the macabre puppets of white narratives of liberation and freedom. *American Sniper* is set during the Iraq war; *Zero Dark Thirty* moves across the US, Afghanistan, and Pakistan while Jessica Chastain hunts Osama bin Laden; and *Eye in the Sky* traverses across Britain and Kenya on a mission to combat Al-Shabaab terrorists. In these films, Muslims look vaguely Middle Eastern and South Asian, except for *Eye in the Sky* where Black Muslims feature in Kenya. In the neo-Orientalist narrative world of these films Muslim racial identity is a marker for a general Other; specifics of identity formation are not the concern of such productions. This is not to say that such representations could remotely be considered positive, but rather that the broad communication of these films in terms of identity categorisation primarily revolves around 'Muslim' as equivalent to 'terrorist'. They deal in representations wherein seeing a Muslim on screen is a Chekov's gun to their death: once a Muslim appears on screen, that is all the signification you need that death is coming. Films such as these are part of a grouping which treat the war on terror as a neo-colonialist endeavour wherein Muslims are terrorists. The kinds

of people which look Muslim are broadly marked as brown Others who threaten the stability of white Western civilisation.

Next, the grouping I will refer to is *Four Lions* (2010), *Yasmin* (2004), and *Brick Lane* (2007). While the previous grouping of films focus on the defeat of terrorism in the East, these films are all set in Britain and feature British Muslims navigating British culture. *Four Lions* was produced by Film4, and features a group of mostly brown men living in Sheffield plotting a terrorist attack. Director Chris Morris satirises the bumbling group of men, who attend a training camp in Pakistan, and everybody from the men themselves, to the police officers hunting them, are shown to be ineffective and incompetent. The Muslims depicted here are working-class brown men, who struggle to react to the surveillance of Muslims, along with the comedic relief of a white Muslim convert. There is much to be said about the film itself, but for our discussion its status as a 'post-9/11' film produced in the same political climate as the likes of *American Sniper* presents a more critical approach to British counter-terror strategies. As will become apparent with the other two films, *Four Lions* places South Asian Muslims as the targets of these anti-extremism strategies, and at the forefront of British Muslim culture, set as they are in working-class communities.

Yasmin is a more straightforwardly stereotypical film, produced by Parallax Independent and featuring Archie Panjabi in the role of a Yorkshire-bred Muslim woman who has been married off to a wild and savage man from Pakistan. Yasmin's life hiding her job and jeans from her family is turned upside down by 9/11, an event which functions within the narrative as sparking racism from her white colleagues and forcing her to choose between them and her brown Muslim family. By the end of the film, Yasmin's conflicts with her family are watered down by her alignment with Islam, expressed through her wearing a scarf in public, and attending the local mosque while rejecting an offer from a white colleague to go to the local pub. The film trades in a clash of civilisations narrative, but the choice to use 9/11 as a marker fits into Alexander's earlier model of 9/11 reinvigorating the latent Orientalism that structures racial categorisation. *Yasmin*, as with *Four Lions*, features only South Asian Muslims which is not problematic in and of itself, but is relevant to the context that we are building here.

It is the same story for *Brick Lane*, also produced by Film4, which follows Nazneen, a Bangladeshi mother who embarks on an affair with a younger man. *Brick Lane* is notable for its nuanced portrayal of a young family, but once again uses 9/11 as a narrative pivoting point. It is 9/11 that triggers the family experiencing racism in their

community and considering a move to Bangladesh. For the purposes of our discussion, this is another film that engages with depictions of South Asian working-class Muslims, and explores themes of double lives, identity clashes, and the position of Muslims in British films.

Each of these films say something about British culture, but the facts of casting and background leave a rather homogenous outlook on British Muslims as primarily South Asian. Of course, no one film or relatively small group of films can be expected to reflect the entirety of any demographic, but the point here is not concerned with these films individually, but is instead about the context that these kind of films build up of being a British Muslim as synonymous with being South Asian. There is of course a large South Asian Muslim community in Britain, but there is also a sizeable Black Muslim community who are often pointedly overlooked in film, but also in social policy and general cultural representations. While these films have important, and upon occasion stereotypically flat, things to say about the lives of South Asian British Muslims they also say something about who is seen to be Muslim in Britain, and who is not.

Conclusion

To put it bluntly, absence is a kind of presence. The Casey Review, an analysis into integration and opportunity in Britain commissioned by then-Prime Minister David Cameron in 2016, devoted a considerable amount of space to British Muslims and picked out Pakistani and Bangladeshi communities as outstanding examples of self-segregation and a lack of integration. The document states that 'the two largest ethnic groups within the overall Muslim population in England and Wales are of Pakistani and Bangladeshi origins, accounting for around 38 per cent and 15 per cent of Muslims in England and Wales respectively' (2016: 27–28). The largest populations of Muslims in the country are used throughout as dog-whistle examples as proof of a lack of assimilation and belonging to Britain. In choosing to ignore Muslims of other ethnicities the, already shaky, conclusions of the review and its approach to Muslims in Britain are further compromised. Black Muslims are not mentioned a single time in the 200-page document, and Black people as a social group are mentioned sparsely, largely in relation to statistics on deprivation in education, employment, and housing, alongside Pakistani and Bangladeshi counterparts. Pakistani and Bangladeshi communities are targeted in supposedly not integrating

Violence, Above All, Is What Maintains the Breach Maryam Jameela

into British society, and the complete absence of analysis on Black Muslim communities speaks to the draw and influence of hegemonic associations in the West that equate being Muslim with being exclusively South Asian or Arab.

These two isolated examples, of British film and of British social policy, speak to a wider concern around the erasure of Black Muslims. This is a kind of erasure which is harmful partly for nuanced and insightful discussions around Muslim communities in Britain, but more importantly to communities of Black Muslims whose identities are parcelled out and kept separate. Of course, none of this is to campaign for the inclusion of Black Muslim terrorists in British film, but rather to draw out the inconsistencies and fallacies of representation in both mainstream film production in Britain, and in British social policy. Black British Muslims have long been discussing their experiences in various contexts and the failure of mainstream academia and other institutions to take notice is a failure of intellect and inclusion. This chapter has aimed to write from a South Asian Muslim perspective that examines the importance of difference in recognising identity formation processes, and critiques in social, cultural, and political spheres – I have not said anything that will be new or insightful for Black British Muslims. Rather, my goal has been to point out the inconsistencies of categorisation in Muslim scholarship, and to provide a brief critique of the efficacy of political Blackness as an example of the necessity of solidarity and unity taking stock of differences amongst communities, rather than primarily in relation to whiteness.

It has only been an understanding of contextual identity formation that has allowed the above analysis to ensure political Blackness as a model of identity does not allow for such discussions which can move towards more nuanced encapsulations of intersecting identities. While generalising terms that label groups that are of colour have their uses, it is vital to avoid flattening out difference in the guise of unity or solidarity. Film critique has its place in making links between cultural and social aspects of identity, and while the concerns about the original publication revolving around Britishness and Blackness are still relevant, there is much work to be done if analysis is to remain fruitful and insightful in relation to differences within intersecting identities. The films discussed here communicate a hegemonic presentation of who is seen to be Muslim in Britain – expanding notions of belonging allow for a more robust kind of solidarity or unity that seeks to look more expansively and include differences from within communities of colour.

Alexander, C. (2018) 'Breaking Black: The Death of Ethnic and Racial Studies in Britain'. *Ethnic and Racial Studies 41*(6): 1034–1054.

Andrews, K. (2016) 'The Problem of Political Blackness: Lessons from the Black Supplementary School Movement'. *Ethnic and Racial Studies 39*(11): 2060–2078.

Chande, A. (2008) 'Islam in the African American Community: Negotiating between Black Nationalism and Historical Islam'. *Islamic Studies 47*(2): 221–241.

Deliovsky, K. and Kitossa, T. (2013) 'Beyond Black and White: When Going Beyond May Take Us Out of Bounds'. *Journal of Black Studies 44*(2): 158–181.

Gilroy, P. (1988) 'Nothing But Sweat Inside My Hand: Diaspora Aesthetics and Black Arts in Britain' in *Black Film, British Cinema*. Edited by Kobena Mercer, 44–46. London: ICA.

Gilroy, P. (2007) *There Ain't No Black in the Union Jack*. Oxfordshire: Routledge.

Great Britain. Department for Communities and Local Government (2016) 'The Casey Review'. December 2016. London: Department for Communities and Local Government. Available at: https://assets.publishing.service.gov.uk/government/uploads/system/uploads/attachment_data/file/575973/The_Casey_Review_Report.pdf (accessed 1 March 2019).

Hall, S. (1988) 'New Ethnicities' in *Black Film, British Cinema*. Edited by Kobena Mercer, 27–30. London: ICA.

Hussein, N. (2010) 'Colour of Life Achievements: Historical and Media Influence of Identity Formation Based on Skin Colour in South Asia'. *Journal of Intercultural Studies 31*(4): 403–424.

Jackson, S.A. (2005) *Islam and the Blackamerican*. Oxford: Oxford University Press.

Jamal, M. (1988) 'Dirty Linen' in *Black Film, British Cinema*. Edited by Kobena Mercer, 21. London: ICA.

Jung, M.K. (2015) 'The Problem of the Color Lines: Studies of Racism and Resistance'. *Critical Sociology 41*(2): 193–199.

Kureishi, H. (1988) 'England, Bloody England' in *Black Film, British Cinema*. Edited by Kobena Mercer, 24–25. London: ICA.

Mercer, K. (1988) 'Recoding Narratives of Race and Nation' in *Black Film, British Cinema*. Edited by Kobena Mercer, 4–14. London: ICA.

Ruíz, E. and Dotson, K. (2017) 'On the Politics of Coalition'. *Feminist Philosophy Quarterly 3*(2): 1–15.

Sayyid, Salman (2012) 'Empire, Islam and the Postcolonial. International Centre for Muslim and NonMuslim Understanding'. Working Paper No. 9, 1–18.

Snead, James (1988) '"Black Independent Film": Britain and America' in *Black Film, British Cinema*. Edited by Kobena Mercer, 47–50. London: ICA.

Tyrer, David (2013) *The Politics of Islamophobia: Race, Power, and Fantasy*. London: Pluto Press.

Part II
Black Film Aesthetics

4 From Harlem to Mazatlán: Transnational Desires and Queer of Colour Politics in the Work of Isaac Julien

Richard T. Rodríguez

Visual artist and cultural critic Sunil Gupta, in his momentous essay 'Black, *Brown* and White', published in the 1989 collection *Coming on Strong: Gay Politics and Culture*, notes how 'in 1987, you could walk into Gay's the Word Bookshop in London and not even find a general Black section. However,' he continues, 'the oldest Blackgay group in the country has been meeting at a site next door for several years. This group has traditionally included all non-white races in its definition of Black, resulting in a mix between largely "Afro-Caribbean" and some "Asian." Meanwhile, published documentation, what little exists, stems almost entirely from the Blackgay American experience' (Gupta, 1989: 163). The same year Gupta's essay was published, Isaac Julien released what would become one of his most widely acclaimed films: *Looking for Langston*.

While one could argue that *Looking for Langston*, as Gupta puts it, 'stems almost entirely from the Blackgay American experience', I prefer to read the film in a broader history of transatlantic cinematic and cultural exchange that makes an indelible impact on both the history of queer Black British filmmaking and queer of colour cultural politics.[1]

72 Indeed, the point I emphasise in this chapter is that Julien's filmic and scholarly oeuvre has consistently drawn from resonant contexts that consider moments of historical and political convergence while also remaining attentive to constructing a decidedly Black British film culture. Thus, I spotlight the transnational influences that contour Julien's cinematic work and identify these influences as stemming from a queer cultural politics that inextricably links the racial and sexual dynamics from a number of temporal and spatial trajectories.[2]

Focusing on two films – *Looking for Langston* and *The Long Road to Mazatlán* (2000) – allows me to identify such transnational circuits of influence in the formation of Julien's queer Black British cinema. In particular, I detail how overlapping African American, Latino, and gay/lesbian histories in the United States have inspired Julien since his involvement with the Sankofa Film and Video Collective in the 1980s and into the present. Addressing efforts to consign queer sexual identities and desires to invisibility during specific historical moments (the Harlem Renaissance in *Looking for Langston*) and geographic locations (the American Southwest in *The Long Road to Mazatlán*), Julien's film practices exemplify what Kobena Mercer – in his foundational essay 'Recoding Narratives of Race and Nation', which opens the *Black Film British Cinema* ICA Documents issue – calls the 'plurality of filmic styles and ways of seeing' that 'reflexively demonstrates that the film, as much as its subject matter, is a product of complex cultural construction' (Mercer, 1988: 11).

Resonant Sources of a Queer Past

Julien's insistence upon the particularities of Black British cultural politics that simultaneously draws inspiration from American contexts are traceable to his early work with the Sankofa Film and Video Collective. In an interview with Cuban American critic and artist Coco Fusco in her monograph *Young British & Black* (published the same year as *Black Film/British Cinema*), Julien responds to a question about the legacy of Black American radicalism from the 1960s and 1970s informing the 1986 film classic *Passion of Remembrance* which he directed with Maureen Blackwood. He explains: 'There was a Black Power movement in Britain that borrowed many of its signs and symbols from America. We do borrow from other cultures within the diaspora, but we are specifically talking about a Black British experience – and we have to be very careful not to substitute an American experience for a Black British experience' (Fusco 1988: 30). Julien continues:

From Harlem to Mazatlán Richard T. Rodríguez

in borrowing those things, we were also prioritizing issues such as British national identity. We did not naively try to transplant a Black American experience onto the Black British experience. It was very important to us to talk about our experience in the diaspora, and the specificity of the Black experience. We always thought that *Passion* would be very interesting for American audiences. Not very many people had recognized Britain as being either Black, or mixed-race, or Asian. They didn't recognize all those other identities in Britishness.

(Fusco 1988: 31)

The recognition of 'all those other identities in Britishness', as Julien puts it, is precisely what enables the insistence that the distinct cultural and historical elements that manifest in Black British film are sustained by an array of transnational influences. Indeed, we must consider how the work of Julien operates at the crossroads of national, cultural, and aesthetic influence. Doing so allows a recognition of the mutual influences of Black, Brown (here meaning US Latinos as well as Asians in the UK), and queer cultural workers whose work generates a more capacious understanding of distinctly articulated and grounded cinemas underscored by the local dynamics propelling their emergence and the global circuits informing their circulation and reception.

Kobena Mercer, in his essay 'Angelus Diasporae', notes how the transnational/transatlantic impetus for Julien's *Looking for Langston* relates back to the transmission of many influential cultural texts of the 1980s. In discussing the cover art of Joseph Beam's 1986 edited collection *In the Life: A Black Gay Anthology* by Deryl Mackie, Mercer writes that 'this breakthrough collection of black gay writings travelled across the Atlantic to become a catalyst for Isaac, who went into production with *Looking for Langston* in 1987, just as the *Tongues Untied* (1987) poetry anthology published by Britain's Gay Men's Press took light in the converse direction to inspire the keynote video of the same name that Marlon Riggs (1957–94) produced in 1989' (Mercer 2013: 67). Mercer's observations keenly reveal that while Julien drew inspiration from American cultural workers like Beam, that inspiration did not proceed from only one direction; that is, a Black American filmmaker like Marlon Riggs was equally attentive to what was happening across the Atlantic with regard to Black gay men, thereby naming his highly regarded film after a collection of

poems published in London. This transatlantic cultural traffic, I insist, comprises a body of queer of colour cultural production whose politics at once recognise yet exceed national demarcation. Further evidence of this point is when Mercer notes that, in travelling with Julien to Los Angeles for the First Lesbian and Gay People of Color Conference in 1986 (where they met Beam, the gay acapella group Blackberri, and 'other lifelong friends'), 'the moment was equally memorable for the way film and cinema were the key routes through which Black Atlantic diaspora cultures entered a new configuration', for 'no one could have foreseen the African-American reception of Black British film, which gave it global currency and impact'.[3]

A self-described 'meditation' on the life of African American Harlem Renaissance poet Langston Hughes, *Looking for Langston* is, as B. Ruby Rich notes, 'so very much about the evolution of a new Black British cinema' and 'equally … one of the founding moments of the movement I would later term the New Queer Cinema' (Rich 1998: 379). Following on the heels of *Passion of Remembrance*, *Looking for Langston* is a stunning film constructed from an expansive archive of materials that bridges African American history and contemporary Black British cultural politics. Aside from the obviously central role Hughes' life history plays in Julien's film, the resonant sources for *Looking for Langston* stretch beyond the focus on an individual figure in Black American history.

Along with the contextual examples offered by Mercer above, one can, for example, point to the important role of Black American gay writer Essex Hemphill's poetry; or the inclusion of the 'American voices' (to which they are referred in the film credits) of eminent writer Toni Morrison (who reads the work of James Baldwin) and actor Erick Ray Evans (who reads writings by Bruce Nugent). Of further note is Julien's choice of music for *Looking for Langston* that arises from both Black American and Black queer contexts. Not only does the film incorporate the sonic contributions of Blackberri but it also fittingly features a house music classic: 1988s 'Can You Party' by New York DJ and producer Royal House (an alias for Todd Terry). The song's inclusion in the film is arguably more than just the perfect song for the dance floor but it's citational politics nod to the Black and Latino and gay house music scenes in Chicago and New York.[4] *Looking for Langston* thus brilliantly resituates that American queer of colour cultural milieu in a British context, specifically a gay bar that, while nodding to Harlem Renaissance nightlife, is nonetheless recognisably situated in a more recent temporal moment across the Atlantic. As the

song blasts in a nightclub where men move passionately on the dance floor, a mob of gay bashers breaks into a secret city location that I read as London. Thus, while earlier in the film the bar symbolically indexes the temporal moment of the Harlem Renaissance, 'Can You Party' assists in fast-forwarding the narrative into the present moment and to a different locale, one in which a new found liberation between Black men as well as men of all colours is established although threatened by large-looming, anti-queer, and racist sentiment.

Steven Blevins perceptively maintains that *Looking for Langston* 'constellates an elegant genealogy of black queer belonging whose lineage runs from Hughes to Countee Cullen and Claude McKay to Alain Locke' (2016: 182–183). However, if we look beyond the content of the film we can witness how both Julien and *Looking for Langston* are part of an elegant genealogical constellation of cultural workers whose mutual influence have led to the enduring lineage of a transatlantic Black diasporic cinema. Consider, for example, African American lesbian filmmaker Cheryl Dunye, whose 1996 film *The Watermelon Woman* has been said to similarly adopt 'irreverence toward cultural icons and ... black-on-white sexual action' (Rich, 2013: 68). More recently, African American gay filmmaker Rodney Evans' 2004 *Brother to Brother* has built upon (and which B. Ruby Rich notes is 'undoubtedly influenced' by) *Looking for Langston*'s consideration of the intertwined politics of race and queer sexuality by focusing on a major figure – here Harlem Renaissance writer and painter Bruce Nugent – in Black queer politics (Rich, 2004). Yet while *Looking for Langston*'s must be understood as a link in the chain of reciprocally influential Black image-making on opposite sides of the pond, one must also account for how Julien's work converses with other racial-sexual histories and cultural traditions from a transatlantic frame.

Scenes from the Global Southwest

José Esteban Muñoz has pointedly argued that 'The turn to the past in Julien's work has never been liner' (2005: 2). Clearly evident in *Looking for Langston*, it is also made clear in Julian's 1999 film *The Long Road to Mazatlán*. An experimental triptych video collaboration with choreographer Javier de Frutos and released ten years after *Looking for Langston*, *The Long Road to Mazatlán* grapples with the ineradicable influence of American cowboy culture – from the Western film genre and Andy Warhol's 1968 film *Lonesome Cowboy* to the persistent fantasy of the cowboy in gay male culture and the

embrace of the vaquero image in US-Mexico border culture. While the film indeed turns to the past in non-linear fashion to think about the cowboy's queer and racialised value in popular culture, I mainly want to consider the film's portrayal of the cowboy in light of Julien's familiarity with the US Southwest and Latino representational politics. Indeed, by foregrounding the terrain of the US Southwest in *The Long Road to Mazatlán* the film initiates a conversation about the dubious casting or flat-out ghosting of Latinos from this popular cinematic mise-en-scène.

While Muñoz's reading of Julien's film from the perspective of the global south (or, as he puts it, as an invitation to 'go south' to 'a mythical Mazatlán') is compelling, I want to emphasise the way 'Mazatlán', to my mind, simultaneously references the popular Mexican resort town of the same name and 'Aztlán', the mythic homeland of the Aztecs which, for politicised Mexican Americans embracing the identity 'Chicano/a', has served as a symbol for collective belonging and empowerment.[5] Understanding 'Mazatlán' in Julien's film this way enables contemplation of the historically touristic response to Mexican culture and bodies from a resolutely political perspective. Moreover, this also solidifies a transatlantic US Southwest/UK connection that informs the film take on cowboy culture.

In a conversation with B. Ruby Rich, Julien declares that he was struck when walking around Texas, during his residency at ArtPace in San Antonio and where he shot *The Long Road to Mazatlán*, he would glimpse 'people in this iconographic cowboy costume, and … recognize it as the same dress code of gay men on the streets of London. So in a way,' he explains, 'I felt immediately at home, oddly enough, in San Antonio' (Rich and Julien, 2002: 57). I would also maintain that *The Long Road to Mazatlán* additionally highlights Julien's knowledge of racial and cultural politics that extend beyond an African American context, broaching the long-standing misrepresentations or glaring cinematic absences of other racial and ethnic communities in the US, namely Chicanos/as and Latinos/as. This is evident not only in interviews with Julien, but even in the film itself when he appears in one frame of the tryptic during a scene in an unmistakably Southwest bar complete with a mariachi band (Figure 4.1). Rather than see Julien's film as a singular attempt to take down stereotypes, it is imperative to place it in the same vein as *Looking for Langston*; that is, operating as a complex view of race and sex that scrambles historical norms to make room for queer politics and unanticipated bonds that traverse time and space. As Adrian Searle argues in his review of *The Long Road to Mazatlán*:

Figure 4.1

This is not a cowboy movie. This is not a road movie, despite the locale and the clothes and the soundtrack, with its cowpoke yodelling and Tex-Mex songs. 'We're not always undone by stereotypes – in some way they sustain us,' Isaac Julien, director of *The Long Road to Mazatlán*, has remarked. This work, part of the exhibition Cinerama at Manchester's Cornerhouse Gallery, takes its title from a line in Tennessee Williams's *Night of the Iguana*, although Julien's film does no more than nod at Williams.

(Searle, 2000)

Julien's film, besides the nod at Williams, reads the figure of the cowboy with what he's familiar seeing 'at home' (in London) within the setting in which he finds himself working (in San Antonio). Similar to how *Looking for Langston* repurposes African American cultural history for a distinctly Black British film practice, *The Long Road to Maztlán* conjoins seemingly disparate temporal and spatial trajectories to fashion a queer of colour transatlantic narrative.

In a discussion with Coco Fusco about his 1995 film *Frantz Fanon: Black Skin, White Mask*, Julien explains how feminist theorist Donna Haraway 'commented that what she thought was important about this film is the way that we [Julien and longtime partner and collaborator Mark Nash] have made an act of visualization a form of theoretical production' (Fusco, 2001: 99). Indeed, along with the historical sources influencing Julien's cinematic work, Julien's filmmaking strategies require grounding within an overall critical-theoretical enterprise collectively shaped by a network of interlocutors consisting of writers, scholars, and visual artists from both the US and Britain like Kobena Mercer, bell hooks, Essex Hemphill, José Esteban Muñoz, Pratibah Parmar, Stuart Hall, and Sunil Gupta. Julien, as Stuart Hall writes, 'is astonishingly knowledgeable about contemporary cinema, and has a deep but well-concealed – and often grossly underestimated – engagement with critical theory' (Hall, 2016: 41).

Thus, along with the cinematic interconnections and intimate desires that underpin *Looking for Langston* and *The Long Road to Mazatlán*, I want to mark the articulation of a queer of colour theoretical discourse whose transatlantic reach has been greatly facilitated by Julien's work and its indelible influence. Consider, for example, the late Cuban American cultural theorist José Estaban Muñoz's foundational text, *Disidentifications: Queers of Color and the Performance of Politics*, that charted the enterprise of queer of colour critique with Julien's work situated at its argumentative core. In his reading of the funeral and the bar in *Looking for Langston*, Muñoz writes that Julien's 'layering of different gay spaces serves to show these different aspects of gay lives as always interlocking and informing each other' (Muñoz, 1999: 73). This, I believe, is an apt way to think about both *Looking for Langston* and *The Long Road to Mazatlán* given their desire to illustrate the interlocking, mutually informing queer of colour politics and the spaces from which they emerge – from London and the US Southwest to Harlem and Mazatlán.

Julien's Transatlantic Desires

I conclude this chapter by referring back to a published conversation in 1991 between Julien and African American feminist critic bell hooks in the pages of the journal *Transition: An International Review*. Titled on the cover 'Fade to Black: Issac Julien's Cinema of Desire' (and inside the journal *States of Desire*), the conversation finds Julien discussing at length the politics that inform his work but specifically those fuelling his first and only feature film: 1991's *Young Soul Rebels*. While the 'desire' in both titles assigned to the conversation in *Transition* most likely refers to the sexual politics that underpin his films, I believe that this desire also applies to the intimate transnational linkages I've gestured to in this chapter. Explaining the appeal of Black music from the US for Black British young men like *Young Soul Rebels'* Caz and Chris, Julien declares: 'What happened, slowly but surely, was that this kind of music became very popular, and younger black people [in Britain] wanted to hear more of it. So they started to broadcast illegally and form their own radio stations. And this is part of the narrative of *Young Soul Rebels*. Caz and Chris would probably be one of the first younger black people to start playing the music that they want to hear' (hooks, 1991: 181).

The inspirational force of the imported Black American music to the UK – not unlike the Royal House track in *Looking for Langston* or

the Mexican American cowboy in the US Southwest in *The Long Road to Mazatlán* – inspires Caz and Chris 'to start playing the music that they want to hear'. This is an apt way to ascertain the inspirational force of ethnic American and queer cultural history that is equally desirable for Julien to make the films he wants to see. To be sure, such films are crucial moments in the chronicle of Black film and British cinema that engage with the politics of representation, perhaps building from a range of American spatial and temporal histories, but most certainly generating a necessary Black British here and now.

Bibliography

Blevins, S. (2016) *Living Cargo: How Black Britain Performs its Past*. Minneapolis: University of Minnesota Press.

Bost, D. (2019) *Evidence of Being: The Black Gay Cultural Renaissance and the Politics of Violence*. Chicago: University of Chicago Press.

Fusco, C. (1988) 'An Interview with Martina Attille and Isaac Julien of Sankofa Film/Video Collective' in *Young British & Black*, 23–39. Buffalo, NY: Hallwalls/ Contemporary Arts Center.

Fusco, C. (2001) 'Blacks in the Metropolis: Isaac Julien on Frantz Fanon, an Interview' in *The Bodies that Were Not Ours and Other Writings*, 99–104. London: Routledge.

Gupta, S. (1989) 'Black, *Brown* and White' in *Coming on Strong: Gay Politics and Culture*. Edited by S. Shepherd and M. Wallis, 163–179. London: Unwin Hyman.

Hall, S. (2016) 'In Isaac Julien's Workshop' in *Isaac Julien: Playtime and Kapital*. Edited by E. Álvarez Romero, 40–46. Mexico City: Museo Universitario Arte Contemporáneo.

hooks, b. (1991) 'States of Desire'. *Transition: An International Review, 53*: 168–184.

Mercer, K. (1988) 'Recoding Narratives of Race and Nation' in *Black Film/British Cinema*. Edited by K. Mercer, 4–14. ICA Documents 7. London: Institute of Contemporary Arts.

Mercer, K. (2013) 'Angelus Diasporae' in *Isaac Julien: Riot*. Edited by I. Julien, 57–68. New York: Museum of Modern Art.

Muñoz, J.E. (1999) *Disidentifications: Queers of Color and the Performance of Politics*. Minneapolis: University of Minnesota Press.

Muñoz, J.E. (2005) 'Meandering South: Isaac Julien and *The Long Road to Mazatlán*' in *Isaac Julien*. Edited by S. Kissame, 1–14. Dublin: Irish Museum of Modern Art.

Rich, B.R. (1998) *Chick Flicks: Theories and Memories of the Feminist Film Movement*. Durham, NC: Duke University Press.

Rich, B.R. (2004) 'Che for Today'. *The Guardian*. Available at: www.theguardian.com/ film/2004/jan/23/festivals.sundancefilmfestival2004 (accessed 2 January 2020).

Rich, B.R. (2013) *New Queer Cinema: The Director's Cut.* Durham, NC: Duke University Press.

Rich, B.R. and Julien, I. (2002) 'The Long Road: Isaac Julien in Conversation with B. Ruby Rich'. *Art Journal 61*(2): 50–67.

Rodríguez, R.T. (2009) *Next of Kin: The Family in Chicano/a Cultural Politics.* Durham, NC: Duke University Press.

Salkind, M.E. (2019) *Do You Remember House? Chicago's Queer of Color Undergrounds.* Oxford: Oxford University Press.

Searle, A. (2000) 'Winsome Cowboys'. *The Guardian.* Available at: www.theguardian.com/film/2000/aug/22/artsfeatures (accessed 2 January 2020).

Notes

1. Worthy of noting is Sunil Gupta's role as the still photographer for Looking for Langston.
2. Julien's engagement with 'queer' politics in a theoretical framework (a point elaborated upon later in this chapter) is reflected by the Spring 1994 special issue of *Critical Quarterly* titled 'Critically Queer', which he edited with Jon Savage.
3. See Bost (2019) for an invaluable investigation of the transatlantic cultural exchanges between black gay men in the 1980s.
4. Salkind (2019) provides an invaluable account of the house music scene in Chicago since the late 1970s.
5. I provide greater detail of the politics of Aztlán in *Next of Kin* (2009).

5 Understanding Steve McQueen

Richard Martin, Clive James Nwonka, Ozlem Koksal, and Ashley Clark

This text is based on a panel discussion with Clive James Nwonka, Ozlem Koksal, and Ashley Clark, chaired by Richard Martin, at the Black Film British Cinema conference at the ICA on 19 May 2017.

Richard Martin: Even at this relatively early stage in his feature film career, Steve McQueen is perhaps the most celebrated Black British film director of all time. He is the only person to have won both the Turner Prize (in 1999) and an Academy Award (in 2014, for *12 Years a Slave*). With the latter award, he also became the first Black British winner of the Best Picture prize. McQueen's career trajectory might tell us something about the different production contexts that have shaped British cinema. Beginning at Goldsmiths in the early 1990s and then creating a series of complex gallery-based video installations, McQueen moved into feature filmmaking, working with Film4, with the UK Film Council and then within the Hollywood system. His new BBC series, *Small Axe* (2020), represents his first sustained engagement with television. In this discussion, we'll take a particular focus on McQueen's cinematic work, looking closely at *Hunger* (2008), *Shame* (2011), and *12 Years a Slave* (2013). In so doing, we hope to create space for the kind of close reading and formal analysis of Black cinema which has too often been neglected. Initially, though, we're going to consider McQueen's career as a whole, how we might understand his practice working in a variety of different contexts, and where we might place him

within mainstream British cinema given his art school training and extraordinary international success?

Ashley Clark: It's difficult to talk about Steve McQueen's film work in a British context because he's so incredibly atypical. In a way, Isaac Julien went the other way – from making a feature film like *Young Soul Rebels* (1991) to moving more into visual arts and the gallery space. McQueen went the other way. But, because he's now predominantly making films in the United States, it's hard to frame him as a British filmmaker. McQueen's not yet making films about Black British life; he may do one day. I'd struggle to place him within mainstream filmmaking in the UK, but obviously he's won an Oscar, which is about as mainstream as it gets. Does he work in a particularly idiosyncratic formal realm? I'm not sure. There are hints of that in *Hunger*, particularly in how he plays with duration. But, formally, he's a fairly conservative filmmaker.

Clive James Nwonka: First, I would consider Steve McQueen to be a Black filmmaker in a British context: he's Black and he's British. I do agree with Ashley that he's not actually making films at the moment that address Black British experience, but that may be defined. However, I'd to expand the paradigm. What do we mean by 'mainstream', in a filmmaking sense? Is there a homogeneous mainstream that everyone occupies? I think there are degrees to the mainstream. McQueen's trajectory from art house to the Oscars is so fluid. I don't think we can situate him in the mainstream where it currently exists. Yet, he is mainstream in terms of acclaim, in terms of his presence in the film scene. However, his film practice in terms of aesthetics is completely non-mainstream in many ways.

Ozlem Koksal: I agree with both of you. I also think McQueen's work is often discussed in relation to whether there are continuities between his earlier work and his later feature films. I try to think about his work in these terms and whether those distinctions are necessary or, if there are continuities, where do we find them?

Richard Martin: What's at stake if we were to divide McQueen's practice between gallery-based moving images and feature filmmaking? Is this a distinction we're interested in making? Or would we rather see continuities across his practice?

Ashley Clark: It's always useful to look at somebody's work as a whole because then you can discern themes that run throughout

it. But I want to make it clear that I don't see it as a pejorative judgment of Steve McQueen that he's not yet making films about Black British life. He's got a long career ahead of him. It's great that he's making the films he wants to make, and avoiding the burdens of representation. At the same time, I can't help feel a slight ruefulness at the lack of a Black Ken Loach or Stephen Frears or Shane Meadows or Michael Winterbottom or Danny Boyle (all male filmmakers, by the way) – that kind of long career arc which is often connected with social realism. Horace Ové has two theatrically released features to his name; Menelik Shabazz has two or three; and Ngozi Onwurah has had just one film released in the UK. There's a huge gap in the last 40 years of Black British filmmaking with no real core of sustained work by a single filmmaker, where we can discern their aesthetic or where their obsessions have been able to come to fruition. So, when I think about Steve McQueen, I often think maybe he's the one – the returning son who will come back and make this great body of work about Black British life. But, as an artist, he is free to follow his own obsessions and make work that he's interested in, wherever that may lie.

Hunger (2008) is the historical drama about the 1981 Irish Hunger Strike in the Maze Prison, focusing on the IRA prisoner Bobby Sands and the second hunger strike that led to his death.

Clive James Nwonka: The first thing to consider is the production context of this film. *Hunger* was made at a time when Channel 4 Films was going through massive, seismic change. It had just come out of a decade-long commercial incarnation led by Paul Webster which failed, ultimately, to crack the American market. Tessa Ross ran Film 4 and Film4 Productions from 2002 to 2014, and I consider what she did there as a kind of homage to the David Rose days of 1980s Channel 4, in terms of a very distinctive British mode of production with low budgets. Second, it's worth considering that one of the producers for *Hunger* was Robin Gutch who ran the Film4 Lab from 1993 to 2003, a descendant of independent film and video collectives, and who was also involved in Warp Films, which again was a distinctively British low-budget production company. So, the production terrain was conducive to a film like *Hunger*, a film that isn't antagonistic to the idea of IRA paramilitary activity. In

that situation – a film about the IRA that isn't negative appearing on a British platform – the only place it could be made at the time was Channel 4.

Richard Martin: How might we read the scene in *Hunger* when Margaret Thatcher's voice is juxtaposed with the image of the corridor in the Maze Prison, which then leads into the start of Bobby Sands' hunger strike? It strikes me that there's a claim being made here about what constitutes political action and who gets to define what's political. For McQueen, not just in *Hunger* but more broadly in his work, notions of the political have very strong links with the body.

Ozlem Koksal: I didn't grow up here, so I wasn't in the UK when Thatcher was in power, but even I get a powerful response when she starts talking in the film. Recently, I have been thinking about *Hunger* with an additional perspective. I signed a document urging the Turkish government to be more involved in the peace process and that resulted in many people being fired from their jobs in Turkish universities. Two of them are on hunger strike at the moment and they are in a critical state. Watching *Hunger* is incredibly uncomfortable for me. When Thatcher says in the film that the hunger strikers are trying to speak to 'the *most basic of human emotions – pity*', I feel how wrong her understanding of the situation was. It's the complete opposite for me, without glorifying the hunger strike. To me, that juxtaposition – how he cuts to Bobby Sands after Thatcher's voice – leaves me thinking that he's very vulnerable. It's very subversive. Is my body the property of the state? McQueen is forcing that question. There's also the earlier long scene of the corridor being cleaned. I always thought of corridors as interesting places in cinema, and architecturally, too. These are supposed to be non-places, that take you from A to B. But in *Hunger*, the corridor is the only opening, it's the only place. I like how McQueen uses space, how he takes his time and how he's not afraid of showing the body and its vulnerability.

Richard Martin: It's extremely visceral, and throughout *Hunger* there's a lot of shit, piss, blood, spit and sweat. This is something McQueen is fascinated by: how bodies are put under pressure and how they change as a result.

Ashley Clark: I'm always impressed by the austerity of *Hunger*, particularly thinking of the rapturous response it received from critics and audiences, which now seems quite remarkable. This austerity doesn't have much of a tradition in British cinema.

But when blood, piss, and shit *are* brought to the fore, there is a tradition of grotesquery in British cinema. I'm thinking about the explicitly political, satirical work of someone like Peter Greenaway in *The Cook, the Thief, His Wife* (1989), which has baroque aspects to it, or even *Monty Python's Meaning of Life* (1983). When British cinema engages with those fluids and substances it's normally in a grotesque, flamboyant way. I think what McQueen does here also highlights Michael Fassbender's performance, which is incredible, how he stripped himself away. There's a sense of commitment throughout the film, and a commitment to duration and austerity.

Clive James Nwonka: Let me pose a question: Is there a way that we could link that particular scene to an understanding of the Black British experience, especially in the 1980s? There are three things that Steve McQueen recalls influencing him as a child in 1981. The first was Tottenham Hotspur winning the FA Cup. The second was Bobby Sands and the images of him on the news every evening. And the third was the Brixton riots.

Going through that trajectory, perhaps we can consider *Hunger* allegorically. For instance, in that scene, what we're seeing is the body politic. We're talking about the failure of the body physically, but also the failure of the political process against Thatcherism. We see laceration, both physically and metaphorically; there's injuries to this body and there's the injuries the IRA suffered against Thatcherism, because ultimately, they wanted political identity within the Maze Prison. What McQueen wanted in the earlier 1980s was identity and recognition, both politically and culturally. There's a very strong link between Steve McQueen as a young Black person living in the 1980s within the context of Thatcherism and Bobby Sands and his collective operating as paramilitaries in the 1980s.

Richard Martin: I'm very struck, Clive, by your analysis of McQueen's focus on whose bodies are vulnerable in a political situation and the politics of that vulnerability. It links to so many recent conversations, particularly in the United States but also in the UK, in the Black Lives Matter movement or in the work of Ta-Nehisi Coates and Claudia Rankine, concerning the vulnerability of bodies, specifically Black bodies. We might also think about the fetishizing of the white body here. It's particularly interesting to think about what happens to Michael Fassbender's body in *Hunger* and *Shame*. Regarding this wider question about how we might situate McQueen's work in terms of its response

to previous eras, there's his frequent engagement with forms of history, memory, and memorialization. We've seen this in his artistic practice with projects like *Queen and Country* (2007), which commemorates soldiers killed in the Iraq War, and his video installation *Ashes* (2002–2015), which is a memorial to a young man from Grenada who was killed. We can also think about *Hunger* as a form of cultural memory, or an attempt, as Clive suggested, to re-orientate perceptions of the Republican movement and how notions of Britishness related to it.

Shame *(2011) is a New York set drama about sex addict Brandon (Michael Fassbender) and his problematic relationship with his younger sibling Sissy (Carey Mulligan) that comes to a head when she moves into his apartment with him.*

Richard Martin: Let's first think about the scene in *Shame* in which the two main characters, the siblings Brandon and Sissy (played by Michael Fassbender and Carey Mulligan), have a long discussion on the sofa watching the television in Brandon's apartment. It's one of those famous McQueen long takes, akin to the conversation that Bobby Sands has with a priest in *Hunger* and the extended shot of the corridor being cleaned that was mentioned earlier.

Ozlem Koksal: This scene is interesting because Brandon is a man with very serious problems with intimacy. He is constantly watching porn or having sex with strangers. He is depicted as a character with a sex addiction, though I don't agree with this terminology.

When this scene appears, you might think: why are we watching this? But something important happens, it's a very important scene. It's not only a very long take; it's also a *still* long take. The camera is fixed. It doesn't move. After a while, the audience notices that, and then you start feeling the suffocation the characters are going through in that moment. They don't move, either. Whoever moves first would make a statement with their own body.

But the most important thing for me is how McQueen locks you into the scene. As Brandon says, 'You trap me.' He says it when he is trying to lecture his sister about ethics and morals, and how to relate to other people.

Richard Martin: This entrapment and claustrophobia can be seen across McQueen's films, all of which involve different forms

of imprisonment. In *Hunger*, we have the Maze Prison; in *Shame*, we have this conversation about trapped bodies; and in *12 Years a Slave*, we have the plantation.

Ashley Clark: The moments when no-one is in the frame during this scene are interesting. There's a surveillance quality to the shot. When the characters appear in the frame, it becomes more voyeuristic and, therefore, quite uncomfortable to watch. Discomfort is a big part of McQueen's *modus operandi*. He wants to take audiences out of their comfort zone. Similarly, during Brandon's fabulously awkward date with the character played by Nicole Beharie, you might detect a slight camera movement within their long conversation: it draws attention to itself, but in quite a subtle way. McQueen's not a whizz-bang filmmaker.

Clive James Nwonka: I was disappointed when I saw *Shame*. *Hunger* is one of the most radical films to emerge in Britain in the last 30 years, in terms of aesthetics and textures. What I saw in *Shame* was quite rudimentary, in terms of its narrative structure. Thinking formally about this long scene with Brandon and Sissy, there is a certain heightened dramatic tension in sustaining a shot for that length of time and with those fixed bodies. There is also a certain sexual tension being expressed here. Let's bear in mind that both of these characters have their own issues with sexuality and how it's expressed. Even though they're siblings, if you cut the audio and just watch that scene without sound, you would assume these two people are lovers arguing. There's a sadistic quality to how Brandon grabs her face and the close proximity between them suggests something else is going on.

Richard Martin: Sissy is introduced to the audience at the start of the film via a desperate phone call. But she's not identified as Brandon's sister so there's the chance for different assumptions around their relationship to develop from the outset. By the time the audience actually has a chance to become acquainted with Sissy, she's been painted in such a negative light and those incestuous intimations have been established. I wonder if a broader conversation is necessary here. So much of the discussion around McQueen is about masculinity and male bodies. How do we view his treatment of female characters?

Ozlem Koksal: I have my issues with this, too. *Shame* isn't McQueen's greatest film, but I don't think Sissy was portrayed in a negative light. She's different in how she deals with her vulnerability and her problems with intimacy. If anyone is

portrayed in a negative light, it's Brandon. He comes across as a jerk until that epiphany in the rain.

Ashley Clark: Isn't Michael Fassbender's obvious physical beauty quite troublesome as well? If, say, Paul Giamatti had been cast in this role: how we might look at it? There's a similarity here with *Taxi Driver* (1976), a film in which Robert DeNiro is handsome, charismatic and remains very sympathetic for at least an hour. There's a seductiveness to these characters. There's also a conservatism in the treatment of sexuality in *Shame*, especially when it comes to homosexuality. At the end, when Brandon has this operatic descent into Hades – that red and fiery club – he gets a blow job from another guy. That moment is positioned as the epitome of his descent. I found that incredibly problematic and ridiculously conservative.

12 Years a Slave (2013) is the biographical film that tells the story of Solomon Northup, a free Black man who is kidnapped and sold into slavery in Louisiana for 12 years before being released after a chance encounter with a white abolitionist.

Richard Martin: One of my first responses to *12 Years a Slave* was discomfort at the way in which a sequence of very famous faces kept appearing, which seemed at odds with the story the film is telling. It felt like a series of star cameos, with the appearance of Brad Pitt being the worst of all. I also wanted to raise questions around the presentation of Solomon Northup. He's constantly told that he's an exceptional man. During the scene in which the enslaved workers sing 'Roll Jordan Roll', Solomon gradually joins in with the collective chorus. This, for me, dramatizes the film's central struggle between Solomon's exceptionalism and his relationship with other Black people. It's also the scene that immediately precedes Brad Pitt's appearance as a white saviour.

Clive James Nwonka: The academic Geoff King has written about 'quality Hollywood' – a form of production that sits just underneath the six major studios, but above independent films. He's talking about films which are socially concerned in ways that most Hollywood films aren't, but which remain socially conservative and palatable to the American middle class.[1] That's essentially the function of *12 Years a Slave*. Solomon is the exceptional slave. He's a northern, highly educated, highly literate slave. His central argument throughout the film is, 'I shouldn't be here amongst these other slaves. I belong

somewhere else.' That, for me, is highly problematic. But what's also problematic is the way the film is paraded as offering a new epistemology of slavery, as the kind of film that takes us into new historical understandings of slavery. I don't think it's that at all. Its problems are obviously shaped by the assumptions of an American middle-class audience which it serves quite well. We shouldn't situate *12 Years a Slave* as an exemplary film about slavery and American history.

Ashley Clark: This is a tricky one because we're talking about authorship in many ways. We can't forget the role of John Ridley who wrote the screenplay for *12 Years a Slave* and who also wrote a remarkable feature for *Esquire* called 'The Manifesto of Ascendancy for the Modern American Nigger' (2006), which is the touchstone of respectability politics. It's Bill Cosby's 'Pound Cake' speech and Chris Rock's famous piece all rolled into one dreadful package. I found it impossible to divorce the film's narrative of exceptionalism from that piece of respectability politics writing. It's really instructive to parallel *12 Years a Slave* with an earlier adaptation of the story by Gordon Parks from 1984, which is called *Solomon Northup's Odyssey*. It has a radically different interpretation of the Brad Pitt character who doesn't show up with a golden mane and solve everybody's problems in a single scene. In Parks' film, he's a much wilier character and it's much more layered in that respect.

I don't expect *12 Years a Slave* to be full of happiness, joy and light. But what some other films about slavery do, including Charles Burnett's *Nightjohn* (1996), is show a more fulsome portrait of the humanity of slaves. Of course, it's not going to be a song-and-dance fest or a joyous, happy celebration. No one's saying *12 Years a Slave* needs to be uplifting, but it's so focused on brutality and the suffering of bodies. These are, of course, endemic parts of that experience, but I don't think you get enough sense of the characters' humanity in the film.

Clive James Nwonka: I'm still conflicted by how we are to situate Steve McQueen. This is someone who's come from an art school background, but who wasn't actually embedded in the Young British Artist scene, and who has surpassed people such as Sam Taylor-Johnson, for instance. I think the structures he's working in now are quite concerning. I would like to see him rely on those artistic beginnings and aesthetics. I think that's what makes him distinctive and unique as a filmmaker. However, I'm not convinced that Hollywood operators would permit that.

Richard Martin: Does his most recent film, *Widows* (2018), reinforce that perspective or make it easier to situate him?

Clive James Nwonka: As we have seen in *Widows*, it's very much a Hollywood genre film. Of course, McQueen displays some wonderfully imaginative aesthetics at certain points, notably the continuous, unbroken shot where the camera is mounted at an angle on the car bonnet as the mayoral candidate Jack Mulligan (Colin Farrell) is driven through the African American populated South Side of Chicago. The scene is so heavily layered and the juxtaposition of the poverty-stricken Chicago neighbourhood he drives through with the sharp contrasting affluence and whiteness of the Chicago area he retreats to is so effective precisely because of the cinematic devices he used. The way that Jack is framed denigrating the very area of the city he is campaigning in as the external view gradually opens the audience to that geographical, social, and racial contrast just minutes away, speaks so much to the political commentary in McQueen's film work and how non-mainstream aesthetics, even in mainstream films, are a crucial part of how that commentary is telegraphed. So, I see *Widows* as an example of the cohabitation, or even compromising, of two differing filmmaking approaches. Yes, the racial and gender politics in *Widows* are very obvious, but I think the politics of identity will always feature in his work in some way and inform when, to what extent, he can revert to some of those art cinema sensibilities. It will be interesting to see the kind of visual and narrational devices he employs for the forthcoming BBC series *Small Axe* (a period drama set in London's West Indian community between the 1960–1980s) and if television drama, as it continues to become more cinematic itself, can become a more permissible space for McQueen's art film aesthetics.

Note

1. Geoff King, *Quality Hollywood: Markers of Distinction in Contemporary Studio Film* (London: I.B. Tauris, 2015).

6 Circumventing the Spectacle of Black Trauma in Practice

Rabz Lansiquot

For many Black people and cultural practitioners in the US, UK and beyond, this decade has been defined by an increase in reported instances of state-sanctioned violence against us, exaggerated by an over-saturation of images documenting that violence disseminated through news outlets, blockbuster and experimental films, and, most significantly, social media. The autoplay features on Twitter, Instagram, and Facebook have meant that images of Black death or pain at the hands of police or other state institutions, or civilians who believe they are acting on behalf of state interests, are difficult to avoid. As we scroll through our feeds for updates on our friends, family, and the world, we are consistently confronted with visual representations of our own proximity to death. While this proximity is something the majority of us are aware of, whether consciously or unconsciously, the repeated witnessing of this level of violence in the visual realm contains its own form of violence, one that echoes far beyond the initial violation. These images are often created with the intention to hold the perpetrators to account, to increase the likelihood of justice; recorded by bystanders, victims, or by state or private surveillance. In recent years I have been concerned with the paradox of these images; their perceived intention, specifically as employed by filmmakers and artists as calls to action or expressions of solidarity; in relation to their psychic, corporeal, and socio-political effects.

This body of work around violence in the visual field – its utility and impact – is one strand of thinking that stems from my ongoing critique of Black film's over-reliance on representation as a goal of practice. I think not of what films – that concern the lifeworlds of Black peoples – do in terms of *representation*, but instead in terms of *liberation*. Here are some of the questions I foreground when I view, make, and programme moving images; the questions act as an open manifesto of sorts. They are questions that I first presented publicly at *sorryyoufeeluncomfortable* Collective's shorts programme at the *Black Film British Cinema* conference in 2017 and so it felt appropriate to articulate the work that has stemmed from that conversation in the last two years. What does a Black moving image practice look like if it foregrounds the rigorous work needed for Black liberation? If it is actively attentive to the 'doing work'? How do these questions expand the possibilities of Black filmmaking? How do they expand the capacity of Black film to act as a tool for resistance? How does this alter how we view Black moving image, and moving image in general? How does this change what we're looking for? Instead of asking 'do I see myself here' or 'how will they see me as a result', what happens when we ask 'what does this mean for my freedom'?

Here, in an attempt to document this ongoing process of research, making, writing, programming, and curating, I bring together my own work as a filmmaker, exploring my 30-minute visual essay *where did we land*, with the most recent work of Bristol-born artist-filmmaker Kat Anderson, presented in her 2019 exhibition *Restraint, Restrained* at Brixton's Block 336 (see Figures 6.1 through to 6.4).

where did we land (2019) is a visual essay which exhibited at LUX Moving Image's BL CK BX. The film is illustrated by a collection of 900 images that relate to histories of people of African descent in various geographic locations, made from 400 photographs, papers, maps, drawings, and etchings. They include images of protests, martyrs, instruments of oppression, enslavement, resource extraction, environmental disaster, willful state neglect, colonisation, war, heroes, villains, icons, labour, celebration, and mourning. Important events, from Europe, Africa, The Americas, and the Middle East. Many are iconic images, widely distributed, easily recognisable to anyone paying even a little attention. Some are from the past and some are contemporary, all Black and white. They've been enlarged and then tightly cropped in an attempt to obscure the full image (which, in itself, is already only a frame of a larger happening): feet, arms, hands, sections of clothing, a smile, an eye, a face in a crowd, part of a sign.

Circumventing the Spectacle of Black Trauma in Practice **Rabz Lansiquot**

Figure 6.1 'Charlottesville Car Attack 2', still from where did we land (2019), courtesy of Rabz Lansiquot

Figure 6.2 'Justice for Ricky Bishop 2', still from *where did we land* (2019), courtesy of Rabz Lansiquot

The images are accompanied by a score, an abstracted and altered version of Drum & Bass pioneer LTJ Bukem's 2000 track *Atlantis (I Need You)*, and a voiceover reading of an essay which I have adapted for this publication.

The film was partly inspired by hearing Tina Campt recall her notion of still-moving-images: 'images that hover between still and moving images; animated still images, slowed or stilled images in

Figure 6.3 'Jordan Edwards 3', still from *where did we land* (2019),
courtesy of Rabz Lansiquot

Figure 6.4 'Edson Da Costa & Son 1', still from *where did we land* (2019), courtesy of
Rabz Lansiquot

motion or visual renderings that blur the distinctions between these
multiple genres; images that require the labour of feeling with or
through them' (Campt, 2018a). In her book *Listening to Images*, Campt
asks 'how do we build a radical visual archive of the African Diaspora
that grapples with the recalcitrant and the disaffected, the unruly and

the dispossessed? Through what modalities of perception, encounter, and engagement do we constitute it?' (Campt, 2017: 2).

This work was not conceived to be didactic. Perhaps the images here highlight the, intentionally, fragmented nature of the archive of Black history and the history of anti-blackness. We don't have the full picture, but we live in the crevices, build from the cracks, the fissures, they become us. Perhaps the images resist the manipulation often done to images of Black people in order to justify violence done to us. The widely distributed image of a stone-faced Mark Duggan being just one example. The media, the police, or whoever else decided to vilify him, cut away the section of the image which shows him holding a stone heart engraved for his daughter, whose grave he was visiting at the time the image was taken, intentionally undermining the legitimacy of the unrest which led to the 2011 London riots.

My hope is that the abstraction of these images in the film becomes a nod towards, or a gesture to, as opposed to a *re*-presentation of the need for Black liberation. The goal is obscurity, as opposed to opacity. The production of a coded language, a conversation of layers to be peeled away if you've lived the life or done the work. A tool to talk about what has and is being done to us, about our rage, about our trauma, perhaps without having to relive it. How do we deal with the realities of anti-Black violence through the audiovisual, without pandering to the desire for spectacle? How do we reckon with the violence done to us outside of the white gaze, which seems to relish in our recollections of it? How do we resist the observation of our mourning and our organising? 'What is it about witnessing death that is so alluring to so many' and how do we render the 'visual appetite for violence' null and void (Elmi, 2016)? How do we honour those lost, the ancestors and the ghosts, always remembering how and why we lost them, without being repeatedly tormented? These were the questions I foregrounded.

where did we land isn't so much a film, a bounded work of art in itself, as an attempt to grapple with the implications of film for Black people and our liberation, an experiment that might well have failed, a question, or series of questions, not an answer. I structured the film in four chapters which I will follow here.

1. Representation (Will Not Get Us Free)

Conversations around Blackness and film most often consider, or I believe overestimate, the capacity of representations of Black people, to contribute to changes in the lived world. This is predicated on two

assumptions. First, that if others see us represented humanely, with a range of experiences and emotions, they will begin to treat us as such, and second, that if we can see ourselves represented as such, that we will begin to believe in our own humanity enough to live/be/feel that change. Frank B. Wilderson III articulates a similar point, that Black film theory has circulated around these questions: 'What does cinema teach Blacks about Blacks? What does cinema teach Whites (and others) about Blacks? Are those lessons dialogic with Black liberation or with our further, and rapidly repetitive demise?' (Wilderson, 2010: 80–81). This preoccupation with responding, and reacting to, negative or untrue visual representation has been a central tenet in the production of Black filmic works as well as in theory and critique and, I believe, has become a distraction from the development of a Black filmic world with the capacity for liberatory potential. Valerie Smith explains that while representation does have some effect on the lives of marginalised peoples, 'the relationships between media representations and "real life" is nothing if not complex and discontinuous; to posit a one-to-one correspondence between the inescapability of certain images and the uneven distribution of recourse within culture is to deny the elaborate ways in which power is maintained and deployed' (Smith, 1997: 3).

2. Who Are the 'We'?

Even if unarticulated, the vast majority of Black people know this. So, who are we trying to prove it to? The notion of trying to 'tell the truth', to 'prove' that anti-blackness exists, or to attempt to reverse or rectify the effects of collective gaslighting, is predicated on the assumption of a white audience in the first instance. And in the second, it assumes that they don't already have all of the information needed to come to the conclusion that something must be done about it. Yes, cultivating accomplices has some use. But the majority of the images and videos played and replayed are widely distributed, instantly recognisable, so don't end up being particularly illuminating.

Susan Sontag writes in her book *Regarding The Pain of Others*,

No 'we' should be taken for granted when the subject is looking at other people's pain. WHO ARE THE 'WE' at whom such shock-pictures are aimed? That 'we' would include not just the sympathizers of a smallish nation or a stateless people fighting for its life, but – a far larger constituency – those only nominally concerned about some nasty war taking place in

Circumventing the Spectacle of Black Trauma in Practice **Rabz Lansiquot**

another country. The photographs are a means of making 'real' (or 'more real') matters that the privileged and the merely safe might prefer to ignore.

(Sontag, 2003: 8)

Sontag is discussing images of war and its aligned atrocities in this book, engaging only very lightly with some images of anti-Black violence that, for some, escape the slippery definition of war, or of atrocity. While her work is rigorous and seminal, it would be necessarily, fundamentally different if it actively acknowledged the ways that Blackness and whiteness, the proximity to one or the other, contribute to the power relations inherent to looking, and being looked at.

So, who are the we? I mean Black people, specifically. An us and them distinction is necessary a lot of the time. James Baldwin's anecdote about spectatorship in his contribution to film theory *The Devil Finds Work* indicates why this is the case when we consider the audiovisual. He writes about a key scene in the 1958 film *The Defiant Ones* which illustrates the complexities of subjective, racialised affect when confronted with the moving image. In the scene, a Black man and a white man, played by Sidney Poitier and Tony Curtis respectively, are on the run attempting to escape the chain gang. Poitier's character Noah manages to jump onboard a passing freight train and is unable to pull John, played by Curtis, onboard. He then proceeds to jump off the moving train, which would have likely gotten him to relative safety, to save John, and in doing so puts himself in grave danger. Baldwin states that while 'liberal white audiences applauded' Noah's sacrifice in Manhattan, the Black audience in Harlem 'was outraged and yelled, Get back on the train you fool!' (Baldwin, 1976). *The Devil Finds Work* asserts the necessity, for the film scholar, of a consideration of the 'the embodied, socially grounded individual' watching a film, what Baldwin refers to as a 'flesh-and-blood person' (Friedman, 2010: 396; Baldwin, 1976). For Black viewers of films, our personal and communal lived experience of anti-Blackness informs this embodied spectatorship, which, when faced with explicit images of anti-Black violence, can produce a number of adverse affective states in response to, and fusing with, already established trauma. As a result of the lack of embodiment and flesh-and-blood identification, the majority of white spectators are able to distance themselves both from the Other, the hurting/dying/dead Black, and, by way of what Frantz Fanon terms 'cognitive dissonance', from the violent individuals, and in turn the violent institutions, *their* violent institutions (Fanon, 1952).

To return to the question, does the dissemination of images of atrocities committed on us, to us, do the work so often expected of it? Does it move those who benefit from anti-blackness, even if only in the sense that they can live knowing that at least they are not Black, to put an end to a world built on it? Will the mass awakening finally take hold? Sontag answered those pretty definitively:

> To designate a hell is not, of course, to tell us anything about how to extract people from that hell, how to moderate hell's flames. Still, it seems a good in itself to acknowledge, to have enlarged, one's sense of how much suffering caused by human wickedness there is in the world we share with others. Someone who is perennially surprised that depravity exists, who continues to feel disillusioned (even incredulous) when confronted with evidence of what humans are capable of inflicting in the way of gruesome, hands-on cruelties upon other humans, has not reached moral or psychological adulthood. No one after a certain age has the right to this kind of innocence, of superficiality, to this degree of ignorance, or amnesia.
>
> (Sontag, 2003: 89)

3. Presented to View

Guy Debord writes in his work *Society of the Spectacle* that 'the spectacle represents the dominant model of life (1967 [1983]). It is the omnipresent affirmation of the choices that have *already been made* in the sphere of production and in the consumption implied by that production. In both form and content the spectacle serves as a total justification of the conditions and goals of the existing system' (ibid. 11). The system he's referring to is capitalism, of course, divorced from its racist roots. So what of blackness then?

The spectacle of Black death and pain has been for many hundreds of years, itself, an instrument of oppression. Jennifer Nash states that 'the black body captured in the visual field is always called upon to "do something", to produce a set of affective, cultural, and political "results", to do something to alter a history and system of racial inequality that is in part constituted through visual discourse' (2014: 35). She refers here to the expectation of Black bodies to always produce labour, even inadvertently, a material and philosophical dynamic which has existed since we were first identified and utilised as the workforce, as commodities, raw material, pure capital.

Circumventing the Spectacle of Black Trauma in Practice **Rabz Lansiquot**

One of Saidiya Hartman's key questions in her seminal text *Scenes of Subjection* concerns what 'the exposure of the violated body yield[s]' and whether 'the pain of the Other merely provide[s] us with the opportunity for self reflection' (1997: 3–4). Hartman asserts that 'only more obscene than the brutality, unleashed at the whipping post, is the demand that this suffering be materialised and evidenced by the display of the tortured body or endless recitations of the ghastly and terrible' (ibid.). She states that the 'consequences of this routine display of the [blacks] ravaged body' are rarely liberatory and that the 'casualness with which' scenes of brutality against the Black body are circulated don't 'incit[e] indignation' instead they 'immure us to pain by virtue of their familiarity … and especially because they reinforce the spectacular character of black suffering' (ibid.).

Tina Campt summarises an ongoing conversation that I, and I'm sure many of us most affected by these displays, have been having in the past few years:

> The 'right to look away' is a perplexing assertion I find myself confronting more and more in our current moment of intense violence against black, trans, queer and gender-non-conforming individuals, and people of color more broadly. It's a perplexing assertion often invoked indirectly or surreptitiously as a right to personal autonomy … as the autonomy to avoid or be exempted from the affective labor of witnessing, and exposing oneself to the harm inherent to witnessing harm done to others, and to black and brown bodies in particular. It is an assertion that seems to be proliferating more recently due to our increasing capacity to visually archive and disseminate such acts of violence and harm through the pervasiveness of our personal technologies of capture, particularly the preferred contemporary modality of capture: cell phones.
>
> (Campt, 2018b)

4. Justice

We know from the many cases of violence against Black people that have been recorded, whether by CCTV or by bystanders, and then reproduced on social media, in Hollywood films and artists films, and in courtrooms, that the broadcast of this violence in no way guarantees justice. In fact, I don't know if it ever has. There is a reason that the implementation of body cams among police forces and the fact that

most people have a camera in their pocket have not resulted in an end to police brutality. Despite the wide distribution of the damning and harrowing footage and the widespread outrage that results from a select few, the vast majority of the police officers involved in such killings are never charged, or are acquitted of all charges, the institutional systems that allow these deaths continue to persist and continue to be celebrated as essential parts of a so-called civilised society. We know intimately that the reason for these supposed failures of justice systems across the Western world is because these are simply examples of the system working just as it is supposed to. Just as it was built to. Just as intended.

5. Restraint Restrained

I want to highlight Kat Anderson's *John*, a pioneering piece of experimental Black British film, and the exhibition *Restraint, Restrained* more generally, in this chapter as an example of the ways that other Black British artists are responding to this issue of spectacular anti-Black violence. Her work is an example of what a liberatory Black film praxis looks like, a body of works, that are made to address the terror and reality of anti-Black violence, but with an attentiveness to the implications of its audience's engagement with it, to their wellbeing and to the wider sphere of work done in the past and being done in the present to combat it.

When I entered the gallery space at Block 336, as a 'flesh-and-blood-person' a Black, queer, person with first-, and second-, hand experience of mental illness, I was struck first by the darkness (Baldwin, 1976). The black walls and low light counteracts the thrown-ness[1] Black people often feel when entering an arts space. It feels oddly warm, inviting. The first piece you encounter is the sound piece … *Hold 2, 3, 4 …* which instructs you to breathe cyclically, the pace slowing as time passes. The work feels like a mindfulness tactic, one that you encounter both on your way into and out of the experience of the film *John*. A way to both prepare you for the complex and difficult experience you are about to have, and to release the stress and anxiety likely created from it afterwards. It brings you into your body to receive, and then back into it to be able to process. … *Hold, 2, 3, 4 …* references both the military technique of tactical breathing, in contrast to Martiniquaise anti-colonial thinker and activist Frantz Fanon's notion of combat breathing, which aims to mobilise your life energies 'in order to continue to live, to breathe and to survive the exercise of state violence' (Perera and Pugliese, 2011). It feels like an

act of care to the Black viewers entering the space, and these references feel like an intimate gesture towards the need to fight.

I then walked through into the centrepiece of the exhibition, the imposing two-channel film *John*. The film follows John, a dark-skinned Black male patient of a psychiatric hospital. The oscillating soundtrack acts as a sonic representation of both mental illness, a dull hum, bass which vibrates the room as you watch it, so constant that sometimes it seems to disappear and other times it is debilitating, and white supremacy, high frequency ringing, tapping, and buzzing in your ears.

The film begins with a black screen, a group chants 'come the light, come the hope', a refrain from the poem 'Revolution' by H.S. and C.B. (two Black sisters), one of the many text references Anderson employs throughout the show from her research at the Black Cultural Archives in Brixton. The voices call John's name and he wakes on an in breath, as if from a nightmare. He struggles to wake comfortably, stirring, thrashing, stretching. The only adornments in his light grey room, which his clothing almost blends into, are a mirror and a red mark on the wall. Blood? He approaches the mirror, pulls at his face, rubs his eyes. Waking up Black in racial capitalism feels like this. Heavy. Dull. As John slowly emerges from his room through a neon-lit corridor, the fact of his institutionalisation becomes clear. A concrete room with blue walls is populated with patients and white medical staff, who appear to engage calmly and sympathetically with the only white patient before they all turn to glare at John as he enters.

He wakes again, same weight. The red smudge on his wall is now bigger and appears to be the head of a horse. As he leaves his room again, faster this time, he witnesses the three white staff members restraining an older Black man. Arms around his neck, his hands pulled behind his back as he struggles to the ground. John is scared, tearful, and runs away as we witness the man fighting for his life. This is not a fantasy. Anderson's work references the formal modes and aesthetics of the horror genre, and this work specifically references the sorts of 'clean' dystopias created in popular science fiction films. As a fan of sci-fi, I'm constantly fascinated by the ways that the worlds and stories, most often told through white protagonists in worlds without any significant Black presence, parallel Black experience in the lived world and *John* is a film clearly made by someone who shares these concerns. This scene refers explicitly to, and draws from, real cases of mentally ill Black people who have died in these institutions, which are set up supposedly for their protection and wellbeing. Sean Rigg

and Olaseni Lewis, whose relatives appear in the film, are just two in a long list of UK cases that include both men and women.

John hides in a dark cylindrical space and follows a flickering light at the other end which leads him to an orange room, filled with a group of Black people who chant, over and over again, 'come the light, come the hope'. The warm oranges and browns of their clothing and the sun-like wall adornment are a stark contrast to the blues and greys of all of the other spaces we've seen John in. The group are played by Black revolutionaries, healers of varying types including Marcia Rigg (activist and sister of Sean Rigg, a Black British musician who suffered from paranoid schizophrenia and died in police custody in August of 2008), Hakim Taylor (teacher, mindfulness practitioner, and child emotion coach), Barby Asante (artist, curator, and creative activist), Melz Owusu (non-binary academic, activist, and poet), Aji Lewis (activist and mother of Olaseni Lewis, who died in 2010 after being restrained by 11 police officers in Bethel Royal Hospital in 2010), Melba Wilson (writer and mental health services advocate and manager), and Leslie Thomas QC (a barrister who specialises in civil liberties, human rights, police and inquest law, and who represents the victims of the Grenfell Tower fire). These revolutionaries nurture John, hold him, hear him, and he is able to return to the ward and resist. Fist in the air, John stands in defiance, still visibly fearful, until one of the staff members tackles him to the floor.

John's protest is, unsurprisingly, met with violence. The ensuing struggle is obscured by darkness, illuminated only by flashing lights red and blue, spilling out beyond the screen to illuminate the room itself. But the struggle we see is not of John, restrained, being killed, yet. It is of John, fist still raised, and of the staff members who are writhing in pain, brought to the ground by fear, despair, and torment. The bass intensifies and Anderson's voice emerges, reciting a complex and nuanced text with Fanonian inflection: 'that moment when, you realise that you yourself are dying, and have been for centuries. But up until now, you have thought that you were somehow, utterly alive' This segment continued to ring in my ears: 'they let you go on thinking that you were alone. Thinking that somehow in your superiority, and moral making, that you were the rights and they were the wrongs of the earth. That you could find a way to finally rid them, the ones of no worth.' I realised quickly that this text was not about me, or John, but was about them, those white people wrapped up in institutional racism to the point of violence. I read this in two ways. First, the effect of violence, its burden, is not just held by those it is enacted on but also on those who enact it. It and the culture, or more specifically

hegemony, of justification around it, reverberates in their psyches, warps reality, produces and reproduces itself. Second, that this act of defiance, this resistance and strength, causes a psychological fissure in the minds of white subjects. It challenges all that they think is right, and just, and all that has told them, throughout their lives and beyond them, of their superiority and of their claim to privilege. The inclusion of this performance of fright by the white actors, who we see screaming, crawling, unconscious, dying, turns the gaze onto whiteness, points the finger, illuminates. It also resists the expectation of the evidencing of acts of violence against Black people, the spectacle of Black death and pain discussed earlier in this chapter. It addresses the double standard in the media, of withholding such imagery of the deaths of white victims of violence, and gratuitously displaying that of Black ones.

This explosion ends with everyone on the floor, seemingly unconscious, and the Black man who appeared to die earlier in the film, coming to, approaching John and with sadness and intimacy placing his hand over his head. He says a prayer, kisses John's head, and suddenly, John's unconscious body transforms into that of a blonde white man. The other man stands to his feet with strength, as if he has accomplished what he set out to do, and as he stands he is lit in orange light, wearing orange clothes, mirroring those of the revolutionaries. He has changed John's lifeless body into that of a person who may demand some collective sorrow, or even receive some justice for his death. Possibly, in death, he may now be afforded some dignity, some humanity.

John blends reality and fantasy seamlessly, as if to say there is no such thing. This may reflect the fractures in reality caused by some mental illnesses but it may also reflect Black living in the world. 'Come the light, come the hope', again. Through to Gallery 2, where a second video piece *Roundtable Conversation* is presented. This piece presents a conversation between the real-life revolutionaries that play this same role in *John*. The work begins with a question: 'Can we map the impact of technologies of race, gender, law, colonialism, empire, capital, and governmentality on Black minds and bodies?' They reflect on the themes of the film and the exhibition at large, they talk through the psychic effect of policies such as the hostile environment and institutional racism in general, their own mental health challenges, the cases of their loved ones who were stolen from them as a result of institutional racism in psychiatric institutions, their strategies for survival and for resistance, and on violence. This piece gives voice to those doing the work. Those fighting back, those trying to heal and

encourage others to heal. It makes real the fantasy, elucidates the terror, reminds us that sci-fi is not just fiction. This kind of violence and negligence is, quite literally, a killer, and it was imperative that *Roundtable Conversation* be included in the exhibition, to remind us of that, from the lips of those who deal with it everyday.

Throughout the exhibition, in both the main space alongside *John*, and in Gallery 2, alongside *Roundtable Conversations*, are six large text prints. The words are beautifully embossed in black on black paper, spread wide across the page, illuminated slightly by the dim lights. They are of texts and poems selected by Anderson while researching in the Black Cultural Archives and draw from Black liberation papers and journals like *Race Today* and *Black Voice*. Peppered throughout the gallery they remind us of the rootedness of this history of struggle and resistance. Black testimonies from H.S. and C.B., Eric Roach, Amadeu Samuel, Carlos Omar, Emanuel Corgo, and Brixton Defence Campaign Bulletin No.4 of revolution, of death and pain. These are not names that bounce around in general consciousness and so, to me, they feel like another starting point. More research to be done, more legacies to uncover.

Kat Anderson's exhibition resists the trope of presenting anti-Black violence in the gallery space, by approaching the issue holistically, with liberatory curatorial intent. The four works address the violence itself, the psychological affect and effect of that violence (both for the Black and the white perpetrator) in *John*, people who in their communities are doing the work of resisting and healing from that violence, including their strategies both in *John* and *Roundtable Conversation*, as well as in the words we can catch a glimpse of on the walls, and last, offering a space to enact one such simple strategy through the cyclical breathing in the sound piece ... *Hold, 2, 3, 4 ...* The painful and difficult labour required to reckon with the horrors that the character of John encounters is supported by the other pieces that surround the film. That work is situated alongside a lineage of ongoing, fierce, and powerful collective resistance to the conditions he, and we, face. It is painful and scary, it hurts as I wrestle with it, but it is not without context and research, not without hope, not without history and community, and most significantly, it is abundant with care.

My intent with this chapter was, on the one hand, to explore this particular debate around violence and the spectacular, and, on the other, to highlight the work being done by a younger generation of makers who, due to a vastly different climate of production, among other reasons, are often left out of the national and international

conversation around Black British film. The politics of displaying racialised violence against Black people in film is not a new concern, however, it is one that has been exacerbated by the democratisation of technologies of capture and modes of imagery distribution and communication. Such technologies have laid foundations for a heightened sense of urgency created by the most contemporary iteration of racial capitalism in Britain and beyond.

I'm doubtful that I succeeded in circumventing the spectacle with *where did we land*. I provided many more questions than answers. And I don't know if I'll ever have the answers – that was never my intention. It is also entirely possible that the violent happenings in Kat Anderson's *John* are still triggering to Black viewers despite the consideration and care gone into the exhibition as a whole. I'm specifically interested, though, in how we build on legacies, how we continue to push our practices forward politically and aesthetically as a community of artists and activists. A liberatory Black film practice, like Black liberation itself, will certainly not emerge overnight. So, for now, I hope that as makers, curators, programmers, critics, and audiences, we can be attentive to, and contribute to, the steady ascent of both.

Bibliography

Baldwin, J. (1976) *The Devil Finds Work*. New York: Dial Press.

Campt, T. (2017) *Listening to Images*. Durham: Duke University Press.

Campt, T. (2018a) '2. Still Moving Images' in *Black Visual Frequency* series, Still Searching, Fotomuseum. Accessed from: www.fotomuseum.ch/en/explore/still-searching/articles/154951_still_moving_images (accessed 14 September 2019).

Campt, T. (2018b) '5. Black Visuality' in *Black Visual Frequency* series, Still Searching, Fotomuseum. Accessed from: www.fotomuseum.ch/en/explore/still-searching/articles/155177_black_visuality (accessed 14 September 2019).

Debord, G. (1967 [1983]) *Society of the Spectacle*. London: Rebel Press.

Elmi, R. (2016) 'Body Cam: How to Reckon with Images of Violence as an Activist Who Wants to Log Off' in *Real Life Mag*. Available at: https://reallifemag.com/body-cam/ (accessed 2 September 2019).

Fanon, F. (1952) *Black Skin, White Masks*. France: Éditions du Seuil.

Friedman, R.J. (2010) ' "Enough Force to Shatter the Tale to Fragments": Ethics and Textual Analysis in James Baldwin's Film Theory' in *ELH*, 77(2), Johns Hopkins University Press.

Hartman, S. (1997) *Scenes of Subjection*. Oxford: Oxford University Press.

Nash, J. (2014) *The Black Body in Ecstasy*. Durham: Duke University Press.

Perera, S. and Pugliese, J. (2011) 'Introduction: Combat Breathing: State Violence and the Body in Question'. *Somatechnics* 9.2–3, 1–14.

Smith, Valerie. ed. (1997) *Representing Blackness: Issues in Film and Video*. New Brunswick: Rutgers University Press.

Sontag, S. (2003) *Regarding the Pain of Others*. New York: Farrar, Straus and Giroux.

Wilderson III, F.B. (2010) *Red, White & Black: Cinema and the Structure of US Antagonisms*. Durham: Duke University Press.

Note

1. Referencing Zora Neale Hurston's famous quote 'I feel most coloured when I am thrown against a sharp, white background' in her essay *How it Feels to be Colored Me* (New York: The World Tomorrow, 1928).

Part III
Curatorship, Exhibition, and Arts Practice

7 An Invitation to Enchantment: How Exhibition and Curation Connect Black Film and British Cinema

So Mayer

Speaking at the *Black Film British Cinema* conference at the Institute of Contemporary Arts in 1988, film curator June Givanni noted that Black British filmmakers did not share a single map of circulation, as 'different practitioners seek different types of exhibition for their work' (1988: 40). The further story of the exhibition of Black British film remains to be told, and is both central and crucial for the reasons that Givanni had already identified in her 1988 paper. While the differential types of exhibition were sought out by practitioners, they were also necessitated by the scarcity of opportunities for Black British filmmakers within either the mainstream or established experimental circuits. The history – and present – of Black British cinema is one, I argue, where the activism of curators and programmers operates as the comma between Black Film and British Cinema, in the sense of opening out the multiple, dynamic, situated, and shifting relations between the terms as a mediated process.

While exhibition and circulation remain, in general, under-theorised within film studies, that is of signal importance for marginalised film practices that likewise remain under-theorised and under-historicised. In particular, understanding the 'lines out' – in Ella Shohat and Robert Stam's term – represented by Black British cinema requires unthinking Eurocentrism not only in terms of recentring representation, but reconsidering authorship and canonisation to extend to curators and programmers, as well as rethinking the productive frictions between community cinemas and national boundaries. Writing as part of the Manifesto! Eleven Calls to Action portfolio in *Film Quarterly* Spring 2019, Raquel J. Gates and Michael Boyce Gillespie recognise the importance of such attention for, as they title their piece 'Reclaiming Black Film and Media Studies'. Although they are writing within a North American context, their argument pertains, as well to the British situation. They argue that, as film scholars: 'We must go to film festivals. We must follow film programmers. Black film thrives in arenas other than the standard cineplex. What might it mean to give as much attention to this context as to the industrial/commercial buzz?' (2019: 14). Citing specific Black programmers and their relationships with institutions, both festivals and specific venues, Gates and Gillespie argue that such situated programming offers 'generative and collaborative opportunities to expansively appreciate cinema' (ibid.). Rather than agitating for the recognition of curators and programmers as auteurs, in the manner of white gatekeepers such as Hans-Ulrich Obrist and colleagues, Gates and Gillespie suggest that Black film programming and curation creates opportunities for community ownership and definition. Studying these practices as both emergent and embedded could generate evidence not only for established and informed audiences, but demonstrate how intersecting networks of creators, exhibitors, critics, and viewers both respond to and generate socio-political formations.

Despite five decades of visible Black film curation and programming in Britain, infrequently but sometimes allied to or supported by institutions and the industry, and equally despite the prolific efforts of programmers and archivists such as Givanni, there is little to no coherent history available that indicates and indexes the circulation of Black film in the UK Multiple lacunae thus remain in both the histories and historiographies grouped under the diptych 'Black Film British Cinema', including the ways in which audiences have understood the terms and their relation due to the multiple,

overlapping maps of circulation and the lack of channels available for the transmission of personal and collective histories. This chapter is therefore a first, brief attempt – or rather, an attempt to collate and provide access to previous attempts, hence the long quotations – to address an urgent necessity to develop a methodology for archiving, researching, and analysing curational practices because of their central role in the circulation and reception of Black British cinema, and because of the place of the exhibition archive within that cinema.

I'm British but ...: Archiving Black Film In/And/As/Beyond British Cinema

In his 2007 book *Archives and Justice: A South African Perspective*, Verne Harris argues for a requisite postcolonial re-situation of Jacques Derrida's 'archive fever', replacing a Eurocentric 'hauntology' with a recognition that, for decolonising communities, archives can be 'an invitation to enchantment, to the play of ecstasy and pain, as we exercise that immemorial passion for the impossible' (2007: 69). Certainly, Black British cinema itself appears to tends towards the impossible – if mainstream accounts are to be believed. It is only independent archives, formal and informal, that allow us to contest that erasure; we need to heed the invitation to be enchanted by the riches they contain that would allow for a fuller understanding of Black British cinema, one that contests erasures that insistently inscribe histories of 'lost'-ness and 'first'-ness within minoritarian cultural production. An archival history of Black British film curation would present the central enchantments of historical continuity and community of practice.

Givanni's work, collected and made available in her Pan African Cinema Archive, is the keystone of this history, and is also of course key to continuing circulation. Collecting festival and season programmes, film and event posters, and event and interview recordings, the archive shows the sources of Givanni's Black Film and Video Catalogue, and hints at the routes by which the films that she lists would travel. As its name suggests, the Pan African Cinema Archive is testimony to the imbrication, *ab initio*, of Black British, African, and African diasporic cinemas globally, for local British audiences; and to the transnational flows of influences stretching from early Third Cinema to current multinational productions. An understanding of the ways in which Pan African and Africanist political and cultural movements initially informed the development of filmmaking and video workshops, as

well as the consciousness of viewers, is contained in the material ephemera of the archive, to be read, perhaps, alongside the three-volume history of FESPACO forthcoming from the US journal *Black Camera* in 2021 (2019).

The archive and its title attest simultaneously to the mobility of Black British films and filmmakers to local and global audiences. Mapping these complex interconnecting and intersecting routes and roots goes beyond the scope of this chapter, but it is what yokes Black Film and British Cinema in all their relations. As Givanni notes in her recent article on the films' travels in the UK, 'A Curator's Conundrum: Programming "Black Film" in 1980s–1990s Britain':

> The vision was expansive … There was a vision that an alternative economy for independent film and video could be viable, free of the requirements of commercial mass consumption, and embrace art and innovation born of integrity, honest experiences, and untold stories. This, in short, was the agenda that was prevalent in the United Kingdom and the environment into which the black film workshops and the independent production companies sought to carve out their role and make their mark.
>
> (2004: 61)

Indeed, the vision was expansive – and our vision of film history needs to expand to meet it.

The 1992 edition of Givanni's catalogue lists 204 Black British films, stretching back to Lloyd Reckord's 16 mm black and white short film 'Ten Bob in Winter' from 1963, produced by the British Film Institute (henceforth BFI). Many of the titles on Givanni's list were produced by organisations rarely thought of as production companies within the film industry, because they lack routes to mainstream distribution: video workshops, university departments, collectives, campaigning organisations, and/or local councils. Some were made by independent production companies, such as Bandung, Azad, and Face Films in particular, which had a specific focus on facilitating films made by filmmakers of colour. Some were produced by the filmmakers themselves. A few were produced for Channel 4; one, Gurinder Chadha's *I'm British but …* (1990) by BFI Productions; and one, Hanif Kureishi's *London Kills Me* (1991), by independent British production company Working Title; notably, both films by British Asian filmmakers.

The catalogue's selections highlight both the changing utility and faultlines in the conception of political Blackness from the 1970s to the 1990s, and its lasting legacy in the dominant conceptualisation of British culture. This trace of an exhibition history attests that the term 'Black Film', in relation to 'British Cinema', not only imbricates global Black African and African diasporic films and audiences, but also British postcolonial and decolonial alliances under the heading of political Blackness; or, more recently, the category BAME. Taken as a curational term, Black Film does not operate as definitional either of racial, ethnic, geographical, and/or political boundaries. Rather, the catalogue demonstrates what Stuart Hall observes in his essay 'New Ethnicities', that 'Black' – as in 'Black Film' – 'came to provide the organizing category of a new politics of resistance, among groups and communities with, in fact, very different histories, traditions, and ethnic identities ... [which] became "hegemonic" over other ethnic/racial identities' (1988: 27). Likewise, the term does not operate descriptively as a value judgement, generic marker, or indicator of mode, but could be said to partake of Hall's argument for 'the end of the essential black subject [and] ... the recognition of the extraordinary diversity of subject positions, social experiences and cultural identities which compose the category "black"', which creates 'a continuously contingent, unguaranteed political argument and debate: a critical politics, a politics of criticism' (ibid.: 28). The catalogue's multifariousness – which could be argued to trust its audience of professional and amateur programmers to judge the context-specific utility of different titles – is crucial to its practice and values: a curatorial politics, a politics of curation. As such, a politicised historiography of circulation and spectatorship of all the films listed would create a fuller context in which to read Hall's closing observation of Black British film of the 1980s and its subsequent unfolding, that 'in spite of these rich [diasporic] cultural "roots", the new cultural politics is operating on new and quite distinct ground – specifically, contestation over what it means to be "British"' (ibid.: 30).

Wheel and Come Again: (No) Histories of Circulation

That politics, however, depends on granularity; on access to the specificities of the contingent arguments and debates facilitated by the films. A complete record of the bookings for the catalogued films and videos, even covering the period 1987–92, would begin to offer an

indication of the circuits of exhibition and curation that wrote these films into history, and could further be placed alongside the publicly available records of their television broadcasts, and their screenings at festivals and in galleries. That record would require that distributors archive their materials as carefully as Givanni has archived hers. As the Independent Cinema Office used to note above the list of UK distributors on its website, 'Film distribution is a precarious business and, as such, companies tend to appear, merge or vanish overnight.' That precarity is exponentially more the case for distributors of minoritarian cinema.

As Eddie Chambers subtitles his article on writing the history of Black British artists, researching such histories can be tantamount to 'Creating Exhibition Histories of That Which is Not There'. Giving a specific example, he observes that, 'Considering the dispiriting example of the erasure of any trace of The Black-Art Gallery [after it was forced to close in 1993] in official archives, we can never regard any "history" – be that of "Black artists" or "British art" – as being complete or accurate, at least until a process of fundamental art historical recalibrating has taken place' (2016: 61). Yet, as he argues, exhibition history is crucial to that process as, without it, Black artists risk constant erasure and re-presentation as 'new' or 'emerging', as mainstream visual arts curators are unaware of the alternative circuits in which artists' work may have been seen, or of community and alternative histories and genealogies on which artists may be drawing.

Similarly, without recalibrating film history to place distribution and exhibition at the centre, Black British film remains subject to both wilful and neglectful erasure from national film histories and canons. Given the lack of mainstream theatrical distribution and television programming for Black British cinema, the largely independently produced films that constitute the anti-canon need to be accounted for primarily in terms of their routes to audiences. Understanding genealogies of influence and inspiration remains almost impossible when the history of a film's circulation is obscured. This in turn allows the gatekeepers to continue to propound the logic that 'no-one watches' such films, because their circulation, reception, and influence are under the radar.

In their 2004 book *Bidding for the Mainstream? Black and Asian British Film Since the 1990s*, Barbara Korte and Claudia Sternberg note that Black British filmmakers continued to struggle for distribution throughout the 1990s 'because they are considered unmarketable from the outset' (2004: 23). That was despite the presence of the Third Eye Festival (1983), programmed by Givanni, and later the Bite the Mango

festival in Bradford (since 1995), Film Noir in Birmingham, and Black Screen North West in Liverpool. But the account of exhibition and distribution takes up only two pages of their book, which defines the 'mainstream' for which the films were bidding as national television broadcast rather than theatrical exhibition. As Givanni comments in 'A Curator's Conundrum', wide-reaching and varied distribution across platforms and media, through the regions and nations, is 'a prerequisite that has never been really resolved and continues to be an infrastructural hindrance to the development of Black British cinema on a commercial level' (2004: 70). Like the feedback loop caused by the loss of exhibition history leading to assumptions about lack of audience, a lack of histories of wide and varied distribution circuits has led to similar assumptions, which could be called self-perpetuating, where the stakes of the status quo in maintaining them not so evident.

A more granular history of the distribution and exhibition of Black British film, video, and artists' film and video would act as a potent intervention into such perpetuation. Available archival materials and print sources such as *Black Film Bulletin* (1993–99) edited by Givanni and Gaylene Gould could act as a framework for seeking oral histories not only from filmmakers, curators and exhibitors, but also audience members. Such documentation could help to unpack – and to challenge – the complex narratives of systemic exclusion, unconscious (and conscious) bias in gatekeeping, and unchanging decision-making within changing formats and circuits that are implied in the institutional-speak of 'considered unmarketable from the outset'. Such a history would be confrontational in ways that are practical: surveying and accounting for the locations, personnel, circuits of information, and attendance at Black British film programming on alternative circuits, towards measuring the films' impacts on community and identity formation, and on artistic development. A history with such granularity would also present a theoretical challenge.

Burning an Illusion: Black Films, Visible Audiences

Such a confrontation with assumptions about film spectatorship is palpable, if not foregrounded, in Narval Media's 2008 research report for the UK Film Council, *Stories We Tell Ourselves: The Cultural Impact of UK Films, 1956–2006*, with Ian Christie as lead researcher. In a section entitled (unironically) 'Rainbow', the report surveys the impact of 'UK Films Involving Black and Asian Talent' (2008: 50–63). What's notable about the case studies in this section,

in contrast to those throughout the rest of the report (which surveys what we might call non-rainbow films given that they involve only 'white talent'), is that the studies have to account for *how* and *where* audiences might have encountered the films, rather than being able to present any overview of critical or viewer reactions based on an assumption of mainstream distribution.

Drawing on an interview with director Horace Ové, the report notes that his film *Pressure*, completed only in 1975 after a struggle to find production financing, then struggled to find theatrical distribution. Lola Young notes in *Fear of the Dark* that 'it was also reported that both Scotland Yard and what was then the Race Relations Board had requested to see the film before its release', due to those organisations' racist assumption that the film might provoke riots (1996: 142). The film finally opened, in 1978, at the Coronet Cinema in Notting Hill, not too far from its diegetic location of Ladbroke Grove, 'attract[ing] a large audience in a venue which was then identified with courageous alternative programming', as Young reports (ibid.), before a very limited theatrical release by Rank to their Odeon cinemas (Narval, 2008: 55).

Three years later, *Burning an Illusion* (1981) by Menelik Shabazz was also denied a wide UK release, thus also necessitating investigation into its patterns of distribution to understand its cultural impact. Narval's case study is worth quoting in detail, as the information it contains is not part of standard British film histories:

> Despite not having a wide release, *Burning an Illusion* toured widely to regional film theatres, conference halls and universities, arousing impassioned contemporary debate about race and gender identity. Menelik Shabazz remembers one such occasion when the film was screened to a packed audience at the Commonwealth Institute: 'The audience was overwhelmingly made up of women. They identified with the lead character's struggle for autonomy and self-definition. And it is women who have continued to give life to the film over the years, to keep it in the black cultural consciousness.' Isabel Appio, writing for *The Caribbean Times* remembered that evening: 'The most overwhelming audience turnout [at the Commonwealth Institute's Black Film Festival] was for *Burning an Illusion* which had eager viewers spilling into the aisles. Females reacted openly, cheering Pat (Cassie McFarlane) through her journey as she sheds her "colour TV and engagement ring" values, confronts her troublesome boyfriend, and discovers a more rewarding political identity.

An Invitation to Enchantment **So Mayer**

It was proven that night that there is a vast and receptive audience starved of films dealing with subjects with which they can identify.'

<div align="right">(Narval Media, 2008: 56)</div>

Givanni's archive, with its records of the Third Eye Festival (1983) and the subsequent Anti-Racist Film Programme, supported by the Greater London Council (GLC), would enable a more complete trace of both films' exhibition, while archives of Black British publications such as *The Caribbean Times* would provide further, significant insights into reception and circulation.

Reporting on the picture for UK distribution for *Vertigo* magazine in 1994, Holly Aylett and Margaret Dickinson note that the Electric Cinema in Notting Hill, which had re-opened in 1991, was in the vanguard for independent UK exhibition and distribution as a whole. Aylett writes:

> Kwesi Owusu is one of the two representatives from Black Triangle in the newly formed Electric Triangle consortium. Along with Paul Buck, he is responsible for running the cinema. The other partners [are] ... Val McAlla from Voice Communications Group and Neil Kenlock from Choice FM radio ... between them they offer a potential access to around 250,000 people. According to Kwesi Owusu, 'Our bid for the cinema wasn't based on the idea of sending out a monthly programme and waiting to see if people came to see the films, but of interlocking into a media structure which already exists. The Electric "experiment" is structured around a new black media synergy. We are introducing new audiences to the cinema using radio, through the pages of *The Voice*, leafleting and collaboration with community organisations.'
>
> <div align="right">(1994)</div>

An oral history project on Black British film spectatorship might follow Owusu's audience development strategy to the letter, advertising for contributors through Black British legacy and digital media, and working with community organisations such as the Black Cultural Archives (BCA) to identify, invite, and include cinemagoers in (changing) the history of Black British film circulation.

Ever alert, Givanni had noted in her 1992 catalogue the success of the 'Nubian Tales' season at the recently re-opened Electric, which then moved to a larger screen in Central London's The Prince

Charles cinema. The success of the season offers a rare example of early 1990s independent Black British film curation and exhibition and its methods of generating marketing strategies and audience development outside the mainstream press, lessons that remain significant for contemporary distributors and exhibitors today. As Aylett and Dickinson's account for *Vertigo* makes clear, the alternative circuits of distribution and exhibition for Black British cinema offer both important strategic guidance for distributors facing the continuing challenges of gatekeepers who wish to ignore BAME cinema, and – as importantly for us as scholars – a coherent model for bringing exhibition and distribution into focus within film history. Because Black British film has travelled of necessity by alternate routes (and I can only gesture here at some of them), it makes those routes (and, in contrast due to their exclusionary nature, the normative routes of exhibition and distribution) significantly more visible than does dominant cinema. Thus, Black British film offers a paradigm both for independent curatorial practices, and for considering their history and historiography.

The Ghosts of Films: Theorising Moving/Image Encounters

Extending from, and extending, such practical study is a theoretical concern, a search for a methodology that would underline the combination of archival research, oral history, and media studies needed to relate, in full, the circulation of Black British cinema. In fact, such practices already underscore any attempt at a theorisation, as archival interventionism was central to the practice of the Black Audio Film Collective (BAFC). As former *Third Text* editor, Jean Fisher delineates in her catalogue essay for the BAFC exhibition *The Ghosts of Songs*, 'through the radical re-articulation of the historical archive with testimonial memory, the films of the Black Audio Film Collective disclose the intersecting constellations of the past and present, where memory is understood not as a dead past waiting to be excavated but as a product of the present [via …] the reinvention of storytelling' (2007: 16).

Fisher draws a parallel with Walter Benjamin's account of the storyteller, arguing that BAFC work posits moving image media as, centrally, a relation between storyteller and listener, and therefore that no history or theory of production is complete without a history and theory of reception, to which exhibition and curation remain, literally, pivotal. As Kodwo Eshun and Angelika Sarkar note in

their introduction to the same volume, that inter-relation does not happen in the abstract, but in what they call 'spatial scenarios' that are created – or curated – to hold and frame encounters that remain only rarely possible within the British mainstream. They describe how the idea for the exhibition came together from observing viewers in a non-theatrical screening space. 'Watching audiences watching Black Audio Film Collective's 1986 essay film *Handsworth Songs* during the first afternoon of *Documenta 11*, replaying the attention that people bestowed upon it later that evening, a curatorial proposition slowly began to emerge: could one invite audiences into spatial scenarios that allowed for distinctive kinds of encounter with the entirety of the Black Audio Film Collective's oeuvre?' (2007: 13). It is the 'distinctive … encounter' that concerns me here: not defined by the distinction of the gallery from or over the cinema, but by the need to deploy oral histories and subjective accounts that highlight the ways in which encounters with Black film have been curated and programmed in the UK; that is, that due to lack of mainstream distribution and press, they are always distinctive encounters in curated spatial scenarios.

The Ghosts of Songs catalogue includes exhaustively researched histories of the gallery installation, and selected festival and theatrical exhibition, for BAFC's films, videos, and tape-slides. *Handsworth Songs*, for example, had three different screenings in 2006 'at Tate Liverpool, as part of *Making History: Art and Documentary in Britain from 1929 to Now*, curated by Tanya Barson; at the Arnolfini in Bristol as part of *Ghosting: The Role of the Archive Within Contemporary Artists' Film and Video*, curated by Picture This; and at Kunstverein in Munich, as part of *The Secret Public: The Last Days of the British Underground 1978–1988*, co-curated by Michael Bracewell and Ian White' (Eshun and Sarkar, 2007: 215). Implicit in the listing – even in the act of listing – is a fascinating study to be undertaken on the film's re-evaluation three decades after its initial release; the development and significance of its mobility across modes of reception and exhibition, and as itself both a vector and index of the process of artists' moving image relocating from theatrical screens to the gallery; and its representational quality as synecdoche for a particular moment in British culture, as well as of the intervention it made therein. All of these would be bound up with, and related through, a historiography of viewers' 'distinctive encounter[s]' with the film that carefully engage the shifting specificities of ethnicity, class, and geographical location within the porous and expansive borders of Black Film (as) British Cinema.

Second Coming: The New Black Film Curation Community of the Twenty-first Century

Curator and historian of African American cinema, Pearl Bowser titles her book, co-written with Louise Spence, on Oscar Micheaux, *Writing Himself into History* (2000). It is abundantly clear from their book that the interlinked circuits of Black-owned film theatres and print media in the northern US – the complex collaboration between exhibition, advertising, reviewers, and audiences – were crucial to Micheaux's ability to write himself into history, both in terms of how his films rewrote the histories they depicted, and how his presence alters film history books. Minoritarian filmmakers continue to write themselves into history in collaboration with minoritarian and ally/accomplice curators and critics: at a moment where exhibition and distribution are once again in flux, and grassroots independent curators are once again leading the charge to bring Black films to audiences, we need to attend to this collaboration so that memory is not forced to become 'a dead past waiting to be excavated'.

There is a new wave of independent curation bringing individual Black films to British screens, most importantly Priscilla Igwe's The New Black Film Collective (TNBFC). Initiatives such as Film4's partnership with Kaleidoscope Films for British film *Second Coming* (Debbie Tucker Green, 2014) that aim to drive audiences to a specific title exist alongside longer-term, venue-based initiatives such as Jan Asante's Black Cultural Archives Film Festival, often offering a proving ground for emerging curators. The twenty-first century has seen the emergence of a number of Black film curation continuing projects, both institutional and independent: Film Africa, the Royal African Society's annual film festival; the London African Film Festival; the new UK Nollywood Film Festival (2018–); the African Odysseys monthly screenings at the BFI and Gaylene Gould's 2017–19 tenure as Head of Cinemas and Events at the same venue, culminating in No Direct Flight, a season of contemporary Pan African digital screen media paired with classic features, co-curated by Tega Okiti. No Direct Flight crosses over with SOUL Fest, a collaboration between four organisations who serve Black audiences and talent, and also host independent programmes at other venues: TNBFC, Screening Our Unseen Lives (S.O.U.L.) Film, audience-led event-based film programmers We Are Parable, and talent showcase/database The British Blacklist. Non-venue-based collectives of young womxn of colour curators, WOC Film Club, and Reel Good Film Club, have also programmed extensively in London (RGFC have also programmed in

Manchester and Brighton), screening films by and about womxn of colour at often non-traditional and independent venues to draw new audiences. Images of Black Women Film Festival ran 2004–16 at the Tricycle Theatre (now the Kiln), but is currently on hiatus.

Outside London, there are festivals such as Africa in Motion in Glasgow and Edinburgh, Afrika Eye in Bristol, and the Cambridge African Film Festival, which formed a programming coalition with Film Africa in 2013 (Rosser, 2013). A similar pattern to London pertains, of independent collectives and programmers working occasionally with venues, such as the Birmingham-to-Bristol Come the Revolution collective, including Karen Alexander, which works with the Watershed in Bristol; Sophia Ramcharan's programming and audience development work at Broadway Cinema and New Art Exchange Gallery in Nottingham; Mikaela Smith programming a focus on Black British Identity for Black History Month at Showroom Sheffield, where she is the Audience Development Coordinator (Smith, 2019); the short-lived but much-loved Liverpool Small Cinema's commitment to its 58 per cent programming, led by Jo Mohammed of Elsewhere Cinema, focused on films by women, trans, and non-binary filmmakers, with particular attention to filmmakers of colour; and GLITCH, an international platform for film and art created by queer/LGBTQIA+ people of colour programmed by Digital Desperadoes in CCA in Glasgow.

Notably, cutting-edge, contemporary Black British film curation is led by womxn and LGBTQIA+ curation and content, from Jay Bernard's tenure at Flare (formerly the London Lesbian and Gay Film Festival) to Aya Distribution's unconventional rollout of *Rafiki* (Wanuri Kahiu, 2018) in collaboration with independent cinemas hosting local LGBTQIA+ POC programmers and speakers. Accounting for curation and programming shifts the focus from auteurism to the hidden labour practices of canon and meaning creation in screen media, and particularly highlights the oft-unnamed, unsung, underfunded, and obscured contributions of womxn behind-the-scenes. As experimental film curator Kim Knowles has noted of her research on the history of the Edinburgh International Film Festival, 'amongst all history's "great" men, there are women who were doing pioneering work, sensitive and inclusive, and I don't think that has been acknowledged enough' (in Mayer, 2017: 15). She could have been speaking of Givanni, as well as all her many collaborators and descendants.

Despite this growth and development in Black film programming talent, Tara Brown is – with Gould's departure from BFI – currently

the only Black British lead film programmer at a venue, working at the Bernie Grant Arts Centre in Tottenham, where she took over the role from Hakeem Kazeem; she is also a programmer for Fringe! Queer Film and Arts Fest, and a curator (with Kazeem) of Batty Mama. Many of these independent programmes, whether in London or elsewhere, are occasional or go dormant and may be disbanded or discontinued due to lack of funding and venue support – but not audiences. Others will arise, but the attritional effect on both programmers and the invisibilised history of their programming is a serious problem for Black British film audiences and scholarship. The creation of 'spatial scenarios' for viewing and interacting is key to Black British cinema's living multiplicity, and thus a critical practice that values curation is essential. The enchantment is in the invitation.

Bibliography

(2019). 'Call for Papers: Three-Volume Collection on the History of FESPACO (1969–2019)'. *Black Camera 11*(1): 12. Available at: www.muse.jhu.edu/article/741453.

Aylett, H. and Dickinson, M. (1994) 'Distribution: Now You See It, Now You Don't'. *Vertigo 1*(3). Available at: www.closeupfilmcentre.com/vertigo_magazine/volume-1-issue-3-spring-1994/distribution-now-you-see-it-now-you-don-t/ (accessed 14 September 2020).

Bowser, P. and Spence, L. (2000) *Writing Himself into History: Oscar Micheaux, His Silent Films, and His Audiences*. New Brunswick, NJ: Rutgers University Press.

Chambers, E. (2016) 'Black British Artists and Problems of Systemic Invisibility and Eradication: Creating Exhibition Histories of That Which is Not There' in *The Curatorial Conundrum: What to Study? What to Research? What to Practice?* Edited by P. O'Neill, M. Wilson, and L. Steeds, 54–61. Cambridge, MA: The MIT Press.

Eshun, K. and Sarkar, A., eds (2007) *The Ghosts of Songs: The Film Art of the Black Audio Film Collective, 1982–1998*. Liverpool: Liverpool University Press.

Eshun, K. and Sarkar, A., eds (2007) 'Preface' in *The Ghosts of Songs: The Film Art of the Black Audio Film Collective, 1982–1998*. Edited by K. Eshun and A. Sarkar, 12–15. Liverpool: Liverpool University Press.

Fisher, J. (2007) 'In Living Memory … Archive and Testimony in the Films of the Black Audio Film Collective' in *The Ghosts of Songs: The Film Art of the Black Audio Film Collective, 1982–1998*. Edited by K. Eshun and A. Sarkar, 16–42. Liverpool: Liverpool University Press.

Gates, R.J. and Gillespie, M.B. (2019) 'Reclaiming Black Film and Media Studies'. *Film Quarterly 72*(3): 13–15.

Givanni, J. (1988) 'In Circulation: Black Film in Britain' in *Black Film, British Cinema*. Edited by K. Mercer, 39–41. ICA Documents 7. London: ICA.

Givanni, J. (2004) 'A Curator's Conundrum: Programming "Black Film" in 1980s–1990s Britain'. *The Moving Image: The Journal of the Association of Moving Image Archivists* 4(1): 60–75.

Hall, S. (1988) 'New Ethnicities' in *Black Film, British Cinema*. Edited by K. Mercer, 27–30. ICA Documents 7. London: ICA.

Harris, V. (2007) *Archives and Justice: A South African Perspective*. Chicago: Society of American Archivists.

Korte, B. and Sternberg, C. (2004) *Bidding for the Mainstream? Black and Asian British Film Since the 1990s*. Amsterdam: Rodopi.

Mayer, S. (2017) 'Rethinking the Past'. *Sight & Sound* 27(7): 14–15.

Narval Media (2008) *Stories We Tell Ourselves: The Cultural Impact of UK Films, 1956–2006*. London: UK Film Council.

Rosser, M. (2013) 'UK's African Film Festivals Unite'. *Screen Daily*. Available at: www.screendaily.com/news/uks-african-film-festivals-unite/5062646.article (accessed 14 September 2020).

Smith, M. (2019) 'Why We're Looking at Black British Identity This Black History Month'. *Showroom Workstation*. Available at: www.showroomworkstation.org.uk/black-history-month-2019 (accessed 14 September 2020).

Young, L. (1996) *Fear of the Dark: 'Race', Gender and Sexuality in the Cinema*. London and New York: Routledge.

8 Spaces of Intervention: Politics, Aesthetics, and Archives in the Films of John Akomfrah

James Harvey

John Akomfrah is one of the most important British filmmakers working today. Akomfrah has been mining the archive for affective images of the migrant experience in postcolonial Britain since the 1980s, is responsible for some of the most formally inventive and thematically rich explorations of black subjectivity in the history of British cinema, and has, through his many films and installations, formed one of the most consistent and distinctive aesthetic styles around. This chapter will explore his use of montage and the archive, analysing how, since the 1980s, Akomfrah repurposes artistic techniques from film history to construct a *space of intervention* against racist discourses of national identity and prohibitive forms of black representation.

Akomfrah's aesthetic and thematic preoccupations are evident in his earliest films, undertaken as part of Black Audio Film Collective – even in the non-film work, such as the slide-tape exhibition, *Expeditions* (1982). Images explicitly or indirectly connected to narratives of British colonialism are matched and mismatched with allusive captions, reframing the way we understand such histories. *Expeditions 1: Signs of Empire* alludes to the French theorist Roland Barthes' book, *The Empire of Signs* (1982). Here, Barthes undertook a semiotic analysis of texts that

constituted cultural fantasies surrounding Japan. Influenced by theorists like Barthes, Louis Althusser, and Michel Foucault, Black Audio Film Collective were attempting a similar deconstruction, delineating the constituent elements of the cultural fantasy that is British national identity. Foucault in particular would prove a key influence. In *The Archaeology of Knowledge*, Foucault discussed what he termed an 'historical *a priori*' – 'a condition of reality for statements' (Foucault, 1972: 126). For Foucault, positivist discourse – that is, the quantitative analysis of historical events – cannot reveal absolute truth. It can, though, reveal the environment in which competing narratives emerged. Akomfrah's narrative interest is the colonial and postcolonial alienation of people within official national histories. Foucault's archaeological approach to historical narratives – his concern for 'discursive formation' (ibid.: 131) over and above a search for beginnings – guides Akomfrah's practice. Foucault argued that the archive 'emerges in fragments, regions and levels' and that these fragments gain 'greater sharpness, the greater the time that separates us' (ibid.: 130). How then does this help to construct a historical analysis of the black British experience at the beginning of an artistic career? How does one deal with the merely fragmentary and temporally distant visibility of a subject, when such work is to make seen the unseen? An aesthetic style arises out of this dilemma during the 1980s, as this chapter will now explore.

Beginnings

To be British in the 1980s was to exclude aggressively all those who do not so easily fit that limited label. This thematic preoccupation would align Black Audio with the post-Marxist cultural theory of the preceding decade, as well as the academic discipline of Cultural Studies, one of the founders of which, Stuart Hall, became the focus of the more recent *The Unfinished Conversation* (2012) It would also align them with other filmmaking collectives working in this era, including Sankofa Film and Video Collective and Ceddo Film and Video Workshop. This was a fertile moment for black visual culture in Britain. Thematically concerned with the nightmarish realities of structural racism and supported by the introduction of public sector funding to engage BAME communities, such collectives were able to convene around a shared concern in new ways. Black British artist and art historian Eddie Chambers noted an emergent embrace of the political and racial prefix in art of the period (Chambers, 2014: 107). Influenced by the 'Black Art' movement arising contemporaneously with Black Power discourses in 1960s America, this urgent

proclamation of blackness informed a newfound concern for social and political engagement.

Running parallel also to the development of neoliberalism in Ronald Reagan's America, increased inequality in Thatcher's Britain had a profound influence on British cinema in this period. Lester Friedman claimed that visual artists of the era 'instinctively understood that ... Thatcher's ideology, her creation and re-creation of past and present history, must be matched by an alternative vision that offered a different version of this era' (Friedman, 1993: 11). Convening around a common cause, motivated in part through a shared personal experience and history, the film work produced in this period represents a significant body of political art, which should surely be held-up and lauded as such. We can draw our own conclusions about its relative neglect in the critical and artistic canon, as well as in popular culture. One possibility, though, is the *way* in which culture, society, history, and identity are broached in these films. John Akomfrah has never made easily accessible films. Rather, they are fragmentary; experimental, *avant garde*, essayistic, *bricolage*, exploratory, poetic, ruminative, and artistic. They could not be otherwise; the intellectual engagement of the spectator is a fundamental part of each film's ethos. To explain, let's turn to Coco Fusco's 1988 interview with Akomfrah and Black Audio members, Reece Auguiste, Lina Gopaul, and Avril Johnson. Here, Fusco questions the aesthetic quality of 1986 film, *Handsworth Songs*, to which Akomfrah replies:

> In terms of the established boundaries of discussion – aesthetic interventions around race – there were questions of paternity at stake. In other words, who was the holder of the law – the law of enunciation? Who had the right to speak, who had the right to map out and broaden the field that everybody had to speak in? It was in that sense that the film was received as a transgressive text, because it clearly didn't fall into line with the established concordat concerning the Black intelligentsia and their discussion of race. That then makes the film an *avant-garde* text. Those who were willing to live with a more mixed economy of dialogue around figuration and race accepted it, and those who didn't, didn't accept it.
>
> (Fusco, 1988: 50)

Here, Akomfrah is primarily responding to the criticism that *Handsworth Songs* does little to reframe black people in a 'positive light' (or a light other than the one seen regularly in the mainstream

media). The most infamous critique of the film came from Salman Rushdie in an opinion piece in *The Guardian*, where he claimed the filmmakers let us hear 'so little of the much richer language of their subjects' (Rushdie, 1988: 16). Its problem is one of language, asserted Rushdie. Stuart Hall replied days later, arguing that Rushdie simply did not understand that Akomfrah was searching for a 'new language' (Hall, 1988a: 16). The black sociologist and political activist Darcus Howe wrote in to reply to Hall in Rushdie's defence: Rushdie said nothing of the sort, argued Howe. 'He simply says that the attempt to shape a new language does not work, and I agree with him' (Howe, 1988: 16). Neither Rushdie nor Howe specify precisely what does not work in *Handsworth Songs*' language, but Hall does attempt to locate reasons why it *does* in his pathbreaking essay, 'New Ethnicities'. Hall introduces the now ubiquitous phrase, 'politics of representation' (Hall, 1988b: 27). Attempts to depict identity on screen are routinely guided by tropes surrounding that identity, with little attempt to deconstruct those tropes. Why, for instance, must a film about black people in 1980s Britain engage with any topic in particular? The expectation of a preferred aesthetic approach (which is what Rushdie and Howe imply) is emblematic of such a reductive representational regime. *Handsworth Songs* approaches this challenge head-on through its primary focus on mediation itself, foregrounding the film/archive relationship as key to the analysis of the politics of representation. Hall claimed, 'there can ... be no simple "return" or "recovery" of the ancestral past which is not re-experienced through the categories of the present' (ibid.: 30). Hall is encouraging us to consider the film's inventive approach ('the category of the present') to archival footage ('the ancestral past').

The 'Jerusalem' montage is exemplary in this regard (Figure 8.1). Newspaper articles are layered against a black background, cut-and-pasting text, utilising scroll-like movements suggestive not of the contemporaneous video technologies of the 1980s (like rewind and fast-forward) let alone the contemporary smartphone's touchscreen aesthetics. This playful approach to the archive is closer to the microfilm readers, developed around the same time as early cinema, but popularised in libraries in the mid-twentieth century as a means of magnifying texts for research purposes. This attempt to lift the spectator out of the visual language of the film's present-day jars with our expectations. It contrasts with the immersive experiences we associate with progressive, advanced film aesthetics. The sequence lacks more common documentary techniques (such as voiceover narration, reconstruction, or onscreen textual signifiers). But it introduces

un-filmic devices, thus foregrounding an authorial presence. One might be reminded of the tactile encounter with a material text, usually ignored or immobilised through film's audiovisual priority. It implicitly reminds us, then, that the image presented to us has been constructed; and it suggests that it can, in turn, be *deconstructed*.

Moreover, there is a more thematically resonant mode of analysis going on here. Hamid Naficy has claimed that this preoccupation with 'tactile sensibilities' is a recurrent tendency in diasporic films, 'since some of the most poignant reminders of exile are non-visual and deeply rooted in everyday experiences' (Naficy, 2001: 28). In order to illustrate the feeling of marginalisation within a culture, Naficy suggests films regarding diasporic subjects reroute our sensory engagement with the image. Attempting to capture a non-audiovisual form of representation is, therefore, to challenge a hierarchy that dictates who speaks and who is spoken for – in Foucault's terms, to question the 'condition of reality for statements'. Akomfrah is attempting to engage with a history of a people through an archive that contains primarily unreliable material. As Jean Fisher explains, 'for the diasporic artist to

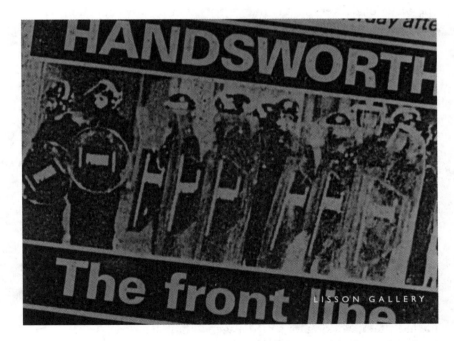

Figure 8.1 A playful approach to the archive, constitutive of the "cut and mix" aesthetic of *Handsworth Songs,* which encourages engagement from the spectator on the forms of mediation around the riots

disarticulate this archive … is a subversive act insofar as it usurps the power of authority to control meaning' (Fisher, 2006: 26).

In addition to the image, we hear Mark Stewart and the Maffia's dub version of William Blake's hymn to England. The combination of the Maffia's steel drums and Black Audio sound designer Trevor Mathison's industrial sonic landscape (hollowed-out machinic percussion; an unnerving tension brought about through turning cogs and grating materials) broaches the intersecting race and class dynamics, which defines dissent with old Albion in the Thatcher era. In Mark Fisher's words, this version of Jerusalem is 'a bid for an account of Englishness from which "blackness", far from being something that can be excluded, becomes instead the only possible fulfilment of the millenarian promise of Blake's revolutionary poem' (Fisher, 2015). Again, the objective is to carve out a mode of representation from an archive that excludes the black subject.

Trapped by Fake Testament

The reason that *Handsworth Songs* – and Akomfrah's work thereafter – provoked such mixed responses, is that the film is as concerned with the *mode* of delivery as the message itself. This preoccupation with the mediation of blackness continues into the films produced after Thatcher's leadership. In *Testament* (1988), the film's protagonist (Abena) is a journalist reporting on Werner Herzog's *Cobra Verde* (1987) – a film about the slave trade, shot on location in Ghana. The story of Abena's own exile from Ghana in 1966 (after the coup against socialist leader Kwame Nkrumah) filters through as she visits former activist allies. While on Herzog's set, Abena explains how 'she felt momentarily trapped by fake testament'. This journey of self-discovery through return reveals the loss of self, experienced by the diasporic subject, working now for a British media agency and covering a German filmmaker who is making exoticised images of Africa. Abena's realisation of this 'image Africa' (Landau, 2002: 2) echoes Walter Benjamin's 'Angel of History', whose 'face is turned towards the past. Where we perceive a chain of events, he sees one single catastrophe, which keeps piling wreckage upon wreckage' (Benjamin, 1999a: 201).

Abena's return has led to the epiphany that her acclimatisation to life in Britain, working for a media agency, has included a detachment from her roots. Her British identity has overridden her identity as a committed African socialist. Her personal narrative allegorises Ghana's own historical struggle against colonial, then military, rule.

Also following Benjamin, Kobena Mercer describes the core theme of *Testament* as 'postcolonial *trauerspiel*' (Mercer, 2006: 56). Like Benjamin's 'angel of history', Abena looks back on the past from the present to show how the supposed progress of the present is built on the forgotten ruins of the past. This is conveyed in *Testament* through the melancholic mood and the desaturated landscapes of Ghana.

Black Icons

Benjamin's angel becomes an explicit reference point in the 1996 film *The Last Angel of History*. Here, Akomfrah utilises a more conventional talking-head style to tell the fictional story of the 'data thief', who carries the secrets of a black technological future. *The Last Angel of History* is an essay film on the emergence and development of 'Afrofuturism' in pop music. From Parliament's 1975 album 'Mothership Connection' through underappreciated hip-hop and the techno scene of the mid-1990s, the speakers in the film regard the data thief as a sonic archivist. As summarised by Laura Marks:

> since the great rupture of the Middle Passage, African diaspora people have been doing science fiction … ever since Africans were kidnapped, forced onto slave ship holds and plantations, and forbidden to use their languages, their descendants have survived and created in this alienated, dislocated state. They have done so by assembling futures from fragments of the past, preferring to disdain the present that accords them less than human status or, at best, offers 'inclusion' in a humanity not of their design, and using technology and art to invent when historical research fails to yield anything useful.
>
> (Marks, 2015: 122–123)

Building on *Testament, The Last Angel of History* departs from the focused concern with diasporic identity in Britain in order to consider a narrative of displacement for black people internationally. The film also initiates an emergent interest in black musical icons, followed by *Goldie: When Saturn Returns* (1998), *The Wonderful World of Louis Armstrong* (1999), *Mariah Carey: The Billion Dollar Babe* (2003), and *Urban Soul: The Making of Modern RnB* (2004). *The Last Angel of History* is also followed by two films about Martin Luther King: an episode of the BBC documentary series, *Reputations*, entitled *Days of Hope* (1997) and, more recently, the Denzel Washington-narrated, *The March* (2013). On one level, these films represent more conventional,

expository takes on cultural icons. Taken together, though, we find a continued concern for interrogating the construction of black subjectivity in popular culture. A correlation can be traced across these though, between the demand for rights 'by any means necessary' and the saccharine lyrics of Mariah Carey. Like *The Last Angel of History*'s subversive take on the displacement of African people through the contextual frame of science fiction, these are examples of what Hal Foster called 'failed visions' (Foster, 2004: 22) recouped and rearticulated as part of a reconceived archive of black cultural history.

While aesthetically more conventional than earlier works on the whole, these films all utilise the montage aesthetic that drives Akomfrah's entire oeuvre. They are also not entirely removed from his consistent preoccupation with migration and black subjectivity. Each film engages with the social and cultural determinants of each subject's rise and fall. When considered alongside *Testament* and *The Last Angel of History*, we begin to locate a more international approach to blackness than the one revealed in *Handsworth Songs*. Kodwo Eshun has described these film's 'agnosticism' to the question of blackness, arguing that the 'black' of Black Audio stands for 'a question of the unthought, a dimension of potentiality' (Eshun, 2006: 76). Eshun thereby highlights the difficulty of defining a consistent conception of the black subject in Akomfrah's films through the terms available in critical race discourse.

Akomfrah was more candid on this subject in relation to his 1993 film, *Seven Songs for Malcolm X*. Discussing the influence of Harlem photographer James Van Der Zee, Akomfrah raises the significance of 'necrophilia' as a conceptual device – 'in a postmodern sense, in which people are invoking figures, there is a sense of feeding off the dead'. This necrophilia is 'at the heart of black filmmaking', he claims (Banning, 1993: 30). A melancholia arises in relation to the lost figure, which creates icons of those once-living beings. Figures such as Malcolm X – whose ideas inspired so many to act – become concretised in the minds of many today. His words, while no less potent today than in their contemporary moment, still refer to a time passed. The actions, while no less necessary today, become associated with a chance lost. An icon, in this sense, is something irretrievable. He returns to the closing images of *Testament* to elaborate, whereby Abena's mourning represents 'a kind of stultification, atrophy … a wish fulfilment of death … There is a kind of level of morbidity which I think people have to realise in the quest for identity' (Figure 8.2) (ibid.). This *having to realise* appears, then, to be something like a warning from Akomfrah. Melancholy arises as a result of being stunted, or stultified,

by the beguiling spectre of the unresolved past traumas embodied by unacknowledged black icons.

A paradox emerges. There exists an obligation to engage with key figures of history; but to define oneself solely in relation to figures of the past is severely limiting. In this sense, his portrayals of icons are consistent with his archival method, insofar as he employs an archaeological regard for the politics of representation.

Aesthetic Intervention

In a 2015 interview for Tate, he refers to what he terms 'the philosophy of montage' (Akomfrah, 2015). Montage, in this sense, is not simply a combination of shots but a *way of thinking*. 'Everyone who helped popularised montage,' Akomfrah says, 'was interested in one thing: deferred meaning. That somehow, when two opposites collide in this dialectical way, some sort of synthesis is engineered or brought about and in that, a new form, a new meaning, or a new way emerges' (2015). Montage connects Akomfrah to a history of political filmmaking: from Eisenstein and Vertov in Soviet Russia, through 'Third Cinema' filmmakers in Latin America in the 1960s, to essayists like Chris Marker and first-person documentarians like Trinh T Minh-Ha. Images drawn from the 'memory bank' (which is what he calls the archive in the same interview) are brought together; meanings once solidified explode; montage reconfigures the fragments to produce something new. Montage in itself is not innovative – it is the basis of cinema itself. Even in the political mode exemplified by Eisenstein and colleagues, the commonality of dialectical montage can hardly be called novel.

However, Akomfrah's personal stylisation can be located in various ways. This begins in *Handsworth Songs* through the use of still images and Mathison's haunting sonic landscapes. In *Seven Songs for Malcolm X*, he introduces the use of original, staged images. Always engaging with history and memory, this aesthetic play with new and old promises an alternate take on a past event. This is exemplified in *The Nine Muses*. Retracing the history of diasporic migration to Britain after the Second World War, Akomfrah uses Homer's *Odyssey* as a founding myth of foreignness. Neglected found footage is brought together with ancient verse, a diverse soundtrack and crisp digital imagery. The recurring appearance of a yellow-jacketed stranger looks out onto anonymous landscapes, echoing Casper David Friedrich's romantic wanderer, deliberating meaning and place in an uncaring world. Purposively clashing with the texture of archival footage, digital

Figure 8.2 A metaphorical but highly affective rendition of the stultification of repressed histories in *Testament*

film imagery pronounces another level of historical difference. Much like *Handsworth Songs'* use of obsolete, unfilmic technologies, the mode of representation is being questioned, here. Film technologies come to the foreground, utilised as a way of rephrasing historical debates on nation, migration, diaspora, and difference. Like Dziga Vertov's 'Kino Eye', Akomfrah's montages take as their content the tools of production themselves. Marrying the montage form with a reconsideration of cinema's technological development, Akomfrah is always questioning the aesthetic base of representation alongside his more apparent social and cultural themes.

Aesthetic intervention also occurs at the level of exhibition. In 1998, Black Audio Film Collective disbanded. Akomfrah and producers Lina Gopaul and David Lawson took the pragmatic decision of switching from art collective to independent film production company, renamed Smoking Dogs Films. However, this did not result in a shift from the art world to film festivals. Rather, quite the opposite occurred; since the turn of the millennium, Akomfrah's output has resided primarily in the gallery space. In the aforementioned Tate interview, Akomfrah discussed his way of working between cinema, TV, and the art world. This allows him to engage a wider and more diverse audience. Unlike TV and cinema – even to some extent the art house cinema – the gallery has long been a space of privileged spectatorship, limiting

participation through financial constraint and lack of thematic engagement (due to the representational limitations applied to the content, forms, and subjects typically on display). There is an important institutional intervention in play when Akomfrah chooses to work in the gallery space. Screenings of films by black filmmakers in a typically white space remain rare. Films about black and minority ethnic history within these spaces are similarly few and far between. *The Nine Muses* (2010) received a very modest art cinema release, before being distributed by London-based art film and documentary distributors, New Wave Films. But prior to this, *The Nine Muses* took the form of a single-channel installation, entitled *Mnemosyne* (2009) and running about half an hour shorter than *The Nine Muses*. The installation originally screened at The Public – a contemporary art gallery in West Bromwich, which has since closed its doors. Some of the archival footage in *Mnemosyne* and *The Nine Muses* is taken from BBC footage of the area in the 1960s. There is an investment, then, in engaging a more diverse spread of audiences – particularly in local areas with histories of migration shared with the subjects of his films. This is repeated with the more recent *Mimesis: African Soldier* (2018), which (following its initial exhibition at the Imperial War Museum in London) was exhibited at Nottingham's New Art Exchange – an institution with a particular investment in cultural diversity. There is an attempt to intervene on an institutional level: first, through the diversification of gallery content, and second, by exhibiting outside of areas with greater access to the darlings of the art world.

The politics of this subject goes beyond the more apparent questions of representation. There is an *aesthetic politics*, emanating from formal and technical decisions. Working across different sites of exhibition, Akomfrah's constant concern for hybrid identities – forms of being existing in a state of betweenness – carries over, from the content to the mode of production. As I have argued elsewhere, film installations in the gallery 'infer an interruptive exhibition space, often employing multiple entry-points and exit-points that never close, undetermined lighting conditions and a greater diversity of seating and screening positions' (Harvey, 2018: 138). These gallery film installations intervene in the cinematic apparatus in two senses. First, as we see in *The Unfinished Conversation*, the use of a single screen to exhibit a single stream of images through the montage form is fragmented across screens (Figure 8.3). This intervenes in the cinematic category of *audience*, enabling instead an individualised *spectator* to engage in a singular manner with the images – in one's own time, freely moving around one's own space. Second, this

reframing of the single montage across several screens returns us, to some extent, to the pre-cinematic mode of viewing images on the gallery wall. This is an anachronistic return to what Benjamin called 'the aura' of the image on the museum wall – far removed from today's media landscape (Benjamin, 1999b: 215). As Erika Balsom has argued, 'elements of the contemporary integration of cinema into the museum are marked by a reversal of this process' (Balsom, 2014: 17). *Why would Akomfrah mobilise this contemporary tendency to reverse cinema's democratisation of the image?* Detaching the viewer from the egalitarian ethos of the cinema audience, the gallery spectator enjoys a freedom to engage at will with an image that has more in common with elite traditions. This would, in turn, appear to conflict with his career-long concern for reappropriating the archive.

While running counter to cinema's departure from the museum, there are strong grounds to describe Akomfrah's return to the gallery as *even more* invested in democracy. Throughout film history – from the development of film technologies designed for white skin through to today's discourses around diversity – clearly hypothetical access to images has not resulted in a democratic regime of images. Access to image production and reception remains guarded and regulated. Returning, then, to the gallery space with images commonly ignored, inviting an audience typically neglected, Akomfrah corrects the contemporary tendency to prioritise thematic representation above all else. The site of exhibition itself is a 'condition' of the 'discursive formation' of the archive. Akomfrah's commitment to working in the gallery has a strong political agenda: it is not enough to simply legislate for more minority bodies on screen; the problem is structural and demands a reconsideration of how this form of representation itself began.

What artistic shifts enabled an undemocratic cinema to emerge? What technological short-sightedness would limit the ability for black bodies to become producers? These questions inform the aesthetic politics of Akomfrah's significant body of film installation work. Structural in nature, this political aesthetic interrogation of film as a media, technology, and art form carries over into the more recent shift to climate politics.

Same Aesthetic, New Themes

The later preoccupation with ecopolitics became pronounced in the BBC documentary, *Oil Spill: The Exxon Valdez Disaster* (2009). Shot in March 2009, the film returns to a small town in Alaska

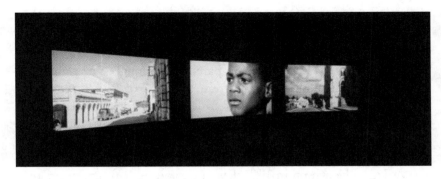

Figure 8.3 The mode of spectator engagement alters through
the fragmentation and multiplication of screens, in
The Unfinished Conversation

20 years after an ecological disaster, when a giant super tanker –
the Exxon Valdez – ran aground emptying 11 million gallons of
crude oil, affecting the natural life inhabiting the region to this
day. The effects of the event on human life continue, too. The local
fishing industry was destroyed and the wider Alaskan economy was
severely impacted. A made-for-TV documentary, *Oil Spill*, carries
the hallmarks of a more conventional, expository documentary, in
ways similar to Akomfrah's music documentaries. However, there
are several distinctive authorial marks, such as the appearance of
the anonymous, yellow-jacketed figure stalking the landscapes.
Taking advantage of the Alaskan backdrop, Akomfrah positions the
wanderer in a specific scene – the scene of a disaster, a crime against
nature. He will return in *Mnemosyne* and *The Nine Muses*, abstracted
from the ecological context, quoted visually for his ability to signify
tonal displacement, pensive in a scene of melancholy. His movement
across films emblematises Akomfrah's approach to the 'memory bank'
that is the archive. Originally setting out to correct the absences of
official histories, Akomfrah's own work becomes an archive to draw
from at will.

Vertigo Sea (2015) is the first of his film installations to engage with
climate politics in an explicit way. Premiering at the Venice Biennale
in 2015, this three-channel installation mimics the dialectical physical
arrangement of *The Unfinished Conversation*. In the opening images,
the viewer is confronted with the horrific fate of refugees that have been
washed ashore, as told through a radio broadcast. This initially places
the viewer in the familiar Akomfrian territory of migration; the sense
of familiarity is subsequently reinforced through reference to colonial
history, textual inserts and staged *tableaux vivants*. The introduction

137

of an environmental narrative, though, takes us away from his earlier thematic preoccupations in a pronounced way. But it also enriches those earlier arguments: slavery, colonial exploitation, regulated human mobility are shown to run parallel to animal migration and environmental turmoil. Drawing from the likes of BBC's *The Blue Planet* (2001), the montage aesthetic rejuvenates apolitical observation into sobering archaeological excavation. Perhaps working in his most purely Eisensteinian sense, the three channels are interconnected to make a statement on the Anthropocene; neglect for the natural world is revealed to be symptomatic, relevant to, and perhaps coterminous with, the human exploitation that has concerned him throughout his films (Figure 8.4).

Vertigo Sea represents a break in his treatment of the natural world and as such, a new phase in Akomfrah's oeuvre. The trees, oceans, mountains, flat plains, built environment and architectural relics of earlier films are rich in metaphorical detail. What they offer in terms of historical insight is often even more revealing than the narration. That they are employed, though, solely for the socio-historical metaphor is broadly illustrative of the instrumentalisation of landscapes in these earlier works. *Vertigo Sea* pulls focus on the agency of nature itself – in Bruno Latour's terms, as an *actant* (Latour, 1996: 47).

A commission by the Barbican's Curve Gallery, the proliferation of screens reaches a new height in *Purple* (2017). Six channels multiply the montage's usual effects, repeating, contrasting and affecting the meaning of images to an even greater extent. The curvature of the wall surrounds the viewer in a way that differs from the typical gallery experience. The effect is to bring the spectator in closer to the content, even while the space increases. Both *Purple* and *Vertigo Sea* represent a fidelity to more traditional modes – the museum, archival research, the philosophy of montage, the tableau mise-en-scène. These could be said to lose the impact of new documentary modes (such as recent films produced by Harvard's Sensory Ethnography Lab) that prioritise experience over cognitive engagement. A still-emergent theoretical and political domain, attempting to frame ecopolitical narratives in traditional forms feels complacent compared with the aesthetic achievement of Lucien Castaing-Taylor and Verena Paravel's *Leviathan* (2012). By *Purple*, the stylistic approach appears, at least at first sight, to mimic earlier montages and mount them on to a new debate. Put this way, the archive itself appears limited in terms of what it can reveal about the present. But the contemporary is never detached from the past, and it always has the potential to surprise.

In an interview discussing the Barbican commission, Akomfrah elaborates:

> certain visual motifs really surprised me. For instance, in everything I looked at from the past, especially footage shot in Europe or the US in the 1950s and 1960s, there is this film over everything you see. Slowly it dawned on me that it's all smog, all carbon monoxide in the atmosphere. Basically, when you watch archival material from the 1940s to the 1960s – shot in places such as Manchester or the Ruhr regions of Germany – what you are watching most of the time are images of people living with this permanent stench of carbon monoxide poisoning, smoke everywhere. There is this green monster in the background of these documentaries. That was the background to our lives – it was the stage on which British lives unfolded.
>
> (Harris, 2017)

The archive continues to reveal buried treasures. The image itself, as it has existed for decades in the archive, bears witness to an impending disaster. The aspirations of immersive documentary filmmakers working today are bound to those of all activists – their objective is to hit the spectator with an epiphany, which will awaken them from their indifference to a situation. However, its methods are also identical to the contemporary mainstream film industry's obsession with technological advancement and the immersion of its audience through aesthetic intensity. I digress from Akomfrah's work here to highlight a potential accusation that all great artists will inevitably face – that the style becomes too familiar, that each film simply rehashes the last.

Figure 8.4 *Vertigo Sea* is demonstrative of a new ecopolitical turn in Akomfrah's practice. Images of the natural world are brought together with historical images of human exploitation, demanding greater intersectional inquiry

As stubborn retort to any such potential criticism, Akomfrah's persistence with archival material in the montage form seems only to flourish in its potential over time, expanding on ideas and messages and endlessly productive across socio-political dialogues. As a result, being able to utilise a shared form across different narratives (as Akomfrah is beginning to do with the turn to ecopolitics) has significant political potential. The core problem preoccupying progressive political thinkers for 50 years now has been the dissolution of the masses into different camps. Neoconservatives and neoliberals have made the most of this situation, exploiting the relative differences of these camps in order to divide more deeply. Thatcher's 'law and order agenda' was one example of this, which resulted in riots and public support for the government against the BAME community. *Handsworth Songs* was concerned with delineating the way such an injustice could come to prevail. When Western governments responded to a frenzied market crash with austerity policies, these divisions only increased. In hard times, the poor are encouraged to attack the poor. The disavowal of citizens and the garnering of xenophobia became official government policy during what has since become known as the 'Windrush Scandal' (where diasporic British citizens were wrongly detained under radical new immigration laws, which undercut rights of settlement enforced by the British Nationality Act 1948). Akomfrah pre-empted this with *Mnemosyne*, whereby foreignness is shown to be both a core component of British identity and an endlessly alienating experience. And more recently, how do we negotiate the fact that the rich and powerful so often appear to share an activist's concern for environmental damage, yet have no empathy for the human beings that occupy that environment? *Vertigo Sea* and *Purple* trace the connections – the shared paths of human and animal migration, the repurposing of power stations for luxury apartment complexes on the edge of the metropolis.

The core problem for those interested in contesting these different sites of injustice and exploitation is to find the points of connection, to mobilise across concerns. Those invested in political aesthetics seek out a mode of expression capable of convening these disparate groups. Akomfrah's fidelity to archival montage regards its ability to act as a space of intervention. To conclude, let's return to the disagreements with Stuart Hall's assessment of *Handsworth Songs* as the shining beacon of a new black cinematic language. Akomfrah's commitment to the form as well as its refinement; his recognition as one of the major artistic forces of contemporary British art and film over a 40-year period; his mastery and influence across today's diverse media landscapes: surely, Hall has been proven right.

Spaces of Intervention James Harvey

Bibliography

Akomfrah, J. (2015) 'Why History Matters'. *Tate*, last modified 2 July 2015. Available at: www.youtube.com/watch?v=jDJYyG7jKV0 (accessed 14 September 2020).

Balsom, E. (2014) *Exhibiting Cinema in Contemporary Art*. Amsterdam: Amsterdam University Press.

Banning, K. (1993) 'Feeding off the Dead: Necrophilia and the Black Imaginary'. *Border/Lines 29*(30) (Winter 1993): 28–38.

Barthes, R. (1982) *The Empire of Signs*. Trans. R. Howard. New York: Hill and Wang.

Benjamin, W. (1999a) 'Theses on the Philosophy of History' in *Illumination*. Edited by H. Arendt, 196–209. London: Pimlico.

Benjamin, W. (1999b) 'The Work of Art in the Age of Mechanical Reproduction' in *Illuminations*. Edited by H. Arendt, 166–195. London, Pimlico.

Chambers, E. (2014) *Black Artists in British Art: A History Since the 1950s*. London and New York: I.B. Tauris and Co. Ltd.

Eshun, K. (2006) 'Drawing the Forms of Things Unknown' in *The Ghosts of Songs: The Film Art of the Black Audio Film Collective*. Edited by K. Eshun and A. Sagar, 74–105. Liverpool: Liverpool University Press.

Fisher, J. (2006) 'In Living Memory ... Archive and Testimony in the Films of the Black Audio Film Collective' in *The Ghosts of Songs: The Film Art of the Black Audio Film Collective*. Edited by K. Eshun and A. Sagar, 16–42. Liverpool: Liverpool University Press.

Fisher, M. (2015) 'The Land Still Lies: Handsworth Songs and the English Riots'. *Sight and Sound*, last modified 1 April 2015. Available at: www.bfi.org.uk/news-opinion/sight-sound-magazine/comment/land-still-lies-handsworth-songs-and-english-riots (accessed 14 September 2020).

Foster, H. (2004) 'An Archival Impulse.' *October 110*(Autumn 2004): 3–22.

Foucault, M. (1972) *The Archaeology of Knowledge*. Trans. A.M. Sheridan Smith. New York: Pantheon Books.

Friedman, L. (1993) *British Cinema and Thatcherism: Fires Were Started*. London: UCL Press.

Fusco, C. (1988) *Young, British and Black*. Buffalo, NY: Hallwalls Inc.

Hall, S. (1988a) 'Song of Handsworth Praise' in *Black Film, British Cinema*. Edited by Kobena Mercer, 17. London: ICA Documents.

Hall, S. (1988b) 'New Ethnicities' in *Black Film, British Cinema*. Edited by Kobena Mercer. London: ICA Documents.

Harris, G. (2017) 'John Akomfrah: The Human Cost of Industrialisation'. *The Art Newspaper*, last modified 1 October 2017. Available at theartnewspaper.com/interview/john-akomfrah-the-human-cost-of-industrialisation (accessed 14 September 2020).

Harvey, J. (2018) *Jacques Ranciere and the Politics of Art Cinema*. Edinburgh: Edinburgh University Press.

Howe, Darcus (1988) 'The Language of Black Culture' in *Black Film, British Cinema*. Edited by Kobena Mercer, 17. London: ICA Documents.

Landau, P.S. (2002) 'An Amazing Distance: Pictures and People in Africa' in *Images and Empires: Visuality in Colonial and Postcolonial Africa*. Edited by P.S. Landau and D.D. Kaspin, 1–40. Berkeley and Los Angeles, CA: University of California Press.

Latour, B. (1996) 'On Actor-network Theory: A Few Clarifications'. *Soziale Welt 47*: 369–381.

Marks, L. (2015) 'Monad, Database, Remix: Manners of Unfolding in The Last Angel of History'. *Black Camera 6*(2) (Spring 2015): 112–134.

Mercer, K. (2006) 'Post-colonial Trauerspiel' in *The Ghosts of Songs: The Film Art of the Black Audio Film Collective*. Edited by K. Eshun and A. Sagar, 43–73. Liverpool: Liverpool University Press.

Naficy, H. (2001) *An Accented Cinema: Exilic and Diasporic Filmmaking*. New Jersey: Princeton University Press.

Rushdie, S. (1988) 'Songs Doesn't Know the Score' in *Black Film British Cinema*. Edited by Kobena Mercer, 16–17. London: ICA Documents.

9 Cosmopolitanism, Contemplation, and the Ontopolitics of Movement in John Akomfrah's Gallery Practice

Alessandra Raengo

In Spring 2014, artist and scholar Renée Green convened a Symposium at MIT titled *Cinematic Migrations* to address the centrality of the theme, practice, and epistemology of migration in John Akomfrah's work, as well as a principle of film form. The Symposium approached the idea of 'migration' capaciously: first, as the formal freedom afforded by the essay film, understood, after filmmaker and theorist Jean-Pierre Gorin, as the expression of 'the meandering of an intelligence' as it toggles back and forth between lyric phantasmagoria and the starkly real'. Second, migration referred to the technological developments that have made moving images travel across devices, venues, and contexts, whereby the movie theatre is no longer the privileged space of 'cinema'. Third, migration described 'the sociopolitical and cultural migrations of people, cultures, and ideas across geographic borders'.[1] The event included talks by cinematographer and filmmaker Arthur Jafa and scholars Manthia Diawara, Laura Marks, and Fred Moten (via Skype).

As it turns out, the theme of the MIT Symposium, which took place before Akomfrah presented his three-screen installation *Vertigo*

144 *Sea* at the 2015 Venice Bienniale 'All the World's Futures', curated by the late Okwui Enwezor, was both descriptive and prescient in identifying the centrality of the ontopolitics of movement in Akomfrah's practice. Akomfrah's past work in a variety of modes, including the theatrically released feature film, the made-for-TV documentary, and the single or multi-channel gallery installation, and, even more specifically, his philosophy of aesthetics about lens-based work conducted without attachment to institutional or generic narratives about what roles specific images are supposed to play, were regarded as a type of intellectual errantry, which Diawara interpreted as a Glissantian 'poetics of relation', a *wandering* without pre-determined destination, that is, without the necessity of narrative and identitarian closure. At the same time, Marks' focus on 'manners of unfolding' and the database logic in *The Last Angel of History* (1995) (Marks, 2015), alongside Arthur Jafa's presentation of his own APEX_TNEG (2013), marked a shift toward a greater attention toward what Akomfrah himself described in a celebrated 2007 essay as a 'digitopic yearning', the conviction that digital technologies can reconfigure the poetics of black filmmaking.[2] Finally, the Symposium was also prescient in anticipating the growth in scope and scale of Akomfrah's cinematic migration into the heart of the international art world as it occurred in Venice, which, Ian Bourland suggests, built on 1980s and 1990s black British art criticism's claim that 'the story of blackness in England is the story of England itself, [which] at least implicitly suggested that such a story was that of Western modernity as well' (2019: 131–132). With *Vertigo Sea*, in fact, the previous focus on subjects of diaspora grows in scope to include issues of global migration, refugeeship, religious persecution, and the effects of the Anthropocene/Capitalocene on global climate change. Akomfrah's increasing shift from an hauntological and 'necrophilic' sensibility (Banning, 1993; Eshun and Sagar, 2007) associated with an aesthetic of stasis (Banning, 2015) to an aesthetic of flow, that is, a growing reliance on aquatic imaginaries and on the sea as the figure for the simultaneous resilience, fragility, and unboundedness of diasporic archives as his work increases in scope, supports the idea that the story of blackness is, in fact, a planetary story – even a 'geological' one, as I'll suggest later. This demands new spatio-temporal frameworks as well as a 'scaling up' of the dynamic possibilities of montage Akomfrah had employed since his early work: a cinema of open-endedness, a cinematic migration built on the malleability and 'translatability' of a variety of disparate sources and on the viewer's ability to move nimbly across the audaciously evocative connections a film or multi-screen installation establishes between them.

Cosmopolitanism, Contemplation, and the Ontopolitics of Movement Alessandra Raengo

Whether understood as the epistemological freedom to pursue one's uninhibited inquiries into philosophical question of aesthetics, or whether understood as the mobility and nimbleness of one's practice across institutional, generic, and art-historical expectations, or as the poetics of montage carried out through multi-screen audiovisual practice, or as the defining feature of the cosmopolitan diasporic subject, or, under the guise of fluidity, as the defining trait of the current experience of global interconnectedness in the Anthropocene, the multivalence of the idea of 'migration', which here I interpret as a matter of the ontopolitics of movement, lies at the heart of Akomfrah's work.

As Renée Green, who convened the Cinematic Migrations Symposium, summarised it, cinematic migrations comprise 'motion, migrations, and e-motions', thus *motion* itself triggers a series of ancillary questions, namely: what (moves)? In other words, what is the subject/object of movement? Where does it happen? And how? I contend that the ontopolitics of movement in Akomfrah's gallery practice affects the meanings of cosmopolitanism in the context of the Anthropocene; it impacts the ethics and function of both diegetic and spectatorial contemplation in an increasingly fluid (albeit not attrition-free) world; and it recasts the role of cinematic archives in the context of the anaoriginary relation between blackness and movement. Thus, the answer to these questions, which here I can only provisionally sketch out, offers a key to thinking about Akomfrah's much discussed relationship to the archive(s) as well as about the relationship between fluidity and stasis in his work.

In this chapter, I will begin by reflecting on the *location* and the *subject* of motion in John Akomfrah's gallery practice by following two sets of interlocking tensions: the politics of access and the politics of form. Then I will show how the contemplative still subject that continues to appear in Akomfrah's *tableaux vivant* shifts the ontopolitics of movement to an interior and philosophical kinesis that does not require outward, visible, movement in order to take place. Specifically, in Akomfrah's work, this inner roaming benefits from an HD digital image that has vibrational qualities and therefore can act as a receptable of the subject's intellectual musings. I will suggest that the still human subjects are figures for the anaoriginary archives Akomfrah's work plunges while, at the same time, calling attention to the anaoriginary relation between blackness and motion. Ultimately, I will indicate, Akomfrah's approach to the ontopolitics of movement across his multi-screen practice invites the cosmopolitan viewer to an anacinematic space of precarity.

In terms of access, Akomfrah's growing multi-channel gallery practice has accrued a tension between his earlier investment in filling archival gaps – what the Black Audio Film Collective described as the 'absence of ruins' (Walcott, 1987; Eshun and Sagar, 2007) – and the fact that an exhaustive knowledge of Akomfrah's recent work requires a cosmopolitan viewer able to travel to globally distributed exhibition locations to become the site of another, unavoidably partial, archive. Indeed, by entering the global art scene so significantly, his 'migratory cinema' mirrors the migration of the diasporic subject into frames and spaces from which she was previously excluded (*Purple*, 2017). Yet, at the same time, this practice performs its own forms of exclusivity: because of its technical requirements, it can only be exhibited in selected venues and thus unavoidably adopts what Brian Price describes as the 'willed ephemerality' of limited access global art cinema, which requires the viewer's actual, physical movement 'across a wide range of borders' (2010: 111). Through its implied cosmopolitan viewer, it gives rise to an 'imperfectly formed community of interested participants' and therefore paradoxically re-emphasises privileges of mobility alongside the necessity of an archive of discourses that might extend access to these works (ibid.: 122). Thus, paradoxically perhaps, while it increasingly focuses on *forced migration*, Akomfrah's current gallery practice demands a cosmopolitan *traveller*, very much at odds with the migrant, the refugee, the discarded – 'the shipped' (Sharpe, 2016) – that is the object of his work.

While the very first tape slide shows – *Expedition I: Signs of Empire* (1983) and *Expedition II: Images of Nationality* (1984) – were first exhibited in the art gallery as it was a more receptive environment for the experimental work BAFC was doing in the mid to late 1980s, and as a creative strategy to compensate for limited access to modes of production, exhibition venues, as well as the official archives of British history, 30 years later, at the Venice Biennial, *Vertigo Sea*, which here I use as a convenient marker for Akomfrah's own cinematic migration into the heart of the global art world market, flips on its head the valence of 'limited access' and, in some respects, of cosmopolitanism itself: in 2015 'limited access' characterises Akomfrah's work. And rather than describing the mobility and multiple identities of the diasporic subject, in 2015 cosmopolitanism marks the genre of his film – what Nora Alter (2018) calls 'the contemporary transnational essay film' – as well as its privileged globe-trotting viewership, at a time when the artworld's 'addiction to flying' is being called into question (Chayka, 2019).

Cosmopolitanism, Contemplation, and the Ontopolitics of Movement Alessandra Raengo

At the same time, produced by and focused on diasporic subjects, all of Akomfrah's work has always been cosmopolitan in nature. But it's a different cosmopolitanism: discrepant, vernacular, and non-elitary (Bhabha, 1996; Clifford, 1998; Pollock et al., 2000; Mercer, 2005 and 2016). Indeed, he conceives of the diasporic subject as quintessentially in motion between a number of cultures, formations, alliances, and territories, as it comes to stark focus in *The Stuart Hall Project* (2012).[3] The politics of access of Akomfrah's work, therefore, exists at a point of tension with regards to both motion and mobility.

This tension is further complicated by the way in which the growth in scale of Akomfrah's dynamic approach to the archive, that is, his desire to provide its materials with 'new conditions of becoming', which has produced a now consistent multi-screen practice, clashes against a lingering, seemingly counter-intuitive formal move: figurations of the erratic and forced global movements of diaspora or the unstoppable planetary deterioration of climate change (*Purple*, 2017) through the form of the *tableaux vivant* populated by contemplative and predominantly still upright human figures, contemporary versions of the lone, rear-facing figure featured in Casper David Frederich's *The Wanderer above the Mist* (1817–18). This figure appears first most insistently in *The Nine Muses* (2010), a feature film that signals a transition between the early work and a more established cosmopolitan gallery practice, and in a number of works since: *Peripeteia* (on two African figures found in drawings by Albrecht Drürer, single channel, HD, 2012), *Transfigured Night* (on the early postcolonial moment, two channels, HD, 2013), *Tropikos* (on first contacts between British and Africans, single channel, HD, 2015), *Auto da Fé* (on religious prosecution, prompted by the discovery of a Jewish cemetery in Barbados, two channels, HD, 2016), *The Airport* (on ghosts of Empire in southern Greece, three channels, HD, 2016), *Precarity* (on Buddy Bolden, the legendary father of jazz, three channels, HD, 2017), *Mimesis: African Soldier* (on Africans' contribution to the First World War, three channels, HD, 2018), *Purple* (on the effects of global climate change, six channels, HD, 2017), and *Four Nocturnes* (on the slaughtering of elephants, three channels, HD, 2019). This figure, says Akomfrah, is the quintessential romantic subject who can contemplate the world in the absence of the Almighty – an absence that has opened the door for the 'figure of colour' to migrate into the frame and take possession of her romantic counterpart. Importantly, rather than describing these figures as simply alter-egos, Akomfrah thinks of them as co-participants, standing alongside him, so that 'when they face the *thing*, we do it together' (*Purple*, 2017: 43). This *static* figure's

contemplation, I will argue, should not be understood solely in visual terms – that is, what they are looking at is not what really matters – but in the peculiarly (ana)temporal and jurisgenerative terms of black anaoriginarity (Moten, 2018a): the fact that blackness is *previous* (to capital, to aesthetics, to Man …), but it doesn't have an origin we can identify and, consequently, fetishise (Derrida, 1996).

And while the 'monumental' stillness of BAFC's first two works, *Expeditions I* and *II*, expressed the pursuit of an 'epic construction', the 'desire to elevate Afrodiasporic subjectivity by imbuing figuration with a gravitas hitherto unimaginable in cultural production' (Akomfrah, in Eshun and Sagar, 2007: 81), it was also a byproduct of the chosen medium, that is, the fact that the group was not yet handling moving images, although they were still attempting to create simulacra of their movement (Whitley, 2018: 10). Furthermore, while multi-screen practice is both the natural evolution of logistical solutions already adopted with these same slide-tape shows, which required four projectors at all times, as well as a concrete proposition that the nonlinearity of digital cinema makes available as Akomfrah explains (*John Akomfrah: Signs of Empire*, 2018: 112), his overall attachment to the *tableaux vivant* still begs questioning.

In *The Nine Muses*, for example, the lone-standing and rear-facing figure brings the moving image to the limit of stillness, as if it was halting it to a freeze frame, while the high-definition digital image offers a vivid receptacle for the lone, contemplative, static figure's interior musings. That is, the expressive possibilities, indeed the seemingly *inner vibrancy*, of the highest possible image definition available on the market (*Oil Spill: The Exxon Valdez Disaster*, 2009, was allegedly the first documentary ever to be shot with a 4-K Red Camera and *The Nine Muses*, which uses some of the same footage, followed soon after), are put in the service of the diasporic subject's contemplation within a film that explores the experience and reception of the Windrush generation in England. In *The Nine Muses* the lone figures are featured with ample and vibrant negative space – filled with ripples of water or tiny snowflakes – which acts as a receptacle of their mental 'wandering', the philosophical performances of racial and sexual freedom that are enacted by the subject who invisibly moves along the grooves of her mind (Cervenak, 2014). Importantly, this 'interior kinesis' is not contingent on its legibility, which is displaced onto the image's negative space, just like one 'cannot presume … the absence of thinking – when the body seemingly stands still' (Cervenak, 2014: 165).

Cosmopolitanism, Contemplation, and the Ontopolitics of Movement Alessandra Raengo

Harriet Jacobs on the Way to Cinema

Alice Maurice (2013) argues that since the beginning of cinema, the movements of the black body were harnessed by the cinematic apparatus in order to project a sense of its own wholesomeness. However, the relationship between blackness and motion precedes the cinema: it is both *previous* and without origin. In Fred Moten's words, it is anaoriginary (2018a: 20).

In his contribution to the Cinematic Migrations Symposium, Moten advocated for an 'anacinematic' film practice no longer concerned with the sovereignty of the black subject since the very idea of the subject oscillates between 'the dream of exaltation into sovereignty and the shame that comes from the realization of the impossibility to fulfill that dream', an oscillation that the cinematic apparatus in turn has institutionalised in the tension between movement and stasis.[4] In *Black and Blur* (2017), he further develops this point. Reading a passage from Harriet Jacobs' *Incidents of a Slave Girl*, in which she narrates hearing 'a slow strain of music' coming from an otherwise quiet courtyard beneath the attic of her grandmother's house where she hid for seven years to escape her master's sexual predation, and then, thanks to a streak of moonlight coming from the window, she sees the 'forms' of her two children, Moten comments, 'In the crawlspace … Harriet Jacobs is on the way to cinema' (2017: 69).

Jacobs' pre-cinematic e-motion leads Moten to introduce his idea of the 'black cinematic apparatus' which he sees in image no. 308 from the catalogue of Thomas Eakins' Philadelphia studio: the photograph of a nude, young black girl posed in a way that is in direct conversation with the art historical location of her counterpart, that is, the maid as pure décor, in Manet's *Olympia* (1856). While this photograph participates in the same art historical 'pose', it is an exploration of the possibilities of the motion picture before pictures are in fact capable of moving. 'Motion within the frame is stilled so that motion between frames can be activated' (2017: 75). The imposition of this pose onto the little girl activates the flight that occurs before and after the photographic capture, a 'ruptural suspension' that locates the little girl's agency, paradoxically, in her '*position*, in an appositional force derived from being-posed, from being-sent, from being-located' (2017: 76). For Moten, 'the story that cinema tells in general is held within the frozen and deanimated image of a little girl. Cinema is the animation of *that* image', an animation that is both forced upon and stolen. Here, we find blackness as the 'pre-history of the post-cinematic' (2017: 73, 74).

149

150

If blackness is the pre-history of the post-cinematic because of the fugitivity and anaoriginarity of black movement – 'the black has to be still and still be moving', Moten adds – then it is worth exploring whether the posing figures in Akomfrah's work might partake of a similarly anaoriginary act.

When Akomfrah plunges the official archive of the Windrush generation, as he does in *The Nine Muses*, he is both reanimating and deanimating images that have already harnessed black movement in the service of ideological fixity. He does so in order to resist a dichotomic characterisation of the migrant whom archival representations either fixate in a metaphysical stillness (as James Snead might call it, 1994), or condemn to always arrive, always invade, and always labour. 'It's important to read images in the archive for their ambiguity and open-endedness', says Akomfrah (2016), 'migrants were often filmed in relation to debates about crime or social problems, so that's how they get fixed in official memory. But that Caribbean woman standing in a '60s factory isn't thinking about how she's a migrant or a burden on the British state; she's as likely to be thinking about what she's going to eat that evening or about her lover.' Indeed, while the archive shows migrants in motion – performing manual labour in factory jobs, for example – Akomfrah's intervention in this archive at times introduces moments of suspension of the linear time of capital by focusing on 'still acts' – historical interrogations that occur through 'corporeally based interruption[s] of modes of imposing flow' (Lepecki, 2006: 15) – that offer insights into a complicated interior life, such as a clip of a female factory worker's mental wondering, a temporary suspension registered as a seeming absent-mindedness. Furthermore, while, on the one hand, migrants are shown endlessly journeying, on the other hand, the official archive is not preoccupied with establishing or preserving any sense of continuity in their lives: they step off the boat, Akomfrah says, and they disappear. Thus, if migrancy is the epitome of becoming, the archive does not let this becoming ever come to fruition (Akomfrah, 2016).

The stillness of the lone, contemplative, rear-facing figures in *The Nine Muses* is both of the same and of higher order. These figures are the filmmakers themselves: Akomfrah, sound designer Trevor Mathison, and producer David Lawson, wearing alternatively bright yellow, blue, or black parkas. Additionally, their stillness is the result of an act of endurance: as producer David Lawson told me, 'we are driving around and suddenly stop. One of us gets out of the car and we try to stand still, even though it's cold, the wind is blowing, and we are freezing' (Lawson, 2014). Theirs is a *performance* of stasis, a

Cosmopolitanism, Contemplation, and the Ontopolitics of Movement Alessandra Raengo

second-order 'still act' against the extreme weather. But it is also a direct archival intervention: they 'hold together', and hold ground for, the very movement between the frames – the becoming of the migrants – that the official archive does not care to register and, in the process, assert the anaoriginary nature of the counter-archive of diasporic migration they are fashioning, of their own location within it, and of the very relationship between blackness and motion.

The *Nine Muses* is also one of the first feature films to be shot with the HD Red Camera, which allows the negative space around the static figure to appear buzzing with micro-movements, and 'breath'. The anacinematic or the fugitive movement between the frames cannot be contained by the pose of the human figure and, instead, seeps through the vibrational HD image. At the same time, *The Nine Muses* can also be seen to mark a transitional moment in which the nonlinearity of the digital might have placed the 'offer' of the possibility of a multi-screen practice 'on the table as a very serious ask, as a very serious proposition, and not as a gimmick' (*John Akomfrah: Signs of Empire*: 112) so that an ideological nimbleness in relation to the archive could be pursued by multiplying the possibilities of montage: both the affective proximity between fragments culled from different archives as well as the viewer's required e-motions among them.

Equiano's Law of Motion

Vertigo Sea's 'Oblique Tales of the Aquatic Sublime' begin with the sound of a clock ticking over images of tuna nets; human silhouettes are trapped in them. Images of seagulls plunging into the waters appear alongside. We hear a mantra, 'Jesus, save me; Jesus, save me; Jesus, save me.' It is an audio clip from a BBC radio interview of a Nigerian migrant who survived an illegal crossing of the Mediterranean by being caught in tuna nets after his boat capsized. A double prey (of smugglers and of the technologies of capture of the global food industry), this migrant's underwater view is inserted in the temporality of what Christina Sharpe has described as 'resident time' (2016). It is a position of literal and metaphorical entanglement, which stands in stark contrast with the transcendental view-from-above of most of the footage from the BBC Natural History Unit. That is, *Vertigo Sea* juxtaposes the 'ecological pathos' of the BBC Natural History Unit (Nilsson, 2018: 2) – producer of high-end nature documentary series like *The Blue Planet* (2001), *Planet Earth* (2006), and *Frozen Planet* (2011), which, as David Attenborough recently put it, is currently 'in paradise' because, 'there is nothing on this planet, now, that we cannot

see on film ... There's nothing we can't show' (2016) – with the ethical pitfalls of the Capitalocene, within a long durée that approaches race as a form of appearance of capital (Raengo, 2012). Original footage reenacting the moment the bodies of African slaves from the Zong were either being cast out to sea or washed up on shore is inserted into this complex montage. At other times, the slave daguerreotypes that Swiss natural scientist Louis Agassiz commissioned to South Carolina photographer Joseph T. Zealy in 1850 in support of his theory of polygenesis appear, as if looking out across the double captivity of their photographic fixation (Young, 2010). In the section devoted to the Argentinian Death Flights, underwater footage of sea creatures feeding off of cadavers dissolves into one of these daguerreotypes. Delia, the slave woman on whose face a tear is perhaps visible (Rogers, 2010), oversees the installation's end titles.

Vertigo Sea juxtaposes magnificent views of nature – aerial views of landscapes, and forests, underwater views of ocean, awe-inspiring waves – with archival newsreel footage of violent encounters with the sea in which humans have been either victims or perpetrators. Overall, however, it embraces an aesthetic of fluidity, 'liquid nationality' and geopolitical connectedness (Demos, 2018). When a whale is killed, the moment of death itself remains unseen, washed over by two giant waves crushing over the centre screen. They are followed by birds in flight. The whale is then dismembered, and the meat processed in the centre screen, while forests covered in colourful butterflies appear in the two other screens. Once the whaling footage is exhausted, fog falls on the forests. A title reads: 'The gunners themselves admit that if whales could scream the industry would stop, for nobody would be able to stand it.' Yet, the soundtrack in large sections of the installation contains the voices of the whales mixed in with electronic sounds. In the section on the Vietnamese boat people, introduced by the title 'With Her South China Sea Eyes: 1973', archival footage projected on the left screen shows a woman affected by Agent Orange, shaking uncontrollably, being helped by a nurse to bring an opium pipe to her mouth. On the screen to the right a cat, similarly unable to control its movements, falls from a wooden box; on the left another woman on a stretcher jerks sideways, unable to stop, while the screen in the middle shows a BBC Natural History image of a flat and peaceful ocean surface barely broken by swimming dolphins.

Even in this grandiose tapestry of ethically indifferent, sometimes shockingly jerky and yet consonant, movements in the natural and human world, the lone contemplative figure remains. Shot in the Isle

of Sky, figures dressed in clothes from a range of historical periods look out to sea. They are surrounded by household objects scattered around the landscape: a baby carriage, photo frames, typewriters, dolls, lampshades, chairs, navigational instruments, and a large number of clocks, marking Capitalocene's time and its accumulative and recursive logic (Nilsson, 2018).

Prominent among these figures is Olaudah Equiano. He purchased his freedom in his early 20s and then travelled the world from the Artic to Central America's Mosquito Coast. For this reason, T.J. Demos (2018) describes him as a figure of deterritorialisation that embodies the double-consciousness of migratory modernity. Cassandra Barnett suggests that part of the work's vertigo lies in seeing ourselves seeing the imperialist gaze in action and that we might be invited to take the lead from Equiano 'who (as imagined by Akomfrah resists our gaze, but does not gaze out to sea on our behalf either) [is] … suspended somewhere between passive spectatorship and instrumentalizing action. Perhaps wondering how to begin to tell us *how he sees*. Or whether to speak to us at all' (2016: 28).

Indeed, *Vertigo Sea*'s spectacularity is strategically ambiguous, perhaps functional to showing the 'intolerability of history and image alike': the fact that *Vertigo Sea*'s 'very filmic construction, its act of aesthetic capture, is also a visual component of Western modernity's violent project of dominating nature' (Demos, 2018: 79). This, Drew Ayers has shown (2019), was precisely the project behind *Planet Earth*, which combines the 'contemplative' mode of viewing associated with fine art photography with the technological conquering of a perfectly dominated field of vision. It does so through what he describes as a combination of hyperopticality – everything is crisply in focus – and hyperhapticality – the *stunning* quality of the images embrace and enfold the viewer and stimulate their sensorial apparatus. Both modes unfold through a privileging of Euclidean space, a space that can be penetrated at will, thus positioning the human viewer in the role of man-as-hunter. 'The visual technologies of *Planet Earth* thus initiate viewers into a nonhuman system of perception, one that claims dominance over the natural world through its ability to move effortlessly through radically varying scales, distances, and speeds of sensation' (Ayers, 2019: 192). These technologies' mode of vision is both too-human and supra-human, highly sensorial and distant, a view from everywhere and nowhere at the same time. In the process, *Planet Earth* presents itself also as a unique image archive, a recording of a view of a world that, because of climate change, might never be the same again.

If the BBC Natural Unit enacts an Heideggerian 'world picture', and its unbound cosmopolitanism 'from above', then the lone wanderer's holding posture is all the more essential as a counterpoint. Equiano 'oversees' the 'sublime' tragedies of aquatic deaths (Baucom, 2005), but he is in turn looked upon by Jack, Renty, Drana, and Delia, the slaves captured by the Agassiz-Zealy's daguerreotypes, where the commodity form of race and the commodity form of photography – photography as the money of the real (Comolli, 1980; Sekula, 2003) – meet in the same bodies and blackness itself acts as the *money of the real* (Raengo, 2012).

Thus, the deployment of the BBC Natural Unit materials alongside Akomfrah's original footage and the Agassiz-Zealy's daguerreotypes stage another, more sinister, conjunction between other types of cosmopolitanism: the cosmopolitanism of the BBC Natural Unit's HD image, which promotes and enacts an unbound visibility by acting as an 'all-seeing mechanical eye, a form of vision that augments and surpasses human perception' (Ayers, 2019: 173); 'total-access cosmopolitanism', which, Sean Cubbit (2004) reminds us, is the unrestrained cosmopolitanism of commodities; and the financial cosmopolitanism – a totalising general equivalency – brought to visibility by the Zong massacre and its subsequent trial (Baucom, 2005). These are also types of motion subjected to the frenzy of exchange, which Equiano resists with his contemplative stillness.

Equiano does not have to move because, as Moten argues, he is already a figure for blackness as 'law of motion': he figures both mercantilism (the law) and the mercantile (motion) (2018a: 59). As a former commodity who acquires commodities, he is the beginning and the end of the 'general equivalent', although his own origin is not clear, as Vincent Carretta (1999) has shown when he uncovered published insinuations that Equiano was in fact not born in Africa at all. Ultimately, Moten argues, he 'has no place in the place he is supposed to be found' (2018a: 60). Equiano partakes of the anaoriginarity of blackness insofar as, although his beginning point is unlocatable and unconfirmed, like blackness, he is 'present to his own making' (Moten, 2018b: 174).

But if that is the case, and, as Barnett hypothesises, Equiano is not interested in speaking to us or even share what he is seeing and thinking (i.e., where his mind is wandering), then the figures of stillness that continue to recur in Akomfrah's work might be obliquely directed also at the cosmopolitan viewer as a critique of her potentially 'possessive' spectatorship (Mulvey, 2006) by standing in for the archive's anaoriginary jurisgenerativity. Just like the multi-screen

installation does not afford the possibility of close analysis or to fully capture the logic of its montage, beyond what Akomfrah has described as 'affective proximity' between previously unrelated fragments, then the very limitations of the viewing subject might further complicate the possibility of memory and retention, that is, the possibility for the viewer to become an adequate corresponding archive to Akomfrah's strategically migratory 'anarchives'.

Indeed, Enwezor argued (2018: 86) that the multiplication of screens in Akomfrah's recent practice goes hand in hand with the multiplication of factors involved in the 'making of a historical subject', which I understand to be both the subject of the work as well as the installations' viewer. *Vertigo Sea* is only the first installation in a trilogy devoted to the destructive and self-destructive impulses that underly the Anthropocene. It includes *Purple* (2017), commissioned by the Barbican Curve, and *Four Nocturnes*, presented at the 2019 Venice Biennale for the inaugural Ghana pavilion. As the growth in scale and scope of Akomfrah's concerns extend to the temporal and 'geological' framework of the Anthropocene, his aesthetics become even more starkly divided between an emphasis on movement – whether through modes of fluidity, liquidity, 'entanglement and porosity' (the subtitle of *Four Nocturnes* nominally devoted to the slaughter of elephants, but also dealing with ethnic cleansing, forced migration, climate change, and the impossibility of claiming a privileged place for the human animal), or the unstoppable planetary movement toward destruction in *Purple* (Banning, 2017) – on the one hand, and the lingering static human figures, on the other. And as the scale of the work increases, the ontopolitical relevance of movement deepens: motion, argues Kathryn Yusoff (2018: 5), cuts through geological temporality itself as the discriminant between the '*inhuman as matter* and the *inhuman as race*'. This is because racial inhumanity as extractable matter is 'both passive (awaiting extraction and possessing properties) and able to be activated through the mastery of white men', that is, constantly both de- and re-animated, stilled and set in motion. By holding ground, Akomfrah's still figures reject this distinction.[5]

Bolden's Anaorginary Sounds

Akomfrah's three-screen installation, *Precarity* (2017) commissioned by the Nasher Museum of Art at Duke University for Prospect 4, New Orleans, curated by Trevor Schoonmaker is dedicated to Charles 'Buddy' Bolden. It identifies 'fluidity' and 'plasticity' as two key properties of DuBoisian double-consciousness and descriptors of an

Cosmopolitanism, Contemplation, and the Ontopolitics of Movement Alessandra Raengo

identity that has to be constantly refashioned as it interfaces a variety of confining environments, situations, and expectations.[6]

Boddy Bolden presents a quintessentially anaoriginary archival challenge insofar as, although he is credited as being the father of jazz, there is very little known about him. He has left no recordings of his music and only a couple of grainy black and white photographs, which, however, hardly identify him. *Precarity* is almost entirely composed of still frames, carefully staged tableaux, and barely moving human figures, sometimes framed on either side, by historical footage documenting a vibrant city life around them. A newspaper clipping from the era informs us that he struck his mother with a pitcher of water and was committed to an insane asylum in his early 30s. He died there some 17 years later. Despite the fact that *Precarity* is organised around an interpretation of double-consciousness as fundamental, if circumstantial, pliability, once he is silenced, and literally and metaphorically straightjacketed, it remains impossible to picture Bolden's moves. Consistently, Akomfrah refuses to imagine or (re) produce his sound. In *Precarity*, the stillness of the tableaux coincides with the forced anchyloses of the black subject, who has no choice but to only move along the grooves of his mind. Consequently, even the sound/image relation that Tina Campt (2018) has identified in *The Unfinished Conversation* as creating what she calls '*still-moving-images*', whereby the installation's 'sonic substance' acts as an instantiation of 'black visuality as flow', is halted. What does this say about Akomfrah's broader approach to the ontopolitics of movement?

Bolden's diagnosed schizophrenia registers, if we are willing to see it, the endless interior kinesis of a subject that has reached the limits of his double-conscious plasticity. As he sits, immobile, within the walls of the institution that imprisons his body, we should be reminded that the 'still body is also a roaming, musing body' (Cervenak, 2014: 165). Indeed, the music he initiated moves on, his sound is carried onward by other musicians, eventually giving rise to the most distinct aesthetic form of the twentieth century. As Pedro Lasch argued ('Precarity: Art and Humanities', 2018), his legacy partakes not of the monumentality of the statue, but rather of the ensemblic structure of social movements, which acquire momentum through their critical mass and thus is appropriately rendered through the ephemeral monumentality of video art.

The installation features a number of photographs submerged in running water. Flow, says Mark Anthony Neal ('Precarity: Art and Humanities', 2018), is the metaphor for a non-existing archive, or maybe for the 'incontinence of memory, the effluvial flow of archival flux' (Enwezor, 2018: 84). But also, perhaps for a quintessentially

anacinematic subject who can no longer coalesce around himself: during the installation's first movement, titled 'Fluidity', the voiceover insistently repeats 'between water and the sky, I am the only object'. Deborah Jenson ('Precarity: Art and Humanities', 2018) wonders if the installation's undoing of the visual mastery afforded by Quattrocento perspective, obtained by forcing the viewer to contend with multiple images across different screens, is meant to stage an encounter with neuro-divergence. In *Precarity*, perhaps more explicitly than in any other work to date, Akomfrah takes neuro-divergence as a guiding aesthetic principle for his multi-screen practice against fictions of coherence and singularity. Retrospectively, we can think of this effect as part of a larger project partly directed at the globe-trotting cosmopolitan viewer who, led to the limits of Bolden's plasticity, might be asked to consent to a similar precarity, that is, 'consent not to be a single being'.[7]

Akomfrah's work cannot escape the willed ephemerality of limited access global art cinema, especially at a time when, with increasing global climate concerns, this same globe-trotting art viewer is under scrutiny precisely for their mobility (Chayka, 2019). Yet Akomfrah's multi-screen practice can humble the viewer into a different relationship to their own viewership, cosmopolitanism, and ontopolitics of movement. The viewer is invited to reflect on the overwhelming complexity of the montages' connections, the fugitivity of their movements and, recognising the inadequacy of their own memories, their own flawed capacity for retention as well as the very limitation of themselves as 'single beings', entering a new non-sovereign anacinematic space. Mimicking the incontinence of memory, but also the impossibility to contain blackness's anaoriginary reach, the flow of sound and images rushing across multiple screens is meant to stage again and again the endless possibility of new encounters, encounters that, importantly, are never complete, never definitive, but rather always affected by the 'ambiguity of choice' (Akomfrah, 2019).

Acknowledgements

I want to thank Derrick Andre Jones for his thoughtful comments to this chapter, which has benefited from feedback from audiences at the Futures of Afrofuturism Symposium (University of Tennessee, Knoxville, 30–31 March 2017) and the European Studies Seminar, 'Europe and Beyond' (Center for Humanistic Inquiry, Emory University, 29 April 2019).

(2018) 'Precarity: Art and Humanities'. Panel featuring Pedro Lasch, Laurent Dubois, Michael Hardt, Deborah Jenson, Shambhavi Kaul, and Mark Anthony Neal. Available at: www.youtube.com/watch?v=lrwExeKLMm4 (accessed 10 December 2019).

Akomfrah, J. and Eshun, E. (2017) 'To Make Figures and Subjects Walk into a Frame: John Akomfrah in Conversation with Ekow Eshun' in *Purple*. Edited by Lara Garcia Reyne. London: Barbican.

Akomfrah, J. (2018) 'John Akomfrah in Conversation with Gary Carrion-Murayari' in *John Akomfrah: Signs of Empire*. Edited by J. Akomfrah, M. Gioni, G. Carrion-Murayari, T. Ballard, and D. Kopel. New York: New Museum.

Adusei-Poku, N. (2016) 'Post-Post-Black?' *Nka: Journal of Contemporary African Art* 38–39: 80–89.

Akomfrah, J. (2016) 'In Conversation with Ekow Eshun'. Lisson Gallery. Available at: www.youtube.com/watch?v=Rh9Rb0R_IyU&t=17s (accessed 19 April 2019).

Akomfrah, J. (2018) 'Featurette for Nasher museum, Duke University'. Available at: www.youtube.com/watch?time_continue=122&v=7CCbrGu_AzU&feature==emb_logo (accessed 10 December 2019).

Akomfrah, J. (2019) 'Creating Purple'. ICA Boston. Available at: www.youtube.com/watch?v=Unnuqs-RJuw&feature=emb_logo (accessed: 15 December 2019).

Alter, N. (2018) *The Essay Film After Fact and Fiction*. New York: Columbia University Press.

Attenborough, D. (2016) 'In Conversation with Charlotte Moore at the Sheffield Doc/Fest'. Available at: www.youtube.com/watch?v=boMCGA80JHM&t= 3066s (accessed 9 November 2018).

Ayers, D. (2019) *Spectacular Posthumanism: The Digital Vernacular of Special Effects*. London: Bloomsbury.

Banning, K. (1993) 'Feeding Off the Dead: Necrophilia and the Black Imaginary (an Interview with John Akomfrah)'. *Border/Lines* 29/30: 28–38.

Banning, K. (2017) 'Tomorrow, or the End of Time' in *Purple*. Edited by Lara Garcia Reyne, 21–25. London: Barbican.

Banning, K. (2015) '*The Nine Muses*: Recalibrating Migratory Aesthetics'. *Black Camera: An International Film Journal* 6(2): 135–146.

Barnett, C. (2016) 'Being Still of a Roving Disposition or, De-Seeing: A Polemic'. A public talk on John Akomfrah's *Vertigo Sea* & Bridget Reweti's *Tirohanga*. COCA, 25 June 2016.

Baucom, I. (2005) *Specters of the Atlantic. Finance Capital, Slavery, and the Philosophy of History*. Durham and London: Duke University Press.

Bhabha, H. (1996) 'Unsatisfied: Notes on Vernacular Cosmopolitanism' in *Text and Nation: Cross Disciplinary Essays on Cultural and National Identities*. Edited by L. García-Moreno and P.C. Pfeiffer, 191–207. Columbia, SC: Camden House.

Bourland, I. (2019) 'John Akomfrah: Multichannel Prehensions'. *NKA: A Journal of Contemporary African Art 45*: 131–132.

Carretta, V. (1999) 'Olaudah Equiano or Gustavus Vassa? New Light on an Eighteenth-century Question of Identity'. *Slavery and Abolition 20*(3): 96–105.

Cervenak, S.J. (2014) *Wandering: Philosophical Performances of Racial and Sexual Freedom*. Durham, NC: Duke University Press.

Chayka, K. (2019) 'Can the Art World Kick its Addiction to Flying?' *Frieze*. Available at: https://frieze.com/article/can-art-world-kick-its-addiction-flying (accessed: 26 December 2019).

Clifford, J. (1998) 'Mixed Feelings' in *Cosmopolitics: Thinking and Feeling Beyond the Nation*. Edited by P. Cheah and B. Robbins. Minneapolis: University of Minnesota Press.

Comolli, J-L. (1980) 'Machines of the Visible' in *The Cinematic Apparatus*. Edited by T. de Laurestis and S. Heath. New York: St. Martin's Press.

Cubbit, S. (2004) *The Cinema Effect*. Cambridge, MA: MIT Press.

Demos, T.J. (2018) 'Feeding the Ghost: John Akomfrah's *Vertigo Sea*' in *John Akomfrah: Signs of Empire*. Edited by J. Akonfrah, M. Gioni, G. Carrion-Murayari, T. Ballard, and D. Kopel, 76–81. New York: New Museum.

Derrida, J. (1996) *Archive Fever: A Freudian Impression*. Chicago: University of Chicago Press.

Enwezor, O. (2018) 'The Wreck of Utopia: Alienation and Disalienation in John Akomfrah's Postcolonial Cinema' in *John Akomfrah: Signs of Empire*. Edited by T. Ballard with D. Kopel, 82–91. New York: New Museum.

Eshun K. and Sagar, A. eds (2007) *The Ghosts of Songs: The Film Art of the Black Audio Film Collective*. Liverpool: Liverpool University Press.

Glissant, E. (1997) *Poetics of Relation*. Ann Arbor: University of Michigan Press.

Heidegger, M. (2002) 'The Age of the World Picture' in *Off the Beaten Track*. Translated by Julian Young and Kenneth Haynes, 57–85. New York: Cambridge University Press.

Keeling, K. (2007) *The Witch's Flight: The Cinematic, the Black Femme, and the Image of Common Sense*. Durham: Duke University Press.

Keeling, K. (2019) *Queer Times, Black Futures*. New York: NYU Press.

Lawson, D. (2014) Personal conversation with the author in occasion of Black Audio Film Collective Film and Discussion Series organised by *liquid blackness* at Georgia State University.

Lepecki, A. (2006) *Exhausting Dance: Performance and the Politics of Movement*. New York: Routledge.

Marks, L. (2015) 'Monad, Database, Remix: Manners of Unfolding in the *Last Angel of History*'. *Black Camera 6*(2): 112–134.

Maurice, A. (2013) *The Cinema and its Shadow, Race and Technology in Early Cinema*. Minneapolis: University of Minnesota Press.

Mercer, K., ed. (2005) *Cosmopolitan Modernisms*. Cambridge, MA: MIT Press.

Mercer, K. (2016) *Travel & See: Black Diaspora Art Practices Since the 1980s*. Durham, NC: Duke University Press.

Moten, F. (2017) *Black and Blur*. Durham, NC: Duke University Press.

Moten, F. (2018a) *Stolen Life*. Durham, NC: Duke University Press.

Moten, F. (2018b) *The Universal Machine*. Durham, NC: Duke University Press.

Mulvey, L. (2006) *Death 24x a Second: Stillness and the Moving Image*. Chicago: University of Chicago Press.

Nilsson, J. (2018) 'Capitalocene Clichés and Critical Re-enchantment. What Akomfrah's *Vertigo Sea* Does Through BBC Nature'. *Journal of Aesthetics and Culture* 10(1546538): 1–10.

Pollock, S., Bhabha, H., Breckenridge, C., and Chakrabarty, D. (2000) 'Cosmopolitanisms'. *Public Culture 12*(3): 577–589.

Price, B. (2010) 'Art/Cinema and Cosmopolitanism Today' in *Global Art Cinema*. Edited by R. Galt and K. Schoonover, 109–124. Oxford: Oxford University Press.

Raengo, A. (2012) 'Reification, Reanimation, and the Money of the Real'. *The World Picture Journal 7*. Available at: www.worldpicturejournal.com/WP_7/Raengo.html (accessed 7 July 2019).

Rogers, M. (2010) *Delia's Tears: Race, Science, and Photography in Nineteenth-century America*. New Heaven: Yale University Press.

Sekula, A. (2003) 'The Traffic in Photographs' in *Only Skin Deep Changing Visions of the American Self*. Edited by C. Fusco and B. Wallis, 79–110. New York: International Center of Photography.

Seremetakis, N. (1994) *The Senses Still: Perception and Memory as Material Culture in Modernity*. Chicago: University of Chicago Press.

Sharpe, C. (2016) *In the Wake: On Blackness and Being*. Durham, NC: Duke University Press.

Snead, J. (1994) *White Screens, Black Images. Hollywood from the Dark Side*. New York and London: Routledge.

Walcott, D. (1987) *Collected Poems 1948–1884*. New York: Farrar, Straus and Giroux.

Whitley, Z. (2018) 'Geography Lessons: Mapping the Slide-Tape Texts of Black Audio Film Collective, 1982–84' in *John Akomfrah: Signs of Empire*. Edited by T. Ballard with D. Kopel, 8–13. New York: New Museum.

Young, H. (2010) *Embodying Black Experience: Stillness, Critical Memory, and the Black Body*. Ann Arbor: The University of Michigan Press.

Yusoff, K. (2018) *A Billion Black Anthropocenes or None*. Minneapolis: University of Minnesota Press.

Notes

1. The Symposium description is available at http://news.mit.edu/2014/
cinematic-migrations-symposium-exploration-film-memory-and-identity.
2. For an in-depth discussion of Akomfrah's concept of digitopia in relation to
The Last Angel of History and Jafa's subsequent practice (in particular, *Love is the
Message, The Message is Death*, 2016) see Keeling, 2019.
3. See also Adusei-Poku on Afropolitanism (2016).
4. Moten's argument builds on Kara Keeling's theorisation of the relationship
between the cinematic and the colour line (2007). Moten's talk is available
here: www.youtube.com/watch?v=AIjipUxCYYs.
5. As Frank Wilderson might put it, they remain in the hold, despite fantasies of
flight (2010).
6. *Precarity* is subtitled 'Reflections on Six Properties of Double Consciousness'. They
are: Fluidity, Plasticity, Fugitivity, Enjambment, Waywardness, and Immanence. See
Akomfrah's interview with Mark Anthony Neal for Left of Black, 14 May 2018 www.
youtube.com/watch?v=va-Z_aLBc8o last accessed, 19 April 2019.
7. This is the title of the Fred Moten's trilogy, which comprises *Black and Blur* (2017),
Stolen Life (2018), and *The Universal Machine* (2018) all from Duke University Press.

Part IV
The Politics
of Diversity

10 'Could You Hire Someone Female or from an Ethnic Minority?': Being Both: Black, Asian, and Other Minority Women Working in British Film Production

Shelley Cobb and Natalie Wreyford

Introduction

The nominations for the 2020 British Academy of Film and Television Arts (BAFTA) film awards once again proved so disappointing in terms of diversity that the #BaftasSoWhite hashtag was soon trending on Twitter. The absence of women and people from black, Asian, and other minority ethnic (BAME) communities getting recognition has in recent years become one of the main talking points for awards season, especially since the first iteration of #OscarsSoWhite in 2016. It is also the time when data reports are published on Hollywood's

gender equality and diversity of representation on screen and behind the camera. And while the data always shows that women and BAME individuals are severely underrepresented in film production and on screen, the BAME women at the intersection of these categories are often sidelined in the data and media reporting, even as they number much fewer than white women and BAME men (Cobb, 2019). It is these women that we focus on – both their exclusion from and their work in the British film industry.

This chapter draws on the quantitative and qualitative research produced by the Arts and Humanities Research Council-funded project Calling the Shots: Women and Contemporary Film Culture in the UK, 2000–2015 that counted the numbers of women working in six key roles on British films between 2003 and 2015.[1] The most recent data for 2015 is stark but also emblematic of what all our reports found: 13 per cent of directors were women, 20 per cent of screenwriters, 17 per cent of editors, just seven per cent of cinematographers, 27 per cent of producers and only 18 per cent of executive producers were women (Cobb, Williams, and Wreyford, 2016). These statistics are shocking and have been received as such by some of those working in the British film industry (Roberts 2016). However, for each one of those roles BAME women counted for less than 2 per cent of the entire workforce in 2015 and not one was a cinematographer. This chapter uses the data gathered through Calling the Shots to analyse and describe patterns of employment and collaboration along race and gender lines, and when and how these identity markers appear most significant in securing work for BAME women. By analysing that data in conversation with Calling the Shots interviews, we aim to highlight the intersectional identities and experiences of these women (Crenshaw, 1992: 1244) in an industry that favours whiteness and masculinity.

Methods

In this section we will briefly describe our methods for finding the BAME women working in British film production. A full discussion of our methodology, our challenges, anxieties, and our decision-making processes can be found in an earlier article (Wreyford and Cobb, 2017). For the Calling the Shots team, recording the racial background was as important as identifying the gender of production workers. Using a list of films in production during the years 2003 to 2015, provided by the British Film Institute (BFI), we identified as best we could all the individuals involved in the production of

'Could You Hire Someone Female or from an Ethnic Minority?' Shelley Cobb and Natalie Wreyford

British-qualifying films in six key roles: director, screenwriter, editor, cinematographer, producer, and executive producer. At this point we have full datasets for all six roles for the years 2003, 2004, 2005, and 2015 and we have data on all directors, editors, and cinematographers for every year between 2003 and 2015 inclusive.

From this data we have produced 14 reports detailing the unequal presence of women in the UK film industry. This chapter draws largely on two: 'Calling the Shots: Black, Asian and Ethnic Minority (BAME) women working on UK-qualifying films 2003–2015' (Cobb et al. 2019a) and 'Comparing the numbers of women directors, editor and cinematographers on UK-qualifying films 2003–2015' (Cobb et al., 2019b). The first report focuses on the synchronic data for the years 2003, 2004, 2005, and 2015 and the BAME women we found in all six roles in those years of film production. The second covers the diachronic data from all years from 2003 to 2015 for the roles of director, cinematographer, and editor. At times we will be referencing the raw underlying data that we compiled, for example when identifying a particular film and the individual women workers.[2]

In order to identify the individuals involved in the production of the films we cross-referenced the BFI data with other sources such as the IMDb (International Movie Database), individual websites, Companies House, and ScreenDaily. In the majority of cases, gender and race were read from available photographs, biographical information, and pronouns as our primary concern was how an individual's presentation of themselves is read by others, in particular by potential employers (Wreyford and Cobb, 2017). We recognise that this is problematic and limiting and does not allow for nuance or an understanding of the social constructedness of these categories. However, Byron Burkhalter (1999: 63) has argued that 'racial identity is no more ambiguous online than offline' and that similar stereotyped assumptions can be shown to arise from the way race is read online to that of the physical world. It is this reading of an individual's race, and the resultant assumptions and potential discrimination that we are interested in over the possibility of recording an individual's race as they themselves might define it.

The racial categories that we applied initially were those defined by the Commission for Racial Equality (CRE).[3] The main categories used by the CRE are White, Mixed, Asian, Black, and Chinese. Within these groups the CRE identifies several groups of people who are to be included, for example, within the 'Black' category, the CRE lists: Black, Black British, Black English, Black Scottish, or Black

Welsh, but then offers three choices: Caribbean, African, or 'any other Black background'. Since those involved in making British-qualifying films are not all British, we also collected data on nationality in order to distinguish between, for example, a person living and working in India who was employed on a UK-Indian co-production and a British Asian individual who lives and works in the UK.[4] We were uncomfortable with the last category of 'Chinese' since we had very low numbers of Chinese individuals in our dataset and had similar numbers of people from other East Asian countries such as Korea and Taiwan. Since the CRE's 'Asian' category specifies sub-groups as Indian, Pakistani, and Bangladeshi, we were also concerned that the dominance of this group within the UK's BAME population might conceal the very low numbers of people from East Asian countries and so we decided to use White, Black, South Asian, and East Asian as our main categories. We are aware that these categories elide many nuances of racial identity, but it has sometimes been necessary to aggregate smaller categories in order to cogently analyse and discuss this data. Our more pressing concern is to highlight the paucity of these women in employment in British film production, and to draw attention to those who *have* found a way to work.

Counting the Black, Asian and Minority Ethnic Women in British Film Production

For the synchronic dataset (Cobb et al., 2019a) we were able to find the individuals who held 8,784 credited roles. Within this number, 120 positions were held by BAME women. That is just 1.4 per cent of the British film workforce in the six key roles for those four years. The total number of films for which the data has been completed so far is 801. Of these films, only 80 had one or more women of colour in at least one of the six key roles, meaning that 90 per cent of British films in this set had no BAME women in any of the key roles. We found only 48 BAME women working as directors between 2003 and 2015. This is *1* per cent of all the directors employed on UK-qualifying films during this time (Cobb et al., 2019b). In the same period just 32 BAME women editors were employed (less than 1 per cent of all the editors) and a dismal ten BAME women cinematographers (0.3 per cent of all cinematographers). None of the BAME women cinematographers worked on more than one UK-qualifying film in the 13 years of data. In the following section we will outline the precise numbers and roles taken up by women from each of these racial groups. Then, in the second half of this chapter we consider some employment patterns

we have identified in the data, drawing on some of our interviews with the women themselves, including Taiwanese director Jenny Lu, British Asian screenwriter Smita Bhide, and black British editor Tania Reddin.

The Black Women

As reported in Cobb and colleagues (2019a), we found just 19 black women across the six key roles in four years of British-qualifying film production: six directors, five screenwriters, four editors, one cinematographer, 11 producers, and two executive producers. This is a total of 29 individual roles, ten more than the *actual number* of women, an important distinction to note, as it highlights one of the limitations of quantitative data. When looking at the numbers, it would not be clear that these 29 roles were taken up by only 19 women. There are actually fewer BAME women in the datasets than might be apparent at first glance. This could be a positive indicator that certain women are being employed more than once, meaning that they are potentially building a career, but there are other less encouraging reasons for one woman taking up more than one role that we will come to. Overall, only 23 films have a black woman working in one of the six key roles out of 801 films: *less than three per cent of all the films.*

Similarly, when we looked at directors across all 13 years, we found that although there were 15 times that a film had a black woman director, Brits Amma Asante and Ice Neal were director three times and twice, respectively, meaning that there were only 12 black women directors working between 2003 and 2015. In any year there are never more than two black women credited as directors, and there are several years where there are no black women directors. Black women editors are very scarce over the datasets, and there were several years where none were employed at all. Only five women worked as editors across eight films. British editor Tania Reddin edited two films, as did Nikki Porter and Frenchwoman Maryline Monthieux. There were two black British women cinematographers: Isis Thompson and Jeanette Monero. The third black woman working as a cinematographer was Kalilah Robinson whom we discuss later. In ten of the years there was no black woman cinematographer employed at all.

The black women that we identified also include Isis Thompson, director of *The Real Social Network* (2012),[5] Destiny Ekaragha, director of *Gone Too Far* (2013), and Debbie Tucker Green, director of *Second Coming* (2014). Catherine Johnson was the screenwriter of *Bullet*

Boy (2004); Rita Osei was the writer, director, and producer of *Bliss!* (2016), and Florence Ayisi, a Cameroonian residing in the UK, co-directed *Sisters in Law* (2005). We also found Danish writer/director Hella Joff, South African producer Bridget Pickering and editors Elise Mogue (*Eva's Diamond* 2013) and Folasade Oyeleye (*Breakdown* 2016). Among the British producers we identified Stella Nwimo, Joy Charoro-Akpojotor, Adelle Martins, and Esther Douglas. Michele d'Acosta is the only black British executive producer in our data, but we also identified Americans Tracee Stanley (producer), Carmel Musgrove (producer), and Elishia Holmes (executive producer), as well as two films produced by Frenchwoman Virginie Silla. Writer/director Adaora Nwandu is discussed in more detail shortly in Homophily.

The South Asian Women

There are slightly more South Asian women in the dataset, not least in part because of the predominance of several Indian/UK productions qualifying as inward investments, bolstered no doubt by the success of India's own 'Bollywood' film industry. An 'inward investment' is one of three ways that a film can qualify as British and describes films that are substantially originated, financed, and controlled from outside the UK but shot in the UK because of story requirements (e.g. locations) and/or to access the UK filmmaking infrastructure and technical expertise, and/or to access finance via the UK's tax relief schemes (BFI, 2018: 9). Inward investment films make up almost one quarter (24 per cent) of the films in our datasets from the BFI. UK/Indian films make up the second largest section of this category of British-qualifying films after UK/USA partnerships. Nevertheless, there were just 28 South Asian women working on British films in four years of synchronic data. They held 75 different roles across 45 films. The majority worked as producers (49) and executive producers (10). There were ten screenwriters, seven directors, two editors, and no cinematographers.

From 2003 to 2015 there were only 15 South Asian women directors, across 24 films. Brit Gurinder Chadha directed four of those films. Indian/Canadian director Deepa Mehta, Indian director Mira Nair, British director Pratibha Parmar, Brit Shamim Sarif, Indian Sridevi Yelamanchili, and Indian Chaand Chazelle all directed two films within the period. There were nine South Asian women working as editors during this time period but only one – Brit Anuree De Silva – worked on more than one film (she is credited on three). Only three British women of Southern Asian origin worked

as cinematographers: Shamim Sarif, Neha Parti Matiyani and Anjni Varsani. In 11 of the 13 years of data no South Asian woman was employed as a cinematographer.

Other South Asian women we were able to identify include Avantika Hari, the British screenwriter of *Ramji London Wale* (2005) and Radha Chakraborty, screenwriter and producer of *Someone Else* (2006). Smita Bhide, the British writer/director of *The Blue Tower* (2009) is another of our interviewees, and Indian director Mira Nair and Indian producer Dinaz Stafford are discussed later under Homophily. There were three other British editors: Meera Patel, Pratibha Parmar, and Farrah Drabu and a further five Indian women editors. The British producers we found were Uzma Hasan, Meenu Bachan, Firuzi Khan, Manda Popat, and Anuree De Silva. Also included in the 28 women were Chitra Banerjee Divakaruni, the Indian/American whose novel is the basis for Chada's *Mistress of Spices*, Belgian producer Iwona Sellers, and Canadian producer Mehernaz Lentin. All the rest of the women were based in India and worked as producers and executive producers with the exception of screenwriter Deepa Ghalot.

The East Asian Women

Women in this category were the scarcest of all in our data. We identified only 15 women across the four years of complete data (Cobb, Williams, and Wreyford 2019a). These women held 16 roles and worked on just 12 of the 801 films (1.5 per cent). Once more we see the majority in producing (7) and executive producing (3) roles, with one director, four screenwriter credits and one editor, and, again, in this group there were no cinematographers. Between 2003 and 2015 there were eight East Asian women working as directors on ten films. Xiaolu Guo, a Chinese/British director worked on two films and Leonora Moore a British/Malaysian director, also worked on two. In seven out of the 13 years of diachronic data, there were no East Asian women directing films at all. Twelve women worked as editors across 13 films. Hoping Chen was the only editor who worked on more than one film. Three editors were American, working on big budget films based in the USA, and the rest were British or resident in the UK. Four East Asian women were employed as cinematographers: Shelley Lee Davies, Rain Li, Rina Yang, and Xiaolu Guo. There were nine years where no East Asian woman was employed as a cinematographer at all.

Jeanney Kim was one of the executive producers on *Amazing Grace* (2005), a USA/UK inward investment production. Nila Maria Mylin was the producer on *Those Without Shadows* (2004), a

low-budget British film. Julia Oh worked on white British filmmaker Andrea Arnold's third film *American Honey* (2016). The film was a USA/UK production and Oh was one of six producers, the rest of them men. Winnie Lau was the only woman executive producer of *How to Talk to Girls at Parties* (2017), another USA/UK film. Both Oh and Lau live and work in the USA. Winnie Li is credited as an associate producer on *Cashback* (2006). Emily Leo is British Thai and was the only woman producer of *Under the Shadow* (2016), a British domestic film.

Michiyo Yoshizaki is credited as both producer and screenwriter of *Guantanamero* (2007). Yoshizaki is one of 13 producers on the film which has a white British man as co-screenwriter. Yoko Ogawa is credited as a screenwriter on the film *L'Annulaire* (2005), a French/UK/German co-production that was based on Ogawa's 1994 novel *The Ring Finger* (薬指*Kusuriyubi*). The film was adapted for screen and directed by Diane Betrand, a white French woman and as far as we are aware Ogawa had no role on the film itself. Haolu Wang is the screenwriter of *My Best Friend's Wedding* (2016), a Chinese production which has questionable status as a British-qualifying film.[6] Hsiao-Hung Pai was one of the writers of *Ghosts* (2006) although she doesn't get the same credit as writer/director Nick Broomfield or the other white man screenwriter, who both get 'written by' credits, whereas Pai is credited with 'work of'.

All the rest of the East Asian women that we found in these four years of data worked on the same one film: *The Receptionist*, a film in production in 2015. Jenny Lu is credited as director, screenwriter, and producer of the film; Yi-Wen Yeh as the screenwriter; Hoping Chen is the editor; Shuang Teng and Zi-Ning 'Francoise' Chen are also producers. This accounts for almost half of all the East Asian women in the synchronic data. We will discuss this film in more detail in the next section where we consider some of the employment patterns that can be observed by tracking these BAME women and the films they worked on. What follows are not exhaustive or forensic examinations of individual employment processes. What we hope we offer are ways to understand BAME women's participation in British film production and how their numbers might be increased.

Employment Patterns of Women of Colour in British Film Production

Our data allows us to see with whom BAME women worked and on what films, and to identify repeated occurrences and patterns.

While these are not the only ways to interpret the employment of BAME women on British films, the patterns that we consider in the next sections are those we are grouping under the terms 'tokenism', 'segregation', and 'homophily'. Our use of these terms to analyse our data and interpret our interviews offer some insight into both the opportunities and the limitations that BAME women may come across. Our hope is that by providing a way to talk about these employment tendencies, we can identify potential points of intervention to increase opportunities for BAME women. Throughout, we will draw on both the quantitative and qualitative data compiled for Calling the Shots to illustrate these patterns, but first we will briefly explain what we mean by these discursive labels.

We use 'tokenism' here to describe the numerous occasions where a BAME woman was the *only* BAME woman working in one of the six key roles on a film. Examples of tokenism in employment can be found on the Tumblr account *Shit People Say to Women Directors (& Other Women in Film)*. This account is, in their own words, 'an anonymous open blog for all individuals identifying as women who work in film and television' to share their experiences 'for catharsis and to expose some of the absurd barriers women face in the entertainment business'.[7] When it comes to diversity, it has been all too common for employers to feel that one is enough:

> I'm a DGA Director with Primetime Network TV Credits. I've been told: 'We already hired an African American so we're TOTALLY covered for diversity this season. Sorry!'

> 'Well, they ARE still hiring mid-levels, but they already have their woman.'

Tokenism is a sticking plaster approach to diversity and equality of opportunities. It suggests a lack of trust (Wreyford, 2018) and has the potential to leave the 'chosen' participant feeling isolated and hyper aware of their racial difference. The examples above also illustrate once again how race and gender are used separately and how BAME women are both doubly disadvantaged and simultaneously not even mentioned.

'Segregation' can feel like a loaded word in discussions of racial inequality, but its absence from such discussions can be seen as an attempt to discursively brush over the truth (Massey and Denton, 1993), or perhaps, more generously, a misguided attempt to believe greater progress has been made than in reality. However, segregation

is a term frequently used in employment studies to describe the persistent structuring of opportunities along both gender and racial lines (see for example Bielby and Baron, 1984; Barbulescu and Bidwell, 2013; Tomaskovic-Devey, 1993). Segregation describes instances of a striking proportion of a particular type of person found in one job type, not as product of overt policy but more likely as a result of structural inequality, socialised roles, and an undervaluing of types of persons and types of jobs, as evidenced by nursing (Porter, 1992) and waiting staff (Hall, 1993). In the cultural industries, jobs associated with women tend to be paid less and considered less creative (Hesmondhalgh and Baker, 2015).

In film work, gender segregation is most easily observed along lines of job categories: makeup and hair departments are dominated by women while the more equipment-heavy departments such as lighting and sound are predominantly men (Hesmondhalgh and Baker, 2015). Wreyford (2018) has shown how screenwriters are frequently employed according to gendered assumptions of the type of stories that men and women write. Wreyford describes how the use of terms like 'chick flick' means that women are othered as both audiences and producers. This same process can lead to several BAME women working together on a film, and while this might appear to be progress from tokenism, the women are in effect segregated from the most lucrative opportunities in film production, which are still dominated by men and some white women.

'Homophily' is the tendency of individuals to associate with others who they feel are similar (Ibarra, 1992). Elsewhere we have shown how male homophily is a key factor in creating barriers for women and anyone who doesn't fit the dominant white, wealthy, CIS-gendered, heterosexual, able-bodied mould of those who are currently given the majority of opportunities to make films in the UK (Cobb, 2019; Wreyford, 2018). In our research for Calling the Shots we have been able to identify that women play a critical role in employing other women and can often be found working together (Cobb, Williams, and Wreyford, 2019c). Tokenism and the low number of BAME women actually accessing work make it more challenging to find examples where BAME women work with other BAME women but there are examples we discuss below. Perhaps the most hopeful of our discursive categories, homophily might be most useful in showing who is doing the best work employing BAME women. In the next three sections we will address each category in more detail, drawing on examples from our datasets and from our interviews with the women themselves.

Tokenism

In our synchronic data, tokenism was most pronounced with black women. We found only one film with more than one black woman working in a key role: *Rag Tag* (2010), which has two. Tokenism is sometimes hard to identify because – as discussed above – what looks at first glance like multiple women of colour working on a film turns out to be one woman working in several roles. British Asian Director Gurinder Chadha is an example of this: she often works as director, screenwriter, and producer on her own films but rarely works with another woman of colour in a key role. Editor Tania Reddin is one example of a mixed-race black woman who had not worked with another BAME woman on a film in our data. Reddin told us that she got her first break in editing from a woman editor who trusted her to take over a job and that she jumped at the chance to work on *Poirot* (*Curtain: Poirot's Last Case*, 2013) in order to work with Hettie McDonald because, as she said, 'women directors are so rare'. And yet, when it comes to her work on films, she has worked most often with the director Adrian Shergold, editing six films with him.[8] They have a very good working relationship, and she gives him credit for both understanding the demands of parenthood and trusting her so much that he has been regularly flexible with her working schedule.

That a white male director and a mixed-race woman editor have created a consistent and successful working relationship is a good thing, but it should, of course, also be a normal thing, not something the white man gets special credit for (Cobb, 2019). And because so few white men work with women of colour and there are very few women directors, from the bigger picture of the data, Reddin's success represents tokenism. Reddin's talent is not in question, nor is Shergold's respect for it, but with so few women editors of colour, her career is both exceptional and the exception that 'proves the rule' that very few women of colour can make it.

Reddin originally wanted to be a writer, and early on wrote several scripts with largely black casts. She told us that when she put these in front of producers and financiers, they would say:

> Who would you cast in this? I mean literally, if it hasn't got Denzel or Samuel L Jackson in it, though they're American, how are you gonna get this made?

There are multiple forms of institutional racism constructing this feedback to Reddin: first, that there aren't enough black actors in the

industry; second, that only a couple of black actors have enough fame to bring in money; and third, that despite its rarity, a film with a black cast of unknowns isn't worth taking a risk on. This very risk-averse perspective on BAME creativity in multiple forms is both at the heart of tokenism and upholds tokenism. If very few white men take a risk on BAME stories and BAME individuals, there are never going to be enough established names and proven track records for financiers to feel reassured. It is a self-fulfilling prophecy and must be addressed.

The inability to see potential in scripts that do not submit to hegemonic whiteness is something that Smita Bhide also experiences as a British Asian writer. Bhide was a member of the Southall Black Sisters in the 1980s and first picked up a movie camera in the 1990s when the council gave funding to a mother and toddlers group for a workshop with a local filmmaker. She was writer-director and – with her husband – funder of her feature-length film debut, *The Blue Tower* (2009), and since then has developed a successful television-writing career. Halfway through our interview with her, she stated: 'race has played so much, a so much greater part in my career, shaping it or not shaping it, as anything to do with gender'. She then told us a story that might, by some, be discussed as the 'unconscious bias' of individuals but for us reflects the structural and cultural racism of the industry:

Is this what the audience wants? Are these characters likeable? Which are the questions all filmmakers face whatever race or gender they are. Obviously it impacts you more if you're the only Asian filmmaker that year who's got a project and it doesn't happen. I had a script that was an action film with an Asian female heroine, which was one of the scripts that people have read over the years and gone 'this is great'. I've got jobs off the back of that script. We got a producer; we got finance. It was set in Yorkshire so we got some money from Screen Yorkshire to develop it with a very reputable, small independent company. And it was going up for financing at the same time as *Brick Lane* (2007), which was, you know, a novel, a BBC film, had some named talents attached. And um, people were saying, well one, financier said, or sales agent said, 'this is great; this is very, very exciting. This is so much more exciting than this other project, but we're going to go with the other project because it's BBC films'. Because it has provenance, the novel, BBC films, that talent attached. They're only going to make one brown-faced film a year, every five years. So, which one are they gonna choose?

The 'they' that she refers to are not specific individuals or groups, they are the power structures of the industry. 'They' are the assumptions made about what audiences want to watch, what financiers will take a risk on, what is seen as an 'authentic' or 'believable' British Asian story. As she said, 'they're only going to do one and that is inevitably the one that feels like the safe one', a clear example of tokenism in the British industry.

Near the end of our interview, Reddin discussed further what we might see as 'positive' tokenism. She told us about a BFI-funded, high-profile feature film for which she was hired as editor, where multiple crew members with hiring power told her they needed to hire more women. She was asked that if she needed to hire an assistant, 'could you hire someone female or from an ethnic minority or gay?' Reddin's interpretation is that the BFI's Diversity Standards were a lever in the hiring of her and the motivation for these conversations. There is no evidence yet that the Diversity Standards are having a significant impact on the industry as a whole in terms of the numbers of women and persons of colour working in key roles (Nwonka, 2020), but Reddin's story suggests that they may be having some influence on individuals getting repeat work after becoming known for their skills while also being able to tick a diversity box on a funding form. Radically altering the wider makeup of the industry in terms of numbers and developing individuals with successful longevity should not be mutually exclusive, but for now that seems to be the case.

Segregation

The Receptionist (2018) stood out in our synchronic data as it has 15 East Asian women working across the six key roles on one film. This could be seen as a particularly strong example of homophily (see below) that increases diversity numbers, but the production context complicates this positive view of the data. Lu received money from Taiwan alongside funding she got from the UK, making the film an official British-Taiwan co-production. Part of the requirement for receiving the Taiwanese funding was that a portion of the film had to be made in Taiwan with a Taiwanese crew. Co-productions are films with dual nationality and are a key part of the British industry. Calling the Shots has shown that British co-productions have more than twice as many women directors than British domestic films, and that co-productions have more women in all roles than domestic films (Cobb, Williams, and Wreyford, 2019). However, while co-productions are clearly a positive form of international collaboration, they can also

isolate British filmmakers with hyphenated identities, keeping them out of domestic production. Award-winning author, Xiaolu Guo, writer-director of *She, a Chinese* (2009), which is half set in China and half in London, told us it took seven years to get UK funding for the film even though the script had won a competition at her NFTS graduation. She didn't even try to get British funding for a film completely set in China because, according to her, 'No one here, no one in the UK would give a damn. They see someone Chinese and say: "Go away". *The Receptionist* suggests that British co-productions with Taiwan, China, India, and South Africa might cause us to read a film with several women of the same racial identity as evidence of (the slightly more positive term) homophily when it could also be interpreted as segregation.

Segregation allows 'diversity' to happen without infiltrating the concerns of the people controlling the majority of films and film financing in the UK (Grugulis and Stoyanova, 2012). While individuals might find their way into mainstream film production through tokenism, when BAME women work together it is often only on certain types of films, those which tick diversity boxes or allow British money to be stretched further through co-productions with other countries. It can also mean that certain subjects and certain job opportunities are seen as appropriate for certain types of people. Natalie Wreyford has shown elsewhere how women are pigeon-holed as being inherently more suitable for smaller, romantic and relationship dramas, despite the fact that women have been involved in making all sorts of genres and budgets for as long as films have been made (Wreyford, 2018). Smita Bhide's experiences detailed above can also be viewed an example of segregation, where a person's identity limits the content that they can create to what will not disrupt the white, male status quo. These films are not often the ones that receive large marketing budgets, wide distribution, or can afford well-known actors. Still, within a pattern of segregation, homophily can play a part. In our April 2017 interview with Lu, she talked warmly of her editor Hoping Chen, who is also a Taiwanese woman living and working in London: 'I don't think anyone else would do that with me. Work til 4 in the morning … And she's a woman. I think that's why she's so sensitive and cares for the details. And it's a woman's film, and I think that's right to have her edit.'

Homophily

As mentioned above, the film *Rag Tag* (2010) is one of the examples of homophily that we found in our synchronic data. It was in

production in 2005 and is a low-budget British film about two black men who were childhood friends and discover feelings for each other when they meet again as adults. The film was written and directed by Adaora Nwandu, who identifies on her Twitter account as an Afro Briton based in Los Angeles and on her Instagram account as 'Nigerian bred, UK born, USA based'.[9] The film's cinematographer is Kallil Robinson. Her website, www.kallilahrobinson.com says she was born and raised in Bermuda, attended Stanford University and the American Film Institute's cinematography Master's program. Calling the Shots has shown that women cinematographers are more likely to be employed on a film with a woman director: 43 per cent of films with women cinematographers also have at least one woman director and 40 per cent have *only* women directors (Cobb, Williams, and Wreyford, 2019b). This is very significant given that women direct only 14 per cent of films overall. It is perhaps not so surprising then that the only BAME woman cinematographer in our dataset is found working with another BAME woman. Our research has shown again and again that women can be found working with other women (Cobb, Williams, and Wreyford, 2019c) and as Cobb (2019) has shown elsewhere, BAME women are already 'doing diversity'.

Some women in the Southern Asian category are prolific producers and therefore, unsurprisingly, South Asian women often work with other South Asian women. In the four years of complete data Vibha Bhatnagar produced 11 films, Sunanda Murali Manohar produced nine films, Meenu Bachan produced six films, and Subha Sandeep produced four films. Seventy per cent of films with a South Asian woman in a non-producing key role also have a South Asian woman producer. In addition, as with black women, we see a preponderance of white women and BAME men producing these films. Indeed, only 15 per cent of films that have a South Asian woman in a *non*-producing key role are produced solely by white men. The 2004 film *Vanity Fair* was directed by Mira Nair, an Indian-born, Harvard-educated director, and co-produced by Dinaz Stafford, an Indian producer who has worked predominantly in Bollywood. Although this film has just two Indian women working in key roles, a closer inspection of the film provides us with a case study for a particular kind of homophily we believe to be significant in the employment of BAME women: white women employing BAME women. This particular adaptation of *Vanity Fair* originated within the film department of the British television company Granada Film, headed at that time by Pippa Cross, whose previous producing credits included *Jack and Sarah* (1995). Working

with Cross was another white woman: Jeanette Day. It was these two white women who brought Mira Nair on to the film as director. Stafford's involvement happened once it became certain that some of the filming would be taking place in India.

When we analysed films with BAME women in *non*-producing roles, we found more evidence of homophily working through gender or race, even though BAME women were rarely found working together. For example, where a black woman was in a non-producing role, half of all the producers on their films were either white women or black men. This is extraordinary given the scarcity of white women and black men in the wider dataset in comparison to white men. Indeed, 81 per cent of these films have at least one white woman producer or one black man producer (Cobb, Williams, and Wreyford, 2019a). While we do not wish to suggest that BAME women need the help of white women or BAME men to succeed in filmmaking, it is clear that with BAME women still being shut out of many key roles and decision-making positions, it is white women and BAME men who offer more opportunities to BAME women than white men currently do. We can only imagine what the crews of films produced by BAME women would look like if more were encouraged and resourced.

Conclusion

In response to award nominations in 2020, Melissa Silverstein, founder of Women and Hollywood said:

> You don't have to look further than the movies nominated for the most Oscars this year to realize how white boy centric Hollywood is. A war movie, a mob movie and a movie about an incel. Why we continue to glorify these stories over and over again is the crux of the problem.
>
> (Scott, 2020)

In the same article, the British BAFTA awards are accused of doing worse in diversity terms than the American Oscar nominations, but both attest to the valorisation of whiteness and masculinity in the film industry. So what are BAME women to do? Bhide did make a point to tell us that she felt it was better to be in the industry than out of it since there were 'just not enough' British Asian women in the industry and that she had 'learned to play the game better'. This is, of course, a paradox of critical interventions into diversity. Is being in the industry enough, or at least a start? Does the inclusion of some help others

like them, in other words, does representation matter in a structurally sexist and racist system? The data suggests that support for individuals through whatever institutional levers does not produce significant shifts in the overall numbers, but our interviews did indicate that seeing someone like oneself in the job you want or being supported by someone like oneself matters (Cobb and Williams, 2020). Bhide, Lu, and Reddin all told us it was *other women* who gave them their first break in the industry. At the same time, Bhide said 'you have to have so much self-belief to work in this industry, but then you have to have ten times as much if you are a woman, and 20 times as much, 50 times as much, if you are a woman of colour'; and Reddin said: 'I always felt I had to work harder to be taken seriously … I always felt … I had to do a lot more than anyone else because … on some jobs I'd walk into the room and people would go "huh", and they just weren't expecting me to look like me.' BAME women should not have to work harder or have more self-belief than others to make it in the British film industry. The British film industry needs to work harder for and have more belief in BAME women.

Bibliography

Barbulescu, R. and Bidwell, M. (2013) 'Do Women Choose Different Jobs from Men? Mechanisms of Application Segregation in the Market for Managerial Workers'. *Organization Science 24*(3): 737–756.

BFI (2018) 'Screen Sector Certification and Production'. *BFI Film Forever.* Available at: www.bfi.org.uk/sites/bfi.org.uk/files/downloads/bfi-screen-sector-certification-and-production-bfi-2018-09-03.pdf (accessed 17 January 2020).

Bielby, W.T. and Baron, J. (1984) 'A Woman's Place is With Other Women: Sex Segregation Within Organizations' in *Sex Segregation in the Workplace: Trends, Explanations, Remedies.* Edited by Barbara F. Reskin, 27–55. National Academy Press, Washington DC.

Burkhalter, B. (1999) 'Reading Race Online' in *Communities in Cyberspace.* Edited by Marc A Smith and Peter Kollock, 60–75. Routledge, London.

Cobb, S. (2020) 'What About the (Cis-, Hetero, Abled, Middle-class, White) Men? Gender Inequality Data and the Rhetoric of Inclusion in the US and UK Film Industries'. *Journal of British Cinema and Television 17*(1): 112–135.

Cobb, S. and Williams, L.R. (2020) 'Histories of Now: Listening to Women in British Film'. *Women's History Review.*

Cobb, S., Williams, L.R., and Wreyford, N. (2016) 'Calling the Shots: Women Working in Key Roles on UK Films in Production During 2015'. Available at: https://womencallingtheshots.com/reports-and-publications/ (accessed 27 November 2019).

Cobb, S., Williams, L.R., and Wreyford, N. (2019a) 'Calling the Shots: Black, Asian and Ethnic Minority (BAME) Women working on UK-qualifying films 2003–2015'. Available at: https://womencallingtheshots.com/reports-and-publications/ (accessed 27 November 2019).

Cobb, S., Williams, L.R., and Wreyford, N. (2019b) 'Calling the Shots: Comparing the numbers of women Directors, Editors and Cinematographers on UK-qualifying films 2003–2015'. Available at: https://womencallingtheshots.com/reports-and-publications/ (accessed 27 November 2019).

Cobb, S., Williams, L.R., and Wreyford, N. (2019c) 'Calling the Shots: How Women in Key Roles on UK-qualifying Films Work to Employ Other Women'. Available at: https://womencallingtheshots.com/reports-and-publications/ (accessed 27 November 2019).

Crenshaw, K. (1992) 'Mapping the Margins: Intersectionality, Identity Politics, and Violence Against Women of Color'. *Stanford Law Review 43*(6): 1241–1299.

Grugulis, I. and Stoyanova, D. (2012) 'Social Capital and Networks in Film and TV: Jobs for the Boys?' *Organization Studies 33*(10): 1311–1331.

Hall, E. (1993) 'Waitering/Waitressing: Engendering the Work of Table Servers'. *Gender & Society 7*(3): 329–346.

Hesmondhalgh, D. and Baker, S. (2015) 'Sex, Gender and Work Segregation in the Cultural Industries'. *The Sociological Review 63*: 23–36.

Ibarra, H. (1992) 'Homophily and Differential Returns: Sex Differences in Network Structure and Access in an Advertising Firm'. *Administrative Science Quarterly 7*(3): 422–447.

Massey, D.S. and Denton, Nancy A. (1993) *American Apartheid: Segregation and the Making of the Underclass*. Cambridge, MA: Harvard University Press.

Nwonka, C. (2020) 'The New Babel: The Language and Practice of Institutionalised Diversity in the UK Film Industry'. *Journal of British Cinema and Television 17*(1): 24–46.

Porter, S. (1992) 'Women in a Women's Job: The Gendered Experience of Nurses'. *Sociology of Health & Illness 14*(4): 510–527.

Roberts, B. (2016) 'Female Film Directors Must Get Equal Funding – But They Mustn't All Be White'. *The Guardian*. Cannes Film Blog, 13 May 2016. Available at: www.theguardian.com/film/filmblog/2016/may/13/female-film-directors-must-get-equal-funding-but-they-mustnt-all-be-white (last accessed 14 January 2020).

Shoard, C. (2020) 'Joker Leads Oscars 2020 Pack – But Academy Just Trumps Baftas for Diversity'. *The Guardian*. 13 January 2020. Available at: www.theguardian.com/film/2020/jan/13/oscars-2020-nominations-joker-irishman (last accessed 14 January 2020).

Tomaskovic-Devey, D. (1993) *Gender & Racial Inequality at Work: The Sources and Consequences of Job Segregation* (No. 27). Ithaca, NY: Cornell University Press.

Wreyford, N. (2015) 'Birds of a Feather: Informal Recruitment Practices and Gendered Outcomes for Screenwriting Work in the UK Film Industry'. *The Sociological Review 63*: 84–96.

Wreyford, N. (2018) *Gender Inequality in Screenwriting Work*. London: Palgrave Macmillan.

Wreyford, N. and Cobb, S. (2017) 'Data and Responsibility: Toward a Feminist Methodology for Producing Historical Data on Women in the Contemporary Film Industry'. *Feminist Media Histories 3*(3): 107–132.

Notes

1. The authors would like to thank the Arts and Humanities Research Council for funding the necessary time and resources to do the research for this article, the BFI for being a project partner, providing us with the film list and much helpful staff time; and Linda Ruth Williams, co-investigator of Calling the Shots.
2. Our data set is circumscribed by the list of British-qualifying films provided to us by the BFI's Research and Statistics Unit.
3. 'Categories for ethnic monitoring' (The Commission for Racial Equality, 2001). Available at http://miris.eurac.edu/mugs2/do/blob.pdf?type=pdf& serial=1017161876525, accessed 21 November 2019.
4. Recording nationality also allows for a complication of the category 'white' since it encompasses individuals who may be othered by sections of the British population (for example those of Middle Eastern origin). Our data captures the degree of participation and/or exclusion from these communities although this is not the focus of this chapter.
5. All films are referenced with the year of release. Since our dataset focused on year of production the dates might sometimes be outside of 2003–15 and may suggest some discrepancies with the numbers we describe in this chapter.
6. For a full discussion of the inclusion of films like *My Best Friend's Wedding* in the dataset see Wreyford and Cobb (2017).
7. https://shitpeoplesaytowomendirectors.tumblr.com/about (last accessed 14 January 2020).
8. Three of those have been since 2015, the last year of our data.
9. https://twitter.com/adaoramuka?lang=en and www.instagram.com/adaoramuka/ (both accessed last on 14 January 2020).

11 'Enriching Danish Film with Cultural Diversity': Danish Representational Politics through the Lens of the Danish Film Institute (DFI)

Tess S. Skadegård Thorsen

Despite its relatively small nation-context, the Danish film industry has long maintained influence and impact beyond its borders. Denmark was among the first nations after France, the UK and the US, in 1896–97 to begin film production. Nordisk Film, the Danish film company that is still responsible for most mainstream releases in Denmark, is one of very few film companies in the world with a history that dates back to the beginning of filmmaking over a century ago. Even today, most Brits will recognise the new wave of (export-successful) Nordic Noir films and series, including *The Bridge*, *The Killing*, and *Borgen* and may even be familiar with the Dogme 95 wave in Danish film 25 years ago. Within the context of efforts on racialisation, representation, and diversity, however, the Danish film industry leaves much to be desired.

This chapter sets out to better understand the (infra)structures of the Danish film industry's work with diversity and representation. It does so through close analysis of a central stakeholder to the

development and sustainability of Danish film; the Danish Film Institute (henceforth the DFI). The chapter argues that Danish studies of diversity, 'ethnicity', and representation have much to gain from closer scrutiny of the structural aspects of film. This approach draws on Stuart Halls Birmingham-school work, in its emphasis on production as inherently tied to product and consumption (Hall, 1973, 1996, 1986). It also translates (for a Danish context) a critique raised by Anamik Saha in the UK, about textual foci in research (and policy) on diversity in film, arguing that comprehensive understandings of representational practices require processual analyses of the (infra) structures of the cultural industries (Saha, 2018). In addition, it draws on thinkers such as Kimberlé Crenshaw, bell hooks, Jasbir Puar, and Alexander Weheliye to provide a framework for understanding the particular intersectional assemblages of race, class, gender, sexuality, age, and ability in the context of Danish filmmaking (Crenshaw, 1989, 1991; hooks, 2009; Puar, 2012, 2017; Weheliye, 2014). As the below excerpt illustrates, the DFI is often framed, characterised, and understood as a central stakeholder to Danish film in the minds and discourses of creatives: 'as an industry, it is highly subsidized by the DFI [Danish Film Institute] … There are some people who have an idea about what good film is, and what the criteria for good film is, right? … and to be subsidized, well, then it [the film] has to be significant, and what makes it significant, is actually that people watch it.' (Interview with Al Agami, actor, 1:11–2:05).

Understanding the DFI as a central actor in the structuring of the industry and in the financing of film, the chapter asks how the DFI's initiatives for 'ethnic diversity' are designed, which underlying premises they are built on, and what the consequences are of these choices. Building on these questions, the chapter ventures to analyse how 'diversity work', as Sara Ahmed terms it, is understood in a Danish context, and how particular understandings of race and difference in the context of diversity work might shape powered dynamics of filmmaking (Ahmed, 2006).

This chapter draws mainly on reviews of the policies, records, reports, and materials pertinent to the diversity initiatives of the DFI. In addition, the analysis of the DFI's initiatives is supplemented with 17 in-depth interviews with industry professionals (what Danish scholar Hanne Bruun calls exclusive informants) as well as observations on film sets, in editing rooms, and at premieres and screenings in the Danish film industry from 2015–19 (Bruun, 2014).

Through close analysis of the three central elements to the DFI's diversity initiative for ethnic diversity: a) a mentorship program,

b) a casting database, and c) a charter for ethnic representation in film, respectively, I argue that the DFI has set a precedent for a 'Danish model for diversity'. This model, I find, places the onus on the 'industry' under the guise of encouraging a bottom-up or even 'grassroots' approach to diversity. However, the chapter finds that this neoliberal approach to representation, effectively, works to free the DFI of any accountability for discrimination in funding, and actively maintains the status quo of Danish film as an overwhelmingly white, heterosexist patriarchal machine of hegemony.

Racialisation and the Danish Context

Recent Scandinavian research on racialisation, racism and race has found that Scandinavian countries operate under a logic of contextual exceptionalism, in which each context devises its own self-narrative of an exceptional and particular reason that they do not operate through (or risk reproducing) the same forms of racism and racialisation that have been identified in most other research-contexts (Hervik, 2019; McEachrane, Gilroy, and McEachrane, 2014). In Sweden, for instance, one might find narratives that Swedes are particularly multicultural, diverse, and anti-racist. While this narrative of exceptionalism is founded in Sweden's less restrictive immigration policies in comparison to Denmark, it is misguided to assume that the particularities of the Swedish political landscape exonerates Swedes of racism all together (Habel, 2012). Similarly, in Denmark, a national narrative of exceptionalism rules. Under the guise of a particular type of humour, directness, or no-nonsense approach, Denmark reproduces a logic in which racism can be expressed through state-sanctioned statistics using proxies for race, like 'non-western immigrants and descendants' (Danbolt and Myong, 2019; Rødje and Thorsen, 2019; Hervik, 2019). This narrative is often founded in a presumption of a recent homogenous (white) past and an influx of immigration, when, in fact, the relative rise in immigration occurred some four to five decades prior, and the presence of racial others is documented centuries (if not millennia) ago, as the effect of trade, slavery, and colonisation (Mikkelsen, 1998; Andreassen and Henningsen, 2011; Pálsson, 2016). Ironically, while Sweden and Denmark seem to base their exceptionalisms in oppositional national narratives, they both reproduce a self-narration founded on identifying as 'post-race' (and therefore, automatically, post-racism) (Hervik, 2019; McEachrane, Gilroy, and McEachrane, 2014). This discursive pattern can, in part, be contributed to a general aversion in Scandinavian countries to

terminology of and around, 'race', perhaps as a consequence of (and response to) the race politics of the Second World War (Hervik, 2019; McEachrane, Gilroy, and McEachrane, 2014; Sandset, 2019; Skadegård and Jensen, 2018).

Scandinavian countries might self-narrate their contexts as free of, or less prone to, racism, but recent research shows that in practice this is far from the case. A number of anthologies document the insidious racial and racist logics and processes that seep through Scandinavian policies, behaviours, discourse, and 'culture' (McEachrane, Gilroy, and McEachrane, 2014; Hervik, 2019; Andreassen and Vitus, 2016). While concepts like racialisation, anti-blackness and structural discrimination are relatively new to the Danish research context, and may vary in expression in Denmark compared to other contexts, they are all documented nonetheless (Danbolt, 2017; Hervik, 2019; Petersen, 2009; Rødje and Thorsen, 2019; Chandhok Skadegård, 2016; Chandhok Skadegård and Horst, 2017).

Do White People Only Want to See White People in Film?

In a context like the Danish one, where racism and racialisation are understudied or are not understood in the shared imaginary of academia and the Danish population, how, then, does 'race' and related aspects like skin colour, racism, and colonialism manifest in cultural imagery, and in particular, in film? As Anamik Saha has illustrated was the case in the UK some 40–50 years ago, the first studies that began to tackle racialisation and representation in Denmark have centred news media (Saha, 2018). These comprehensive Danish studies have documented a series of racialising stereotypes linked to presumed cultural differences (Hervik, 2002, 2011; Nielsen, 2014; Hussain, Yılmaz, and O'Connor, 1997; Andreassen, 2005). The studies have in common an emphasis on the racialisation of Muslims in Denmark. Under the guise of 'cultural' or 'religious' insurmountable differences, these minorities experience particular targeting and stereotyping in the Danish context. As such, 'religion' and 'culture' are found to operate as proxies for race, effectively sustaining racist and racialising logics of othering (ibid.). Meanwhile, very little research has focused on 'race', representation, and racialisation in Danish film, and none, to my knowledge, have centred on representations of blackness in particular. This, despite a long history in Danish film of engaging racialising (and often racist) topics, tropes, and stereotypes. As far back as 1907, Danish film has featured black actors (Thorsen, 2020). This presence provides layers of documentation. On the one hand,

the presence of black actors at the beginning of Danish filmmaking provide evidence of the existence of racial others within Danish cultural production more than a century ago, which can be seen as a counter-narrative to the white homogeneous imaginary of Denmark associated with that time. On the other hand, the framing of black characters in these early films (as servers, helpers, and local guides in exotified locations) illustrate how central racialised understandings of difference were to early practices of othering through film, in Denmark. As such, the specific design around, and performativity of, 'race' in these instances still works to sustain and reproduce anti-blackness through stereotypical and 'othered' roles.

In contemporary Danish film, this stereotypical and racialising framing of blackness continues. However, while misrepresentation was a huge challenge for the black and racially minoritised film-creatives in Denmark, who were interviewed for this study, under-representation, or erasure, was an even more pressing issue. As one interviewee, a black actor, put it when we were discussing failed career trajectories for otherwise successful racially minoritised actors: '[P]eople have this idea or thesis that, uhm, to put it roughly; white people only want to see white people in film' (Interview with Al Agami, actor, 6.35–6.45).

The sentiment that there is little or no audience for films about non-white people was mirrored across interviews with both actors, directors, casters, and producers, regardless of racialisation. In some instances, like in Agami's case, the sentiment is troubled as he refers to the presumed costliness of racial diversity as merely an 'idea or thesis'. Another racially minoritised interviewee explained how, according to a producer she had met, both the DFI's consultants as well as industry producers and distributers were 'the ones who have rooted this fear [in society or the industry] that darks don't sell.[sic]'. She continued: 'I find it deeply concerning ... that people ... create projects and films and products based in the belief that no one wants to see [minorities]. It is actually pure discrimination and, I mean, it is ... Well I think all of this, uhm, discrimination and racism and Nazism it uhm, we have created it ourselves – the [film] industry has created it ourselves' (Anonymous interview with writer-director and actress, conducted by author, 58:25–1:00:07).

While not all interviewees were as adamant as the above anonymous interviewee and actor, Al Agami, that these ideas are rooted in fear and misconceptions rather than fact, most interviewees agreed that the conception of non-profitability of diversity was a key cause for under-representation of racialised minorities on screen, which has been documented by the DFI's reports (Det

Danske Filminstitut et al., 2015). The narrative that diversity doesn't sell was sometimes countered with corresponding arguments for diversity; that consumers are more diverse now or that it is good for (and interesting to) majority consumers to have access to a diversity of stories. This aligns with Clive Nwonka's argument, that institutionalised discourses of diversity mimic a genre, in the ways that they are consumed, reproduced, and commercialised (Nwonka, 2020). In Denmark, as Nwonka and Malik have shown is similarly the case in the UK, commodification and incorporation of the other through discourses of diversity and inclusion replace any thorough examination of exclusion, racism, and discrimination in the industry (Nwonka, 2020: 42; Nwonka and Malik, 2018). Regardless of whether one is arguing for or against diversity using measures of audience-interest, the overall premise of this parameter for diversity maintains a neoliberal argument that the main issue of diversity is cost/benefit.

Whether reproduced or contested, the narrative of the cost-benefit analysis of 'ethnic minority' viewers as (non)viable audiences can be seen as an example of how internalised and intersecting logics of racism and capitalism have spread throughout the industry from the DFI, which first introduced the idea that 'ethnic minority characters' would not be marketable to a rural Danish audience in a rejection-letter for funding of the Danish childrens' film *MGP Missionen* (2013). Upon receiving critique in Danish media for the wording of the rejection, the DFI set in motion a large diversity initiative.

The Role of the Danish Film Institute (DFI)

As a 'small nation' context, much Danish filmmaking relies on funding via state-subsidy-systems that are managed by the DFI. Every film-professional that was interviewed for this study and worked with funding or financing of films mentioned the DFI as central to the making of mainstream and broad-scale films. Indeed, one famous producer even argued that he would have to drop a film if it did not achieve support from the DFI and at least one large distributor (Anonymous interview conducted by author, 2016). As such, the DFI functions as a gatekeeper to mainstream film production in Denmark, a context which, without subsidies, would not be nearly as competitive or viable. In other words, the DFI is not only the driving force for Danish film production, wielding the power of distributing state financing for film, they are also both the catalyst of (and perhaps one of the root causes for a need for) diversity initiatives in the Danish film industry.

Enriching Danish Film with Cultural Diversity Tess S. Skadegård Thorsen

Following the critique of their rejection-letter for *MGP Missionen* (2013), the DFI launched a first-of-its-kind comprehensive diversity initiative on ethnic diversity. At launch events, public meetings, and industry hearings, the DFI's representatives (a diversity project manager and the director) reiterated that the central goals for their diversity initiatives are to 'replace presumptions with knowledge' (Kirsten Barslund, project manager of the diversity initiative, DFI) and to create an industry-driven and -controlled approach to diversity, in which they assume a facilitating or hosting role. This industry-driven, 'bottom-up' approach to diversity has been framed by the DFI as a model for diversity work which guarantees engagement across industry stakeholders (Thorsen, 2020). Henceforth the DFI's approach to diversity will be referred to as the 'Danish Model'.

The diversity initiative that the DFI set in motion began with an emphasis on ethnicity, and soon grew to include an initiative for gender as well (Figure 11.1). On their websites sub-page for 'Diversity Initiative' (Mangfoldighedsindsats), the header reads: 'Danish Film should reflect the whole population – both in terms of gender, heritage, social background and geography. The Film Institute works with the film industry to strengthen and develop a diverse film culture' (DFI, 2019, my translation).

Below the header we find two clickable sub-headers, which reflect their two comprehensive initiatives – gender and ethnicity – and each lead to separate tabs for those topics, respectively. The description for 'gender diversity' (kønsdiversitet) reads: 'The Film Institute and the industry work together to create a better gender balance in Danish film with efforts that document, raise awareness and contribute to change' (DFI, 2019, my translation). Meanwhile, the description for 'ethnic diversity' (etnisk mangfoldighed) reads: 'Danish film does not mirror the ethnic diversity of society. Therefore a series of initiatives have been set in motion to enrich Danish film with the cultural diversity that exists in the population' (DFI, 2019, my translation). Particular to the DFI's approach to diversity, then, is a separation of, and distinction between, various categories of diversity and oppression, and their solutions. In this vein, the DFI have chosen disparate and diverging strategies for handling gender and ethnic diversity, respectively. In the case of 'ethnic diversity', for instance, the DFI's approach has included: 1) the development of a charter, 2) the development of a casting database, and 3) the development of a mentorship program. These initiatives were not selected for the DFI's work on gender, which instead relied on working groups and a self-reporting audit. Furthermore, two of

KØNSDIVERSITET

Filminstituttet og branchen arbejder sammen for at skabe en bedre kønsbalance i dansk film med indsatser, der dokumenterer, bevidstgør og medvirker til forandring.

ETNISK MANGFOLDIGHED

Dansk film afspejler ikke samfundets etniske mangfoldighed. Derfor er der igangsat en række initiativer, så dansk film beriges af den kulturelle diversitet, der findes i befolkningen.

Figure 11.1

the three working groups were led by women and two visibly racial minority women were included. In other words, a central difference between the two initiatives is the visible leadership from (some of) the minorities that the initiative set out to support. While female leadership seemed central to the work on gender diversity, no visible minorities were highlighted as leaders of the initiatives on ethnic diversity.

The Ethnic Diversity Initiative Part 1: The Charter

On the website tab for 'ethnic diversity', described above, the last line indicates that the goal of the initiatives for ethnicity is 'to *enrich* Danish film with the cultural diversity that exists in the population' (DFI, 2019, my translation and emphasis). In contrast to the text on the button for 'gender diversity', which emphasises 'balance' and 'raising awareness', the language of the 'ethnic diversity' sub-header moves focus from fairness and inequality to 'mirroring' and 'enriching'. This discursive sleight of hand may, at first, seem like a simple question of word choice. In effect, however, the onus of the diversity initiatives in question, and the underlying premise of the diversity work at play, shifts when we move the discussion from exposing oppression to 'enrichment'. The language of enrichment carries over in the foundational pillar of the DFI's initiative for ethnic diversity, the Charter for Ethnic Diversity. At the outset of their comprehensive effort on diversity, the DFI, in collaboration with central industry organisations, developed a 'Charter for Ethnic Diversity'. Unlike a policy or a due diligence process, the charter does not require any specific or legally binding measures be taken by the DFI or the industry stakeholders who were involved. Rather, it can

be interpreted as a statement of intent. This aligns with the DFI's bottom-up approach in relying mainly on industry stakeholders' intentions and a presumption that increased knowledge will lead to behavioural changes. The charter included a core statement: 'In our opinion, ethnic diversity *enriches* and *develops* Danish film, and we wish for diversity to be an integrated part of Danish film-art and film-culture. We wish for access to Danish films, for filmmakers as well as audiences, to be independent of ethnic background, and for Danish films to be identity-creating, engaging and entertaining for *all Danes*' (Nicki, 2015, my emphasis and translation).

In line with the communication on the website, the Charter, similarly, frames ethnic diversity as 'enriching' and 'developing'. This wording provides insight into the underlying premises and foundational strategies that the DFI builds its understanding of diversity around. Similar to what Clive Nwonka has found in the wording of the UK Film Council's approach to diversity, the DFI, too, seem to rely on 'a commercial conception of inclusion' in their understanding of diversity (Nwonka, 2015: 8). The terminology of enrichment and development charges the discourse around film with a consumerist tone, appeasing or calming any fear of the cost of diversity. In other words, it provides space for diversity only if and when the premise of enrichment and development is fulfilled. While such wording may be intended as a stance against the previous narratives from the DFI (that ethnic minorities do not sell), it simultaneously frames ethnic diversity as an addition to a (presumed white or, at minimum, non-diverse) 'Danish film-art and film-culture'. In separating 'ethnic diversity' and 'Danish film culture' the DFI actively reproduces the narrative of a white, homogeneous Danish context, in which the 'spice' of 'ethnic diversity' serves to provide something new and 'other' for the consumption and prosperity of the majority population. This contingency of enrichment and development thus encapsulates otherness as valid only through consumption. As bell hooks has shown, in such instances, the premise is that the 'other' is there to be eaten (or consumed) in order for the majority to get release (or enriched) (hooks, 1992). What might have happened if the first paragraph, rather than emphasising enrichment, had utilised a vocabulary of inequality or inequity or even balance and change, as is the case in the DFI's discourse around gender?

In the second paragraph, we learn that while this is a charter specifically designed for 'ethnic diversity', the phrasing decisively adheres to a generalist and all-encompassing terminology of 'all Danes'. This phrasing is likely intended to signify the inclusion of 'ethnic

minorities' into the Danish imaginary through a shared conception of the implied 'we' of 'all Danes', and can be interpreted as resistance to the frequent discursive separation of 'ethnic minorities' and 'Danes'. Nonetheless, this symbolic gesture of inclusion simultaneously mimics what sociologist Eduardo Bonilla-Silva has deemed 'color-blind racism': in efforts to erase racial difference, such gestures (sometimes inadvertently) erase the various expressions and effects of racism as well (Bonilla-Silva, 2006). By centring the 'entertainment' of 'all Danes' the language of the DFI's charter effectively de-races and de-classes the film professionals and consumers who are most affected by inequality and oppression, effectively creating an 'intentionally culturally unspecific (and socially cohesive) creative frame' (Malik, 2013: 236), as Sarita Malik has found was also the case in diversity discourse in the UK creative industries.

The Ethnic Diversity Initiative Part 2: The Casting Database

Following the publication of the Charter for Ethnic Diversity, the first effort to be rolled out under the DFI's initiative for ethnic diversity was a casting database consisting of approximately 150 'ethnic minority' actors. The casting database, which is maintained and run by a few of Denmark's most successful casting agents, was initiated in collaboration with (and co-funded by) the DFI, who advertise the database as part of their initiative on ethnic diversity on their website and who hosted the casting event in Copenhagen.

The casting call (see Figure 11.2) invites participants as follows: 'Do you have multicultural roots? And do you have an actor hidden inside?' At the bottom of the flyer it specifies who can show up as: 'Anyone with other ethnic background than Danish over [the age of] 16' (flyer distributed on social media, 2018, my translation). Following the initial open casting call, 15 select actors are invited for a workshop where they will 'practice casting techniques' (ibid.) and receive 'camera training' (ibid.) from professional casting agents and directors. In phrasing specifications as 'other ethnic background than Danish', the casting call reproduces typical terminology to signal non-whiteness without coding for (or mentioning) racial markers. In an interview with one of the involved casting agents, she explained that while there had been a lot of excitement around the initiative, and it was now entering its second cycle (with a new casting call, workshops, etc.), there had also been some pushback, particularly from some of the black and racially minoritised actors: 'Because there were also people of other ethnic minority [sic] who were offended about it

Enriching Danish Film with Cultural Diversity Tess S. Skadegård Thorsen

because they were like: "well I feel Danish and I get the roles I need because I am good"' (interviewed casting agent 16:06–16:25).

In my interviews with racially minoritised Danish actors, they stressed that in the Danish context, most of the roles they had access to were 'typecast' and stereotypical. Interviewees recounted stereotypes like Muslim cleaning ladies, violent/criminal brown men (often as gang-members), and oppressed women who are under the control of patriarchal fathers. These stereotypes mimic those identified by media researcher Rikke Andreassen as frequent in news media (Andreassen, 2005). As such, all of the interviewed racially minoritised performers expressed a wish for colour-blind casting, a practice in which they would be allowed to audition (in fair and equal ways) for roles that were racially un-coded. When the interviewed casting agent experienced resistance to the casting database, it needs to be understood within a context where a segregated casting database, to actors of colour, could signify a threat to their ambition of equal opportunity in casting practices. In addition, it is important to remember that a central aspect of the casting-diversity initiative is founded in the workshop for 15 select actors. When actors resist the initiative because they 'feel Danish' and are 'good', they are resisting the underlying premise of both the workshop and the database; that they are either not good enough or that they do not have access. As such, the workshop fails to recognise the risk that these actors may already have access to castings, but experience rejection due to bias and discrimination, nonetheless.

Resistance to the workshop and 'ethnic minority' casting database as a solution can also be seen as a rejection of being 'presumed incompetent'. Gabriella Gutiérrez y Muhs and colleagues have illustrated that a common hindrance to (achievement and advancement in) the academy, particularly for women of colour, is *presumed incompetence* (y Muhs et al., 2012). In a field like acting, which, perhaps to an even higher degree than academia, depends on individual and subjective interpretations of competence and talent, it is not unfathomable that presumptions of competence could factor into the experienced discrimination racially minoritised actors experience. Regardless of intent, the workshop, in effect, frames the (competence of) the racially minoritised actor as both the problem and solution to onscreen under- and misrepresentation.

The Ethnic Diversity Initiative Part 3: Mentorship

The final leg of the DFI's initiative for ethnic diversity is a mentorship program. 'The purpose of the program is to create an exchange

Enriching Danish Film with Cultural Diversity **Tess S. Skadegård Thorsen**

ÅBEN CASTING 2018

MANGFOLDIGHED I DANSK FILM OG TV

INVITATION

Har du multikulturelle rødder?
Og har du en skuespiller gemt i maven?
Drømmer du om at være med i en film eller tv-serie? Eller har du bare en generel interesse i film og skuespil, så får du her muligheden for at møde castere fra den danske film og tv-branche til en åben casting.

Kom og oplev hvordan det er at gå til casting. Den åbne casting foregår to steder i landet:

København, Det Danske Filminstitut, Gothersgade 55
Torsdag 30. august 2018 kl. 16-19

Århus, Filmby Århus, Filmbyen 23, lokale 5 v. foyeren
Lørdag 1. september 2018 kl. 14-17

FORMÅL

Vi caster ikke til en bestemt film, men du får muligheden for at blive en af de ca. 15 personer, som på baggrund af den åbne casting, bliver inviteret til en gratis castingworkshop i København.

På workshoppen, som ligger i slutningen af september, vil du få chancen for at arbejde intensivt sammen med professionelle castere og filminstruktører. Du vil få grundlæggende kendskab til castingsituationen, øve castingteknikker, blive instrueret, få kameratræning og indblik i selve castingforløbet.

HVEM KAN MØDE OP

Alle med anden etnisk baggrund end dansk over 16 år er velkomne. Erfaring og kendskab er dejligt, men ikke en forudsætning.

TILMELDING
Med op!
Tilmelding er ikke nødvendig

MØD CASTERE FRA PRODUKTIONER DU KENDER
I KRIG OG KÆRLIGHED
IQBAL
LANG HISTORIE KORT
1864
KLOVN
BROEN
DEN DANSKE PIGE
DE STANDHAFTIGE
HVIDSTENSGRUPPEN

OG MEGET MERE...

KONTAKTINFO
Skulle du have spørgsmål til den åbne casting, så skriv til

castingworkshop2018@gmail.com

BAG PROJEKTET ER GIZMO CAST MED STØTTE FRA

Figure 11.2

across the film industry's established networks and practitioner-groups and develop and retain new talents by matching them with more experienced forces. Mentors and mentees work as for instance scriptwriter, director, producer, director, actor, photographer and editor, sound editor, scenographer and more' (DFI, 2019, my translation and emphasis, accessed October 2018).

Like the 'ethnic minority' casting database, the mentorship program has entered into its second cycle. The DFI have not published how many participants partook in the first cycle, however, in interviews with one participant she made it clear that the program had provided her with a wealth of knowledge, access, and experience, and had propelled her career in the industry. Nonetheless, in the case of this interviewee, she, a woman of colour, was mentored by white film professionals, most of whom were senior and male. What does it mean when an initiative funded and hosted by the DFI relies on, and reproduces, the idea that in order to increase diversity in film, the 'ethnic minorities' who are viewed as 'new talents' need to go through specific forms of training by specific people? When the diversity initiatives for ethnicity place the onus on 'improving' the racially minoritised film professionals, they are framed as the central barrier to diversity in Danish film. In contrast, the initiatives for gender equality rely on all film professionals mapping and tracking gender inequalities in their productions, placing the onus on bias and discrimination among the majority and those in power.

Anamik Saha problematises the diversity policies of cultural institutions based primarily on their reconstitution of whiteness through racial capitalism (Saha, 2018: 84–95). This notion is especially noteworthy for two reasons in the context of the DFI. First, the notion of 'enrichment' and the framing of ethnic diversity as necessarily having to 'mirror' society points to some of Saha's central critiques: the notion of enrichment centres on whiteness as that which can be enriched, but through that enrichment can be reconstituted at the centre, as norm. Second, the notion of media as a necessary mirror of society presumes translatability or transferability of categories from society to crew to on screen. In other words, it relies on an essentialising gesture that conflates identity, experience, production, and product for racially minoritised filmmakers, films, and audiences. This presumption is premised on a neoliberal niche-market logic, which reproduces a reductionist and simplistic understanding of representational practices (Saha, 2018: 90–95).

Perhaps unsurprisingly, then, the DFI's 'ethnic diversity' initiatives position the (competence of) ethnic minority actors and film

professionals as the problem, meanwhile only providing one solution to the issue: self-improvement (through training or mentorship). The diversity initiatives for ethnic diversity are premised on a discourse of enrichment for the majority, or, at least, an unspecified category of 'all Danes' (Nicki, 2015). Furthermore, in the financial structuring of these diversity initiatives, those who end up receiving payment for the design and follow-through on initiatives for 'ethnic diversity' are the same majoritised individuals who retain power through maintenance of the status quo narrative that the racially minoritised film professionals are in need of (their) training. This emphasis effectively reproduces the 'paradoxical feature' Nwonka has identified in UK diversity policy: 'It represents aspirations of inclusion but also demonstrates a reluctance to take responsibility for the existing exclusion' (Nwonka, 2020: 26).

At present, while the DFI-catalysed initiatives for gender centre the voices of women, the initiatives for ethnic diversity do not seem to centre any particular leadership or design by those most affected by discrimination and exclusion. The Danish model for diversity in film, as such, relies on the continued erasures of those most affected by oppression, meanwhile overlooking the powered hierarchies the DFI participates in upholding through practices of funding, support, and exposure. At the heart of this small nation film context big negotiations of race and representation are taking place. However, within the benevolent gestures of the diversity genre, any efforts to combat racism, discrimination, and inequality are easily replaced with empty discourses of inclusion, 'enrichment', and development (Skadegård and Jensen, 2018; Skadegård and Horst, 2017; Nwonka, 2020).

Conclusion: Challenges in the Danish Diversity Model

The DFI has developed a model for diversity, the Danish Model, which relies on the industry to take charge, and positions the DFI as a marginal stakeholder. Effectively, while the DFI elects to host, fund, and initiate diversity work, they do not have policies in place to handle potential discrimination in hiring, funding, and internal work. This has produced a series of bottom-up initiatives, run by industry stakeholders, but housed by the DFI, and has engaged industry professionals by tasking them with diversifying Danish film. As such, the Danish Model, whether by design or inadvertently, has protected the DFI from being held accountable for their continued discrimination in funding, hiring practices, and support, by placing the onus on the rest of the industry, and overlooking the role of the

Enriching Danish Film with Cultural Diversity **Tess S. Skadegård Thorsen**

DFI in maintaining structures of power that privilege whiteness. As such, and as this chapter has investigated, while the working groups, reports, and initiatives for gender are run mostly by women, none of the initiatives for 'ethnic diversity' have indicated leadership or design by those most affected by racially discriminatory industry structures.

Acknowledgements

This chapter is based on PhD research conducted from November 2015 to November 2019 at the Department of Politics and Society at Aalborg University, Denmark. Any and all overlap with the material and/or findings of the dissertation for the fulfillment of said degree occur with my permission. The research was funded by the Velux Foundation as a part of the larger research project entitled 'A Study of Experiences of and Resistance to Racialization in Denmark (SERR)' and additional funding for research abroad was received from the Augustinus Foundation.

Bibliography

Ahmed, S. (2006) 'Doing Diversity Work in Higher Education in Australia'. *Educational Philosophy and Theory 38*(6): 745–768.

Andreassen, R. (2005) 'The Mass Media's Construction of Gender, Race, Sexuality and Nationality: An Analysis of the Danish News Media's Communication about Visible Minorities from 1971–2004'. Department of History, University of Toronto (monograph).

Andreassen, R. and Henningsen, A.F. (2011) *Menneskeudstilling: Fremvisninger af eksotiske mennesker i Zoologisk Have og Tivoli*. Copenhagen: Tiderne Skifter.

Andreassen, R. and Vitus, K. (2016) *Affectivity and Race: Studies from Nordic Contexts*. London and New York: Routledge.

Bonilla-Silva, E. (2006) *Racism Without Racists: Color-blind Racism and the Persistence of Racial Inequality in the United States*. Second edition. Lanham, MD: Rowman & Littlefield Publishers, Inc.

Bruun, H. (2014) 'Eksklusive Informanter: Om forskningsinterviewet som redskab i produktionsanalysen'. *Nordicom Information 36*(1). Available at: www.forskningsdatabasen.dk/en/catalog/2389227439 (accessed 18 June 2018).

Crenshaw, K. (1989) 'Demarginalizing the Intersection of Race and Sex: A Black Feminist Critique of Antidiscrimination Doctrine, Feminist Theory and Antiracist Politics'. *University of Chicago Legal Forum* 1987: 139.

Crenshaw, K. (1991) 'Mapping the Margins: Identity Politics, Intersectionality, and Violence Against Women'. *Stanford Law Review 43*(6): 1241–1299.

Danbolt, M. (2017) 'Retro Racism: Colonial Ignorance and Racialized Affective Consumption in Danish Public Culture'. *Nordic Journal of Migration Research* 7(2): 105–113.

Danbolt, M. and Myong, L. (2019) 'Racial Turns and Returns: Recalibrations of Racial Exceptionalism in Danish Public Debates on Racism' in *Racialization, Racism, and Anti-Racism in the Nordic Countries*. Edited by Peter Hervik, 39–61. Cham, Switzerland: Springer.

Det Danske Filminstitut, Kirsten Barslund, DFI (supervising editor) Anne Hoby, DFI Martin Kofoed Hansen, DFI Marie Schmidt Olesen, DFI Lars Fiil-Jensen, DFI Katrine Danielle Bjaarnø, DFI (2015) *Undersøgelse af etnisk mangfoldighed i dansk film*. Copenhagen: DFI. Available at: www.dfi.dk/files/docs/2018-02/Etnisk_mangfoldighed_i_dansk_film_dfi_2015.pdf (accessed 19 April 2018).

DFI (2019) 'Danish Film Institute Diversity Initiatives'. Available at: www.dfi.dk/branche-og-stoette/publikationer-og-indsatser/mangfoldighedsindsats (accessed 1 June 2019).

Habel, Y. (2012) 'Challenging Swedish Exceptionalism? Teaching while Black' in *Education in the Black Diaspora: Perspectives, Challenges, and Prospects*. Edited by Kassie Freeman and Ethan Johnson, 99–121. New York and London: Routledge.

Hall, S. (1973) 'Encoding and Decoding in the Television Discourse'. Paper for the Council of Europe Colloquy on 'Training in the Critical Reading of Televisionl Language.' Organised by the Council & the Centre for Mass Communication Research, University of Leicester, September 1973. Printed by the author at Centre for Contemporary Cultural Studies, University of Birmingham.

Hall, S. (1986) 'Gramsci's Relevance for the Study of Race and Ethnicity'. *Journal of Communication Inquiry* 10(2): 5–27. Available at: http://journals.sagepub.com/doi/10.1177/019685998601000202 (accessed 14 May 2018).

Hall, S. (1996) 'Race, Articulation, and Societies Structured in Dominance' in *Black British Cultural Studies: A Reader*. Edited by Huston A. Baker, Jr., Manthia Diawara and Ruth H. Lindeborg, 16–60. Chicago and London: University of Chicago Press.

Hervik, P. (2002) *Mediernes Muslimer: En antropologisk undersøgelse af mediernes dækning af religioner i Danmark*. København (Copenhagen): Nævnet for etnisk ligestilling København.

Hervik, P. ed. (2019) *Racialization, Racism, and Anti-Racism in the Nordic Countries*. Cham: Springer International Publishing. Available at: http://link.springer.com/10.1007/978-3-319-74630-2 (accessed 5 February 2019).

Hervik, P. (2011) *The Annoying Difference: The Emergence of Danish Neonationalism, Neoracism, and Populism in the Post-1989 World*. New York and Oxford: Berghahn Books.

hooks, b. (1992) 'Eating the Other' in *Black Looks: Race and Representation*, 21–40. Boston, MA: Southend Press.

hooks, b. (2009) *Reel to Real: Race, Class and Sex at the Movies*. Abingdon, Oxon and New York: Routledge. (First published with Routledge in 1996.)

Hussain, M., Yılmaz, F. and O'Connor, T. (1997) *Medierne, minoriteterne og majoriteten: En undersøgelse af nyhedsmedier og den folkelige diskurs i Danmark.* Copehagen: Nævnet for etnisk ligestilling.

Malik, S. (2013) '"Creative Diversity": UK Public Service Broadcasting After Multiculturalism'. *Popular Communication 11*(3): 227–241.

McEachrane, M. (2014) *Afro-Nordic Landscapes: Equality and Race in Northern Europe.* New York: Routledge. Available at: www.routledge.com/Afro-Nordic-Landscapes-Equality-and-Race-in-Northern-Europe/McEachrane-Gilroy/p/book/9780415897433?fbclid=IwAR0LiT3neFKt7zRiFvY847MxA5uFesZ8NayEAN_s93ILRvwKjNSDeV-CawI (accessed 27 October 2018).

Mikkelsen, E. (1998) 'Islam and Scandinavia during the Viking Age' in *Byzantium and Islam in Scandinavia: Acts of a symposium at Uppsala University June 15–16 1996.* Jonsered: P. Åströms Förlag. Göteborg, Sweden., 39–51.

Muhs, G., Niemann, Y., González, C., and Harris, A., eds (2012) *Presumed Incompetent: The Intersections of Race and Class for Women in Academia.* Boulder, CO: University Press of Colorado.

Nicki, B. (2015) 'Etnisk Mangfoldighed på vej til dansk film'. *Filmmagasinet Ekko.* Available at: www.ekkofilm.dk/artikler/etnisk-mangfoldighed-pa-vej-til-dansk-film/ (accessed 21 September 2020).

Nielsen, A.S. (2014) ' *De vil os stadig til livs': betydningskonstruktioner i tv-nyhedsformidling om terrortruslen mod Danmark: ph. d.-afhandling.* Copenhagen: Det Humanistiske Fakultet, Københavns Universitet.

Nwonka, C.J. (2015) 'Diversity Pie: Rethinking Social Exclusion and Diversity Policy in the British Film Industry'. *Journal of Media Practice 16*(1): 73–90.

Nwonka, C.J. (2020) 'The New Babel: The Language and Practice of Institutionalised Diversity in the UK Film Industry'. *Journal of British Cinema and Television 17*(1): 24–46.

Nwonka, C.J. and Malik, S. (2018) 'Cultural Discourses and Practices of Institutionalised Diversity in the UK Film Sector: "Just Get Something Black Made"'. *The Sociological Review 66*(6): 1111–1127.

Pálsson, G. (2016) *The Man Who Stole Himself: The Slave Odyssey of Hans Jonathan.* Chicago: University of Chicago Press.

Petersen, L.M. (2009) 'Adopteret: Fortællinger om transnational og racialiseret tilblivelse'. Aarhus, Denmark: Danmarks Pædagogiske Universitetsskole, Aarhus Universitet.

Puar, J.K. (2012) '"I Would Rather Be a Cyborg than a Goddess": Becoming-intersectional in Assemblage Theory'. *PhiloSOPHIA 2*(1): 49–66.

Puar, J.K. (2017) *Terrorist Assemblages: Homonationalism in Queer Times.* North Carolina: Duke University Press.

Rødje, K. and Thorsen, T.S.S. (2019) '(Re)Framing Racialization: Djurs Sommerland as a Battleground of (Anti-)Racism' in *Racialization, Racism, and Anti-Racism in the*

Nordic Countries. Edited by Peter Hervik. Cham: Springer International Publishing, 263–281. Available at: http://link.springer.com/10.1007/978-3-319-74630-2_11 (accessed 5 February 2019).

Saha, A. (2018) *Race and the Cultural Industries*. Cambridge, UK and Medford, MA: Polity Press.

Sandset, T. (2019) *Colour that Matters: A Comparative Approach to Mixed Race Identity and Nordic Exceptionalism*. London and New York: Routledge.

Skadegård, M.C. (2016) 'Sand Negro' in *Social eksklusion, læring og forandring*. Edited by A. Bilfeldt, I. Jensen, and J. Andersen, 168–182. Aalborg, Denmark: Aalborg Universitetsforlag. Serie om lærings-, forandrings- og organisationsudviklingsproce sser, Bind. 7.

Skadegård, M.C. and Horst, C. (2017) 'Between a Rock and a Hard Place: Navigating Within Structural Discrimination'. *Social Identities*. DOI: 10.1080/13504630.2020.1815526.

Skadegård, M.C. and Jensen, I. (2018) ' "There is Nothing Wrong with Being a Mulatto": Structural Discrimination and Racialised Belonging in Denmark'. *Journal of Intercultural Studies* 39(4): 451–465.

Thorsen, T.S.S. (2020) *Racialized Representation in Danish film: Navigating Erasure and Presence*. Aalbourg, Denmark: Aalborg University Press.

Weheliye, A.G. (2014) *Habeas Viscus: Racializing Assemblages, Biopolitics, and Black Feminist Theories of the Human*. Durham and London: Duke University Press.

12 The Power of Data: BFI, Black Star, and the True Landscape of Diversity in the UK Film Industry

Melanie Hoyes

In 2016, the BFI Southbank hosted a three-month-long season centred around black stardom onscreen in film and television. These annual seasons, known as blockbusters, are usually genre-led and have previously been named Love, Gothic, Sci-Fi, Comedy, and so on. The Black Star season, while being a celebration of blackness and black onscreen talent, immediately threw up wider questions around representation and diversity which previous seasons had not needed to address. Even in the process of programming, the lack of black stardom and opportunities for black leads on the British screen compared to that of Hollywood was evident. This was the year that #OscarsSoWhite was trending on Twitter, a movement that brought attention to the lack of ethnic diversity in the Academy Awards nominees and saw a boycott of the ceremony. This caused AMPAS (the Academy of Motion Picture Arts and Sciences who run the awards) to change the makeup of their board and academy members and voters in order to begin to address this.[1] If Hollywood were taking the time to self-reflect, not only on the diversity of the

Academy but also their industry as a whole, it felt as though these issues needed to be talked about and challenged in a British context, even if in microcosm, in the walls of the BFI Southbank. The drain of black talent from the UK to the USA raised questions about the opportunities afforded to black actors in the UK film industry and how well black people are represented on our screens. This migration of skills also speaks to a wider problem in the UK screen industries regarding skills gaps onscreen and offscreen. In a recent ScreenSkills Employer Survey, 33 per cent of respondents reported suffering from recruitment difficulties during the survey period (ScreenSkills, 2019) and with an increase in production in the UK due to attractive tax reliefs and streaming services creating a demand for more content, this is a problem that needs addressing.

In conversation with the Labour arts diversity inquiry in 2017, Cush Jumbo talked about the glass ceiling she had experienced in the UK that led her to work more in the US, saying, 'There's only so many years I can sit here, hitting that best friend ceiling before I go over to Amazon because they'll give me a role and they'll pay me for it. And because I write as well, I'm offered those opportunities as a writer, and it becomes less and less attractive to come back to the UK because you're coming back to nothing' (in Ellis-Petersen, 2017). There are a multitude of quotes and headlines about this issue from high-profile actors of colour over the last few years which provide anecdotal evidence of the lack of opportunities for black British actors to work in their home country.[2] These are often chalked up to one or two people's experience without linking it to a wider industrial and cultural issue. It was felt that data could help to support this testimonial and provide answers to some pertinent questions: How many British black actors are actively working in the UK? How often do they get to work or play a lead in UK films? What sort of genres do they appear in? Has the representation of blackness onscreen increased over time? There were long-held assumptions about many of these but none that could be answered definitively. Knowledge about diversity in the film industry has remained a tricky landscape to negotiate as data in this area is incredibly inconsistent and difficult to collect. A research project was commissioned to try and increase knowledge and prompt conversation by using data produced and gathered by the BFI, to be presented at a symposium held to launch the Black Star season at the BFI's London Film Festival in October 2016. The symposium brought together a range of panels, speakers, and audience members from the film industry, including David Oyelowo, Julie Dash, Barry

The Power of Data Melanie Hoyes

Jenkins, Noel Clarke, and Amma Asante, with the results of the data tying together the themes and providing a foundation for the day's discussions.

The BFI wears many hats as the national body for film in the UK. In its activity as a funder, archive, library, publisher, and exhibitor of film, it has collected a wealth of data since its inception in 1933. Information about films shown at the BFI Southbank, at its festivals, acquired for the archive, written about in publications in the library or the BFI's film magazine, *Sight and Sound*, are catalogued daily into the Collections and Information Database (CID) which is available to the public in order that the collections can be accessed. Historically, all feature films with a UK theatrical release at the cinema have been catalogued, making this the most comprehensive dataset on which to undertake this new research. This data also spoke most authentically to the questions around representation and stardom, as feature films at the cinema are most likely to be seen by a wide audience. Feature films continue to be pivotal in this analysis, in spite of audiences increasingly looking elsewhere to find themselves in this era of streaming services, social media, and online video platforms.[3] Audiences still look to films and cinema screens for representation. In fact, in 2018, UK cinema admissions were 177 million, the highest level of admissions since 1970 and 3.7 per cent up on 2017 (BFI, 2019). In a culture where you are a minority and your access to representations of people like you are limited, film becomes a mirror to your world and your sense of identity. Seeing representations of yourself become important in understanding where you belong and how to function in your society.

In the BFI's dataset, there are over 10,000 films which have been identified as UK films in CID and compiled into an ever-increasing BFI Filmography. 'UK films' are defined as fiction films of 40 minutes or longer length that are released theatrically in the UK by a member of the Film Distributors' Association and produced or funded in full or in part by a company based in the UK or films certified as British by the BFI's Cultural Test. Data collected includes titles of films, genre, cast and crew credits, and various other information but no personal data is captured. There is no consistent source of diversity data for the film industry, therefore; all of the diversity data for this project was acquired through manual research. A big data project had already been undertaken on this dataset to assign gender to the names in the credits, by bulk matching the credits with list of gendered forenames from the Office of National Statistics (ONS).[4] While not a perfect method (for example, there are names which are both male

and female; the method is incredibly binary and does not take into account other gender identities; there is a lack of information about international forenames and their 'gendered' nature) with some manual research and fixing, the picture around the history of gender in UK film proved enlightening and sufficiently comprehensive to begin to track the longitudinal history of women's opportunities in film. However, this method was deemed unsuitable for the Black Star research as a person's ethnicity is unlikely to be identified solely by their name. A method of online, desktop research over a variety of sources was developed, matching an actor's name with photos, articles, interviews, online CVs, and other sources to reasonably infer if they were Black/Black African/Black Caribbean/Mixed Ethnicity – Black, based on the census categories from 2011 and in line with the largely Afro-Caribbean definition of blackness identified in the remit of the Black Star season. Because of this targeted remit, other ethnicities, although also sorely lacking representation in UK film, were not researched for this project at this time although further research across all of the census ethnicities is forthcoming from the BFI in 2020. Other information such as nationality was also gathered to be able to identify British actors, separately from international actors working in the UK and tell a homegrown story. It was also necessary to identify whether the role played was a lead or supporting role in order to ascertain the agency and control an actor had on the narrative. Existing information such as subject and genre were used in parallel to give further insight to the research. As manual research is slow, it became clear that individually researching the entire cast of 10,000 plus films dating back to 1911 was not going to be achievable in the timeframe. Offscreen talent was also ruled out as there is much more personal information available about onscreen talent available in the public domain which would make the research faster. A sample of 1,172 feature films from January 2006 to August 2016 was chosen to provide the most up-to-date picture of the landscape as well as focusing on researching named roles only, excluding extras and bit parts in order to focus on roles that had more screen time and make the task achievable.

The last census estimates around 4 per cent of the UK population are black, slightly more if including the mixed ethnicity category.[5] In the sample, 13 per cent of films featured at least one black actor in a leading role which seemed like a good proportion in the first instance in comparison to the general population. However, further interrogation of the data reveals a bleaker picture. Looking at the year-on-year account of films with black actors in lead roles, no obvious

story or trend seems to emerge – the total number fluctuates slightly, but the number of lead roles played by black actors is fairly static, suggesting no change or increase in roles for black actors year on year. Even in years where more films are made, no further opportunities are afforded to black leads. The widely held notion that diversity and representation magically increases over time, in spite of there being no fundamental change to the barriers preventing certain groups entering and remaining in work in these screen industries, is shown to be simply untrue.

Looking at roles for black actors as a whole, in lead and supporting roles, the majority of British films produced in the sample, 59 per cent or nearly 700 films, did not feature a single black actor in any lead or supporting roles. Any representation of blackness in these films, if present, would be nameless, background characters. These roles may be presented as Nurse, Joyful Husband, or Jazz Singer, unlikely to have a speaking role or progress the narrative in any meaningful way. So, while some representation exists across the sample, the spread and consistency is poor and little agency is present. This is echoed when looking at the list of the 100 most prolific actors in the BFI Filmography, ranked by the number of roles they had played in UK films in this sample. Only four of the names in the list are black and all of them are men, ranking towards the bottom of the 100 names. None of the names potentially identified for the Black Star season – Idris Elba, Thandie Newton, Naomi Harris, John Boyega, David Oyelowo, Chiwetel Ejiofor – appear in the list, in spite of being instantly recognisable as they have achieved their international star status working in Hollywood and not via UK films. In fact, only ten male black actors and five female black actors played two or more leading roles in UK films across these 1,000+ films, highlighting the paucity of opportunities for black actors to play leads in the UK. As David Oyelowo has stated, when discussing the reasons he permanently moved to Los Angeles in 2007, 'If I looked like Benedict [Cumberbatch] or Eddie Redmayne, I could do the films they have done that are being celebrated now. But myself, Idris Elba and Chiwetel Ejiofor had to gain our success elsewhere because there is not a desire to tell stories with black protagonists in a heroic context within British film' (Child, 2016).

Oyelowo's point is emphasised by looking at the genres and subjects that the black actors in our sample portray. The most popular genre in the Filmography is Drama and black actors in named roles appear in 34 per cent of films with this genre in the sample. By comparison, they appear in 65 per cent of films in the Crime genre and only in

20 per cent of Period or Historical dramas. Not only is it difficult to be prolific and star in leading roles in UK films as a black actor but, when the opportunity to appear onscreen is given, black actors are usually restricted to playing stereotypical versions of blackness. The fact that so few films in the sample that have a historical narrative have very little black representation at all, perpetuates the widely held assumption that black people did not exist in this country before the Windrush landed in 1948 (see Leigh, 2017). This retelling of dominant histories of the UK whitewashes our history, making the white British experience the norm and unfairly erasing black people from these narratives, limiting representation. Where there is representation, the majority of black actors in our sample are clustered into a few films and centre around stereotypical narratives of race. You could watch half of all of the leading performances for black actors in this dataset in just 47 films – just over 100 lead performances by black actors by watching just 4 per cent of the entire sample. And almost all of them have subjects which focus on the ethnicity of the characters – racism, civil rights, gangsters, hip-hop, or are set in Africa. The black British experience is narrowed into a handful of stories with the representation of black people not spread out throughout these texts to provide a multiracial sense of Britishness. National identity is homogenised onscreen into a white experience. Even though there is some representation for black people, there are virtually no examples in this sample of a character's blackness not being the focus of the narrative.[6]

Images are persuasive and allow people to imagine who or what they might be. How is this possible when these representations are so limited? While stereotypes can be used as shorthand in narratives to allow an audience to connect with characters quickly, if this is the only portrayal available, it can be problematic. Stereotypes suggest stasis and limitation, an inability to provoke change, if a concept is referred to as a stereotype then the implication is that it is simple rather than complex or differentiated; erroneous rather than accurate; secondhand rather than from direct experience; and resistant to modification by new experience (Perkins, 1979: 139). The danger with stereotypes is in their fixity, in people seeing their limited representation as real and concrete. This perception does not allow for individuality, making sweeping assumptions about a group, usually a minority group of people. Therefore, representation on film can add to this fixity and, if the representation is negative as is shown in this research, sweeping generalisations and wholesale perceptions of a group of people can seep into a collective understanding of society. Negative imagery

can be damaging and the film industry has an obligation to take responsibility for the images it provides.

The heart of this research was representation – who gets to be seen and how are audiences allowed to imagine themselves and others. In her seminal work on the representation of black Britain on screen, Sarita Malik talks about the importance of seeing yourself onscreen in terms of connecting with your own identity, specifically in the case of ethnicity. She says that British media in general is 'a key site of contestation and cultural negotiation in matters of race and ethnicity, where we, as the viewing nation, both publicly and privately struggle to make meanings around Blackness' (Malik, 2002: 1). The data shows where the UK film industry is failing in this key role as it does little to augment visibility for underrepresented groups or portray them in a nuanced, positive way. These anecdotal tales of discrimination and a lack of opportunity in the industry for black actors are borne out in the figures over and over again. This research, although providing useful and groundbreaking insights, is incredibly laborious and requires significant resource and funding to be kept up to date. There are a number of similar annual research reports in the USA which employ the same research methods as the BFI Black Star research. The University of Southern California's Annenberg Inclusion Initiative's report undertakes manual research of cast and crew behind and in front of the camera. The UCLA Hollywood Diversity Report uses the additional resource of Showtime, an industry database which also manually researches the diversity characteristics of people working in film and television. Both focus on gender and ethnicity as these characteristics are able to be identified visually and both produce an annual, public report and various focused reports around questions of diversity in industry. This consistent production of standardised data provides knowledge to the Hollywood industry regarding the true state of diversity and inclusion as well as allowing for the continuing analysis of trends, that is, whether the industry is progressing or not. They also provide stories and headlines which the producers of the reports are able to use as leverage to gain interest from the press in the endeavour of pushing the agenda forward. The Annenberg 'Inclusionists', as they have branded themselves, have been particularly successful in doing this by getting high-profile players in the industry to endorse their recommendations to shift the dial. Most famously, Frances McDormand used her acceptance speech for Best Actress at the 2018 Oscars to cryptically urge her counterparts to have an 'inclusion rider' which prompted a sharp increase in people Googling this term (BBC, 2018). This was a concept that the founder

of the Annenberg Inclusion Initiative, Dr Stacy Smith, devised to shift the low numbers of underrepresented groups on set borne out in her research. An inclusion rider puts the onus on the main star of a film to use their influence and power to insist that diversity and inclusion is a condition of their contract (see Belam and Levin, 2018). The ability to have this kind of impact and continually produce these reports year on year is possible as both reports command significant investment from the universities they are based in, in terms of staff and student hours and from Hollywood itself, with several studios and organisations such as the Will and Jada Smith Family Foundation subsidising this research to the tune of tens of thousands of dollars.[7]

At the time of writing, the UK has no equivalent data reporting structure and the data around diversity in the industry consists of short-term projects, small samples, and are not comprehensive or longitudinal (see Cameo, 2018). The film industry is situated in a very different landscape to the USA, producing on a much smaller scale and often funded independently or with public money. Yet there is a responsibility to fairly and accurately represent society that is particularly pertinent in this context of public spending. It is time for the UK to recognise and harness the power of data in the same way as our American counterparts. Data capture, processing, storage, and reporting, especially in regards to sensitive personal data, is a difficult field to navigate. The industry is unregulated and largely freelance which means a central process and point of data capture is hard to pin down. The capture of self-declared information is not currently normalised as in other industries and the majority of the workforce is freelance, making it difficult to consistently capture this data or garner sufficient trust to do so. As has been shown, retrospective data capture is slow and requires a huge amount of resource. Recent GDPR legislation and elements of the UK Equality Act 2010 can make it even harder. For example, ensuring anonymity in reporting is essential for data protection but can be difficult when the numbers of people from underrepresented groups working in the industry are so low. In addition, the Equality Act does not allow for positive discrimination so policy to tackle discrimination in the industry often feels watered down as specific groups or deficits cannot be sufficiently targeted. However, the existence of legislation also helps in this endeavour as we have very clear guidelines about what discrimination looks like and which groups should be considered. It is also reasonable to ask people to declare personal data in certain circumstances, especially for workforce monitoring and in order to improve diversity. Neither of these contexts exist in the US as they currently do not have federal

legislation regarding equality so cannot ask for diversity data in some states for fear of discrimination. And yet, they are able to mobilise data in a way in which the UK has not, as yet.

Ideally the film industry in the UK would get to the point where self-certification and declaration of diversity data was a normalised process. This would ensure a regular, reliable stream of data which would provide a true and nuanced view of diversity in the industry. There are plans for the BFI to trial the collection of self-declared personal data from cast and crew on film productions at the time of writing, as it is seen as a logical step in the progression of diversity in the industry. The television industry in the UK has already started to do this via the Creative Diversity Network's Project Diamond and Australia's Screen Diversity and Inclusion Network (SDIN) and Screen Industry Innovation have just launched their new data capture tool, The Everyone Project. However, there are issues with pioneering initiatives which an equivalent project for film would need to be mindful of. Project Diamond's response rate is around 25.2 per cent which makes it difficult to do the deep dive into the data necessary to provide true insights into the workforce (Creative Diversity Network, 2018). This low rate could be because of a lack of trust from industry or survey fatigue as people are asked to fill in this information in several places, multiple times. Advocacy is also key in helping people to understand why filling in another form is important. Conflicting ideas about how the data should be reported has made advocacy within the industry difficult as the Unions who are best placed to effectively support this process want more granular reporting on a production by production level, but Diamond have chosen to report only top-line, aggregated data citing anonymity and GDPR as the reason. In response, the unions (such as BECTU and the Writers' Guild) told their members not to partake and have boycotted the process (Televisual, 2018). There is a thin line to be walked between the needs and concerns of all parties in data collection and reporting, with production companies reluctant to be named and shamed, workers in fear of being identified and the need for transparent and detailed data to help to move the dial more quickly. All of these factors need to be considered and worked out over time in order to ensure engagement with the process from everyone and decent return of data to effectively signpost the areas and actions which will yield the most lasting change. There is no excuse not to try and establish and embed diversity data collection and reporting into the heart of the film industry in the UK. The BFI is best placed to drive this for the film industry as it sits between industry, government, and policy and public interest, but it will need

financial support from government and full buy-in across the industry for the endeavour. Workforce monitoring would allow for a consistent stream of accurate data across a range of data points which would allow for longitudinal and intersectional analysis of the barriers people face. Although it should not be needed, data is useful in setting out a baseline of evidence for the lack of diversity that allows the industry to draw a line in the sand and move forward from assumptions that the situation is improving without any structural change to the industry and its culture. A commitment to this work would demonstrate a real shift in the film industry to take responsibility for the structural and systemic biases that perpetuate discriminatory practices and display a genuine will to make the industry more inclusive.

Since this research was produced, the allegations of sexual harassment against Harvey Weinstein have sparked activism in the #MeToo and Time's Up movements which, although focused primarily on the treatment of women in the film industry, have highlighted the power imbalances and exclusive culture that have allowed bullying and harassment of minority groups across the board. The fact that the focus is now at the heart of the problem provides a window of hope that the behaviours that have created insurmountable barriers to access for this industry may be coming down. Data allows us to monitor this situation and keep the pressure on the industry for change if it is not moving fast enough. It also allows for evidence-based policy to target the areas that need the most help. In a booming film production landscape, the industry cannot afford to lose anyone simply because it does not provide a range of creative opportunities or foster an inclusive environment for a diversity of talent to thrive onscreen and offscreen. It can only be hoped that the diversity of the film industry begins to reflect the rich and nuanced makeup of our society and this begins to be reflected onscreen. Time is up on an exclusive, homogenous, self-reflecting industry that retells the same stories and characters. It is time that every person gets to tell their every story.

Bibliography

BBC (2018) 'Oscars 2018: Who or What Is an Inclusion Rider?' *BBC News*. Available at: www.bbc.co.uk/news/entertainment-arts-43286515 (accessed 10 January 2020).

Belam, M. and Levin, S. (2018) 'Woman Behind "Inclusion Rider" Explains Frances McDormand's Oscar Speech'. *The Guardian*. Available at: www.theguardian.com/film/2018/mar/05/what-is-an-inclusion-rider-frances-mcdormand-oscars-2018 (accessed 10 January 2020).

Berrington, K. (2017) 'Thandie Newton: "It's Slim Pickings for People of Colour"'. *Vogue*. Available at: www.vogue.co.uk/article/thandie-newton-on-lack-of-diversity-in-uk-television-series (accessed 10 January 2020).

BFI (2019), 'BFI Stats for 2018 Show New High for UK Cinema Admissions'. *bfi.org.uk*. Available at: www.bfi.org.uk/news-opinion/news-bfi/announcements/bfi-stats-2018-cinema-admissions (accessed 10 January 2020).

BFI Research and Statistics Unit (2019) 'The UK Box Office in 2018'. *bfi.org.uk*. Available at: www.bfi.org.uk/sites/bfi.org.uk/files/downloads/bfi-uk-box-office-2018-v1.pdf (accessed 10 January 2020).

Boyle, K. (2019) *#MeToo, Weinstein and Feminism*. London: Palgrave Macmillan.

Brockes, E. (2018) 'Daniel Kaluuya: "I'm Not a Spokesman. No One's Expected to Speak for All White People"'. *The Guardian*. Available at: www.theguardian.com/film/2018/feb/10/daniel-kaluuya-not-spokesperson-black-people-black-panther-get-out (accessed 10 January 2020).

CAMEo (2018) 'Workforce Diversity in the UK Screen Sector: Evidence Review', Leicester: CAMEo Research Institute.

Child, B. (2016) 'David Oyelowo Calls for Radical Reform of the Oscars to Tackle Diversity Deficit'. *The Guardian*. Available at: www.theguardian.com/film/2016/jan/19/david-oyelowo-oscars-so-white-radical-reform-diversity (accessed 10 January 2020).

Cox, D. (2016) '#OscarsSoWhite: Who is Really to Blame for the Oscars' Lack of Diversity?' *The Guardian*. Available at: www.theguardian.com/film/2016/feb/25/oscarssowhite-right-and-wrong-academy-awards-audience (accessed 10 January 2020).

Creative Diversity Network (2018) 'Diamond: The Second Cut Report.'*Creative Diversity Network*. Available at: https://creativediversitynetwork.com/diamond/diamond-reports/diamond-the-second-cut-report/ (accessed 10 January 2020).

Ellis-Petersen, H. (2017) 'British TV and Film Industry "Pulls Plug" on Black Actors, Says Cush Jumbo'. *The Guardian*. Available at: www.theguardian.com/stage/2017/jul/11/british-tv-and-film-industry-pulls-plug-on-black-actors-says-cush-jumbo?CMP=Share_iOSApp_Other (accessed 10 January 2020).

Leigh, D. (2017) 'How Actors of Colour Are Reclaiming British Period Drama'. *Financial Times*. Available at: www.ft.com/content/6e4de97a-1dfc-11e7-b7d3-163f5a7f229c (accessed 10 January 2020).

Malik, S. (2002) *Representing Black Britain: Black and Asian Images on Television*. London: SAGE Publications.

McConnachie, S. (2017) 'BFI Filmography Project Overview'. *bfi.org.uk*. Available at: www.bfi.org.uk/archive-collections/bfi-filmography-project-overview (accessed 10 January 2020).

Office of National Statistics (2011) '2011 Census Analysis: Ethnicity and Religion of the Non-UK Born Population in England and Wales: 2011'.

214 *ons.gov.uk*. Available at: www.ons.gov.uk/peoplepopulationandcommunity/
culturalidentity/ethnicity/articles/2011censusanalysisethnicityandreligionofthenonu
kbornpopulationinenglandandwales/2015-06-18 (accessed 10 January 2020).

Perkins, T.E. (1979) 'Rethinking Stereotypes' in *Ideology & Cultural Production*. Edited by M. Barrett, P. Corrigan, A. Kuhn, and J. Wolff, 135–159. Croom Helm: London.

ScreenSkills (2019) 'Annual ScreenSkills Assessment'. *ScreenSkills*. Available at: www.screenskills.com/media/2853/2019-08-16-annual-screenskills-assessment.pdf (accessed 10 January 2020).

Sobande, F. (2017) 'Watching Me Watching You: Black Women in Britain on YouTube'. *European Journal of Cultural Studies 20*(6): 655–671.

Televisual (2018) 'Bectu, Writers Guild to Boycott Diamond Diversity Initiative'. *Televisual*. Available at: www.televisual.com/news-detail/Bectu-Writers-Guild-to-boycott-Diamond-diversity-initiative_nid-6435.html (accessed 10 January 2020).

UCLA (2014–) 'The Hollywood Diversity Report'. *UCLA College Social Sciences*. Available at: https://socialsciences.ucla.edu/deans-initiatives/initiative-archive/hollywood-diversity-report/ (accessed 10 January 2020).

USC (2014–) 'Annenberg Inclusion Initiative'. *USC Annenberg School for Communication and Journalism*. Available at: https://annenberg.usc.edu/research/aii (accessed 10 January 2020).

Notes

1. At the time, 94 per cent of Academy voters were white with only 2 per cent of African American heritage (Cox, 2016). It is yet to be seen if any of the actions from the Academy have had a lasting effect.
2. A quick search leads you to multiple interviews with black British actors on this subject including Cush Jumbo (Ellis-Petersen, 2017), Daniel Kaluuya (Brockes, 2018), David Oyelowo (Child, 2016), and Thandie Newton (Berrington, 2017).
3. Dr Francesca Sobande's research on the rise of YouTube is particularly enlightening (2017).
4. See McConnachie 2017 for more detail about the BFI Filmography and gender project.
5. See Office of National Statistics 2011 for full report.
6. The only example of a film in the sample where race was not a narrative element was Debbie Tucker Green's *Second Coming* (2014), starring Idris Elba.
7. Information obtained in conversation with Dr Darnell Hunt, Dean of Social Sciences at UCLA and lead researcher on the Hollywood Diversity Report in LA, May 2019.

13 A Woman Is Watching: Reflections on Film, When Film Doesn't Reflect You

Bidisha

I always enjoyed watching films alone. I didn't realise that as a woman of colour, I would be making them alone too.

In 2017 I was invited to submit a video clip of myself performing one of my poems. The invitation came from an arts organisation dedicated to improving the visibility and representation of British writers of colour and the fee they offered me, at the age of 39 and by then 24 years into my career, was £75. This arts organisation had been set up in response to the widespread discrimination and marginalisation of poets, novelists, and playwrights of colour in the publishing industry in Britain. They had had a lot of success in commissioning and touring these writers in the UK and abroad. Nonetheless, the rest of the publishing and performance industries – and all the various related nodes of what are grouped together as 'the creative industries' – did not consequently absorb these authors, give them industry support, or enable their full integration into British cultural and artistic life as celebrated creators. The authors have remained in a bubble, a silo – a ghetto – tolerated in its own bubble, but not included, and rarely remembered in canonical or official histories of Britain's creative story.

The film world is the same, but worse. Every year, a new tranche of statistics is produced, after months of diligent and depressing research. These statistics only corroborate what so many creators of colour already know through casual observation, anecdotal testimony from peers and from their own lived experience trying to make a

living and create a body of work. On the screen and on the page, there is a catastrophic lack of non-white representation and of racial variety in terms of the characters featured, the amount of dialogue spoken by characters of colour and the stories told. This is even before we get to who does (or doesn't) get an Academy Award, Golden Globe, BAFTA, or other major award for their contribution and their vision. Of the stories which *are* told, narratives which reinforce racist white Western narratives about other societies, cultures, and races are favoured. For example, in both the 2020 Golden Globe and Academy Award nominations for best actress, the only woman of colour was Cynthia Erivo for playing a slave in Harriet, the Harriet Tubman biopic. As a critic I have often had fun listing the stereotyped and pejorative storylines which are permitted: I was in a youth gang dealing drugs until my friend got stabbed and I found a new way; I was a terrorist/ almost a terrorist/my boyfriend-son-husband is a terrorist; I am a child bride/abused daughter/slave/sex slave/trafficking victim/ refugee/FGM survivor and here is my story of resilience and suffering and how I was saved. These are stories which highlight the abjection, backwardness, self-destruction, and humiliation of black, brown, red, and yellow people and our worlds, and which serve to blame us for our own abuses. Erivo's story is interesting in itself: she is another black Briton of excellence who has had to go to America to further her career, because the opportunities are not available in her home patch, the UK. Yet even when that move is made and projects are funded, when it comes to honouring talent at the highest levels, we are shut out for reasons of sex or race or both – as a combined analysis of the 2020 Golden Globes, BAFTAs, and Academy Awards nominations shows. In the last couple of years directors, including Mati Diop (*Atlantics*), Alma Har'el (*Honey Boy*), Melina Matsoukas (*Queen & Slim*), Lorene Scafaria (*Hustlers*), Rungano Nyoni (*I Am Not a Witch*), Lulu Wang (*The Farewell*), Ava DuVernay (*When They See Us*) as well as Lynne Ramsay (*You Were Never Really Here*), Joanna Hogg (*The Souvenir*), Olivia Wilde (*Booksmart*), Chloe Zhao (*The Rider*), Kelly Reichardt (*Certain Women*), and others have been locked out of best director nominations, which have traditionally been all white and all male – forever. This is not just an issue affecting women – this year Jordan Peele's superlative film *Us* has been completely snubbed, as has its lead actress Lupita Nyong'o. Even where directors such as DuVernay (who made her mark with Selma) and Barry Jenkins, *Moonlight*'s Oscar-winning director, have had previous successes, this has not always guaranteed a strong subsequent career: Jenkins' follow-up, *If Beale Street Could Talk* (2019), was mutedly praised.

It is even worse when we move away from what we see on the screen – from stories and character representation within fictionalised and dramatised narratives – and look behind the camera, or go beyond the pages of a novel and visit the publishers' offices, the production company's offices, and those of the agents, PRs, management, distribution and rights managers, the critics and commentators who create and flesh out an industry in all its dimensions. As I write, at the end of 2019 and the start of 2020, the cinemas are full. I can watch *Knives Out*, a comedy murder mystery with a huge ensemble, an all-star cast. I can watch *The Irishman*, a three-hour long epic about ageing gangsters by an auteur director who is revered amongst his own peers and amongst filmgoers. I can watch *Maleficent: Mistress of Evil*, a fantasy sequel about warring fairy queens in a gorgeously imagined CGI landscape, or *Marriage Story*, an acclaimed psychological drama based on the director's divorce. Well over 95 per cent of the combined casts of these films are white and virtually 100 per cent of the writers, directors, and producers of these films are white – mainly white men. Sam Mendes' film *1917* (2020) has just come out and, like *Dunkirk* (2017) and *Darkest Hour* (also released in 2017), it is the same old story of heroic white young men, England's greatness and the First World War. Greta Gerwig's *Little Women* (2019) is also out and it's an all-white affair except for the two-second cameo of a volunteer aiding the Civil War effort. Gerwig's previous film *Lady Bird* also featured one non-white character in the form of Miguel, the protagonist's adopted brother and the subject of a racist jibe by her during the film. Miguel's story was not explored in the film except to reflect how he and his depressed (white) adoptive father were up for the same job.

The English Problem

Most of the films I've mentioned so far are American made or American funded and I want to add one note: when it comes to talking about British film, there are poor pickings to choose from. England absorbs and internalises American film and TV culture with barely a gulp of protest or a second thought – all the more so given the power of Netflix, Hulu, Amazon, and the other streaming giants. This is fine, were it not for the fact that the relationship does not always go both ways. In the last decades there has been a spate of successes like the late-1990s, early 2000s Richard Curtis-style romcom franchise model – think of *Notting Hill*, *Love Actually*, and *Four Weddings and a Funeral*, in which characters of colour were sidekicks, cameos, or absent. In the first two Bridget Jones films I don't recall seeing any characters of colour, except

in the second film a group of comically presented South East Asian women in prison. The third Bridget Jones film, *Bridget Jones's Baby*, is in my view overtly racist, with a 'comedy' Italian waiter played by British Enzo Cilenti, a joke about an unpronounceable Thai surname and one black man mistaken for another. So often, British film has been about exporting clichés: Northern grit and pluck made good (*Calendar Girls, Billy Elliot, The Full Monty, Little Voice*); the swooning and beautiful-looking intense parlour romances of the Merchant Ivory films I grew up with; or the cosy boarding school adventures of *Harry Potter*, in which barely any characters of colour speak, across eight films. All of these sell ideas of Englishness to overseas audiences, without touching upon the reality of England.

It's tempting to look at American filmmakers' and producers' efforts to diversify their casts and crew and conclude that, though slow, change is finally happening. But it isn't happening here in the UK. In fact, there is a brain drain of non-white talent going from England to America or elsewhere, because performers and creators of colour are hitting the glass ceiling, even after decades in the industry. This has famously been the case with Idris Elba, David Oyelowo, Riz Ahmed, Daniel Kaluuya, Marianna Jean-Baptiste, Archie Panjabi, Cush Jumbo, John Boyega, and David Harewood, but it is also experienced by less high-profile figures such as film director Pratibha Parmar, visual artist Chris Ofili, comedian Gina Yashere, and acclaimed director Steve McQueen. In America, things are not necessarily better, but it's a broader canvas and the glass ceiling is higher. Indeed, British stories and storytellers of all kinds are stymied by race and class expectations when it comes to reaching American audiences. Our cultural exports and 'hit' films or shows like *Harry Potter, Downton Abbey*, and even the *Great British Bake Off*, with its smiling groups of willing cake makers, all pander to clichéd, chocolate-box notions of cute Englishness in which there is apparently no space for contemporary stories of colour. Alternatively, you have something like *Top Boy*, a gangs-and-drugs saga which, no matter how attentively it was made, still meets that narrow range of expectations of dramas features black male characters. Perpetrators or victims: that's all we get to be, with nothing in between. We cannot be represented as whole, complex human beings, and we are not recognised as avant garde artistic creators in the mainstream. At best, we are celebrated for our ability to testify: to create narratives which are, or could be, unmediated outpourings of personal suffering, or the sufferings of our people. Of the British films currently on general release as I write, there is *Sorry We Missed You*, a sincere study of contemporary zero-hours Britain by well-respected veteran director

Ken Loach; *Official Secrets*, a fact-based drama about New Labour-era political history based on a whistleblower's testimony, and *The Aeronauts*, a self-consciously charming and quirky film about a Victorian inventor and his plucky female colleague. Of these films, the first and third have all-white main casts and all three have all-white, virtually all-male behind-the-scenes crews.

At an industry level, as a viewer and as a critic, the sheer whiteness of cinema is staggering, as is its cultural insularity. I have always hated tribal behaviour: sticking to your own. I hate it even in people of colour: that narrow cleaving to the cultural output of 'your people' and a stony ignoring of all others. Yet that seems to be England's story. If you can't beat them, don't join them. If you can't rule them, ignore them. At industry screenings, networking sessions, critics' circles, and other UK film world events, the participants are virtually all white and all men, and that is that. This is the range of their real-world alliances and also the range of their cultural references and interests, no matter what lip-service they pay to 'diversity and inclusion'. Anyone not falling into that ultimately quite narrow category feels like and is treated like an anomaly and an outsider, either through ostracism, tokenism, or patronage. As a film critic for TV and radio I used to sit at the back of screening rooms and count the white men's heads in front of me. I was usually one of a handful of women critics in the room, and the only non-white person of either sex. There is a clear race-based colour bar both in front of and behind the camera and this is reflected in the casual racism, discrimination, invisibilisation, and low-pay or no-pay we receive. I would rather not deal with the major funding and producing bodies than be talked down to, patronised, and given the run-around, while watching young white men called (in my experience of these guys) Tim, Tom, Toby, Matt, Julian, and Dan being given funding, great opportunities, fees, deals, trips, promotions, and champions by the armful. In doing so, I am following the course – or rather, I am consigned to a course – familiar to countless British creators of colour. It involves working with little or no industry support, excluded from major artistic movements and groups, banished from potential sources of networking and cultural capital, in the hope of somehow managing to create a body of work which will be recognised someday, somehow. Along the way, countless artists will give up, unable to sustain their practice given the demands of making a living, sustaining a family life, and keeping food on the table. The result is first isolation, then stagnation, then extinction as the avant garde-of-colour dries up because it wasn't watered and fed. 219

This type of living – making one's art in private or secret, or on weekends or in evenings – is just about possible in writing and some visual forms such as painting and craft. But artforms relying on collaboration and financial investment, from filmmaking to design, render this impossible. Thus, the creation of art becomes an issue of class, contacts, entitlement, and privilege: those with the private means to continue creating will do so, those who don't will find themselves unwanted, unrecognised, and unable to create. It is humiliating and confronting to get far enough into your career to have some perspective, and realise that your race, sex, and now age worked against you and that 'the moment' never arrived. I often look to America for hopeful stories about film, and while there are many women arthouse directors, relatively few are women of colour, and even fewer are women directors of colour who have moved beyond their debut feature and are able to forge an actual career.

Film requires financial investment and collaborators at every stage of the creation process, critics, and viewers once it has been created, and ardent champions as well as programmers and archivists to ensure that it is seen more than once, and more than just on individual laptop screens after being put on the internet for free. Given the extreme marginalisation of women filmmakers of colour, women performers of colour, women critics of colour, and women producers of colour in the UK, the prognosis is a depressing one. Most of us – maybe me too – will create a handful of beautiful film works before giving up because of lack of encouragement. I don't mean emotional encouragement, I mean the kind of industry support and institutional bolstering necessary to create a career and enable artistic and worldly growth.

The truth is, I can't think of any British women filmmakers of colour from my formative years, or any characters or storylines that struck a particular chord simply because they were made by a woman of colour. I am not looking to have my personal experience validated, merely to have the entire world reflected back in all its variety, free of racist stereotype and cliché and free of misogyny, objectification, and victim-blaming. In many ways, 'relatability' doesn't matter to me as a director, performer, or viewer. I am not looking to see just myself reflected back at me. But I do want all of film to reflect all of the world. When I was growing up there was no director I could follow and revere as an artist, nobody whose path as an arthouse creator I could be inspired by or use to maintain faith that people like us would be supported. I watched what was available to watch, same as everyone else, from Hollywood blockbusters to Merchant Ivory

adaptations of Victorian novels to arthouse films by women and men directors from all over the world. I accepted this without questioning it: my film and art education was totally international and there was no sense of difference or otherness in watching different characters of different colours experience different events and emotions. That should be obvious, yet it doesn't go both ways. Audiences of all colours globally are expected to pay to watch what mainstream film produces – all those films by white men, about white men, which make the white men in the industry wealthy, famous, and powerful. I think industry whiteness should return the favour, prove that we are not invisible to them, shut up, put on their listening ears, and watch and learn from films made by women and men who are black, brown, red, and yellow. But it seems not to want to. Even watching a film with subtitles provokes resistance. You know how to avoid watching a film with subtitles? Learn other languages. But it don't want to do that either. Nor does it want to talk about the racism, misogyny, and discrimination that corrupts the industry from end to end and top to bottom.

What about Me?

In terms of pure emotions, my experience as a debut filmmaker of one short film has been a positive one. But this positivity has been assisted by countless layers of class-privilege: I was able to make a film with a camera operator I had met through a prior presenting job for the BBC, using very expensive equipment through the kind favours of a major documentary unit. Because we were all freelance, we were able to make time to shoot. I was able to capitalise on media contacts to ensure that my small film of only seven minutes was reviewed and received coverage, and I was able to capitalise on my existing profile. These are all the workings of privilege, as was the money I paid for location, camera, and editing and for submitting the film to countless film festivals. As it stands, in purely economic terms, I am several thousand pounds 'down' even though the film has boosted my career and enabled a creative evolution. This is how class operates in the creative industries and particularly in film, where income and investment are somehow divorced from other things which carry intangible though covetable value: contacts, buzz, fame, talent. Yet none of these things pay the bills. In this way, film is a world for the rich, and dreaming up and developing films is a process for those who do not have to do other necessity work in their day.

To date, my film *An Impossible Poison* has made the official selection of seven international film festivals and been screened from

New York to London to Berlin in short film festivals. I am coming from an arthouse, avant garde, high-art tradition and find it depressing that my simple film is being perceived as radical simply because it features a woman of colour who is not enacting a literal, grassroots story about the types of oppression I outlined at the beginning of this chapter. I also find it amusing that the film has been reviewed as a horror piece even though it is, as I often joke, 'simply about a woman's emotions'. To create new work, one comes up against a deep-rooted philistinism in the English psyche, a desire to laugh at whatever they don't understand and a refusal to widen their understanding, mixed in with an unearned colonial sense of cultural superiority. I have faith in my work and the short film has achieved more than many of the types of people who have succeeded in the wider film industry: white men. My work has been more highly acclaimed than their work. But instead of being offered the funding to create more films, or the chance to partner with brands to craft promotional films for them – as would be some of the natural progressions for emergent filmmakers – I have only received offers to talk on panels about racism and misogyny in the creative sector. Somehow, I am still on the outside, either ignored or actually invisible. So often, talking about inclusivity, representation, diversity, and equality is a way to avoid doing anything about racism, misogyny, marginalisation, and discrimination.

My experience speaks for itself. As a woman artist of colour working in photography and film, I am creating in total isolation. The film is screened for free and cost thousands of pounds of my own money to make, notwithstanding that £75 fee. I have not been approached by any producers or production companies about supporting subsequent films, despite my success or profile, and nobody has emerged to foster my talent or give me a hand up or anything. I know what happens to visual artists of colour, and it's even worse for filmmakers. We toil in total obscurity until we are really dead or nearly dead, when our paintings are finally 'discovered' and validated by white gatekeepers and *cognoscenti*. This is what happened with painter Frank Bowling, a contemporary of David Hockney. This British Guyanese master was born in the 1930s, found himself completely cold-shouldered by the artistic movements of his day despite having studied and socialised alongside them, relocated to work and teach in New York, and was eventually recognised with an exhibition by Tate Britain in the mid-1980s. With film, the dangers are even greater. It might easily be that our work – which depressingly takes the form of MOV files, with no physical reel – is never found, never clicked on, never played again. Of course, in every generation there are exceptions. In this generation

A Woman Is Watching Bidisha

of British filmmakers there is Steve McQueen, Amma Asante, and Gurinder Chadha. An early pioneer and champion is Pratibha Parmar. But who else is there? And which of them apart from McQueen is in that rarefied arthouse, auteur bracket? I find it significant that Parmar is now based in the US and that all but one of McQueen's feature films have been set in the US. I also find it telling that McQueen's great recent film, *Widows* (2018), was led by an incredible cast of women of colour and was almost completely snubbed at the 2019 Oscars, except for one nomination for Viola Davis and nothing for Cynthia Erivo's belting presence. I considered it a refreshing turn away from the abjection of *12 Years a Slave* – which to me pandered to white audiences' fetishistic desire to see black bodies raped, whipped, and brutalised – and a dynamic opening-up of the claustrophobic psychodramas that made his name, like *Hunger* and *Shame*.

Filmmakers of colour are in a tricky position. So much is changing now, and that is why all the toxic material is coming out. All these 'equality and diversity' conversations we're having on small stages in the UK are in danger of being completely drowned out by the tidal wave of insanely expensive, super glossy 'content' produced by Netflix, Amazon, Hulu, and all the other American tech monoliths. If we are not careful, the entire sum of world entertainment will be produced almost exclusively by white male tech executives from the States, who'll sprinkle a few faces-of-colour into their productions while talking a good diversity game and pocketing the overwhelming majority of the perks. These realities are painful if you love films and love watching films, whatever they're about and whoever made them. However, to make a wide and conscious survey of films which are generally available – including many arthouse, independent films – is often to see the wealth of human experience boiled down to racial and gender stereotypes, to pejorative and bigoted depictions, to cheap comedy and tawdry tragedy wrung from ignorant assumptions. It is to sit through patronising and ridiculous hand-wringing sessions and about equality and diversity – instead of race and racism, which is what this is really about.

Index